THE THREE GRACES
ANTONIO CANOVA

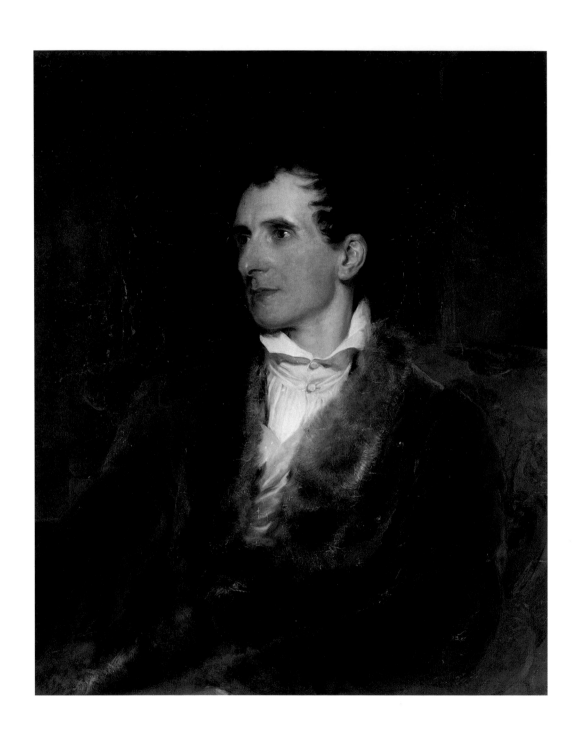

THE

TIMOTHY CLIFFORD · HUGH HONOUR

THREE

JOHN KENWORTHY-BROWNE · IAIN GORDON BROWN

GRACES

AIDAN WESTON-LEWIS

ANTONIO

NATIONAL GALLERY OF SCOTLAND

CANOVA

MCMXCV

Published 1995 by The Trustees of the
National Galleries of Scotland for *Antonio Canova
The Three Graces · A Celebratory Exhibition*
held at the National Gallery of Scotland, Edinburgh
from 9 August to 8 October 1995

Exhibition selected by Timothy Clifford
and Aidan Weston-Lewis
Catalogue edited by Hugh Honour
and Aidan Weston-Lewis
Photographs of *The Three Graces* taken by
Daniel McGrath and reproduced by courtesy
of the Victoria & Albert Museum

Designed and typeset in Adobe Garamond
and Monotype Castellar by Dalrymple
Printed by BAS Printers Ltd, Over Wallop
on 170 gsm Consort Royal Silk supplied
by the Donside Paper Company

Frontispiece: Sir Thomas Lawrence,
Portrait of Antonio Canova, 1815–18, oil on canvas,
90 × 72cm, Possagno, Casa Canova

FOREWORD

ANTONIO CANOVA (1757–1822) suffers not from having been overlooked, but from the superabundance of praise, indeed outright worship, that was meted out to him by his contemporaries and the majority of subsequent fellow-sculptors, connoisseurs, and aesthetes throughout the nineteenth century. Canova was for them *the* quintessential sculptor and in all respects, until perhaps the maturity of Rodin, the role model of all aspiring sculptors.

Late eighteenth- and nineteenth-century fashionable taste may have trembled at the brute force of Michelangelo; they may have been piously titillated by the ecstatic Catholic imagery and baroque flutter of Bernini; but they were profoundly moved by the cool Hellenistic magic of Canova. Emma Hamilton in her *Attitudes* adopted affected classical poses, but Pauline Borghese, all but naked and lying on a sofa, was herself transmogrified by Canova into one of the ideal images of her age. For a Grand Tour public nurtured on the *Belvedere Apollo*, the *Laocoon*, and the *Medici Venus*, Canova fulfilled all their desires of pose, surface, and sentiment, satisfying their reverie, for here was a Modern competing and even surpassing the Ancients. Canova in his chiselling and polishing not only rivalled the surface of the finest preserved antique marbles, but added significantly to the classical repertoire of poses.

Canova looked not just to Greek and Roman prototypes – nor only to the great sculptors of *cinquecento* and *seicento* Italy – but also to painting. He admired painters of the past like Titian, Reni, and Albani, and was much taken by contemporary French artists like Girodet and Prud'hon. His women are pubescent girls (as the classical texts often stressed), with diaphanous drapery clinging lightly to reveal the underlying flesh, gently fluttering at the edges in response to a breeze eddying around Parnassus or wafting through the Elysian fields. Hair is elaborately tressed (worthy of Bronzino or even Fuseli), while flesh, although marble, is very natural: Canova placed great emphasis on such *carnosità*. Some of Canova's ladies are voluptuous, but so too are the finest works of the Ancients, and also later masterpieces such as Botticelli's *Primavera* (as Savonarola recognised), Titian's *Venus of Urbino*, and Goya's *Maja desnuda*. Canova's men are robust and muscular, built on the model of the *Farnese Hercules*, or the *Belvedere Torso*, or the *Horse Tamers* of Monte Cavallo; set expressions probably owed as much to Le Brun's *Passions*, Lavater's *Physiognomy,* and recent studies of phrenology, as to the Ancients. Amateurs were thrilled by heroic sculptures like Canova's *Hercules and Lichas, Theseus and the Minotaur* and *Creugas* and *Damoxenos*, where knotted muscles with veins exposed coalesce with powerful physical poses and set features. Society also delighted in the delicate tiptoe tension of the graceful *Danzatrice* or *Hebe*, the contrasting hieratic grandeur of the personification of *Religion* on the tomb of Pope Clement XIII, and the slack, abandoned repose of the *Sleeping Endymion*. Canova's ability to transform an inert block of marble into a striking classical composition, which simultaneously has infinitely exciting abstract values and sets up the most subtle rhythmic flowing forms, is memorable. Not one of his immediate predecessors, contemporaries, or followers – Banks, Flaxman, Campbell, Sergel, Dannecker, Schadow, or Thorvaldsen – could rival his prodigious invention and remarkable skills of execution.

Melchior Missirini, in his *Della Vita di Antonio Canova* published in 1824, only two years after the sculptor's death, listed thirty pieces of his sculpture in British collections. Canova's influence on British sculpture was enormous and was fortified after his death by the

appearance in three volumes of *The Works of Antonio Canova*, engraved in outline by Henry Moses (1824–28). Canova died acknowledged as the most celebrated sculptor, indeed artistic personality, of his age, but fame is fickle. Who really was this man? Where was he born? What were the circumstances of his youth and training? What did he achieve and, above all, why did he come to be so greatly admired by the British? Many of these questions are addressed and answered in this publication.

The *raison d'être* of the exhibition is the opportunity to show, for the first time in Scotland, a supreme example of Canova's sculpture – *The Three Graces*, executed in 1815–17 for the 6th Duke of Bedford for Woburn Abbey, Bedfordshire, and now jointly owned by the National Galleries of Scotland and the Victoria & Albert Museum. The background to this acquisition is complex, and every detail has been much discussed in the media. As long ago as 1982, negotiations took place between the Bedford Estates and the Museum and Galleries Commission for the purchase of the group by the nation under terms which would have allowed it to remain *in situ* in its original location, but sadly these came to nothing. By the time a major appeal to save the sculpture for Britain had been launched in 1990 by the Victoria & Albert Museum, the sale of *The Three Graces* to the J. Paul Getty Museum in California had been agreed, via an intermediary, subject to an export licence being granted. On 25 March of that year, when the appeal appeared to be failing, the National Galleries of Scotland offered £1 million towards its purchase, but this initiative again failed. This is not the place to review in detail the complex events surrounding the further appeal launched in 1994 and the subsequent court cases. It is sufficient to state that the sculpture was finally bought from Fine Art Investment and Display Ltd in November 1994 by the Trustees of the National Galleries of Scotland and the Trustees of the Victoria & Albert Museum, with most generous support from the National Heritage Memorial Fund and the National Art Collections Fund, and with major gifts from J. Paul Getty II and Baron Hans Heinrich Thyssen-Bornemisza. There were also many smaller but nonetheless most welcome donations from a wide cross-section of the public.

Sharing was forced upon both partners because of the vast cost of this sculpture, but this situation has brought with it many potential benefits. Not only is the sculpture now to be admired by two quite distinct geographical audiences within the United Kingdom, but its context is entirely different in each location. In London it represents one of the jewels in the crown of the Victoria & Albert Museum's matchless collection of European, and particularly Italian, sculpture. There it can also be seen iconographically in its relationship to other interpretations of the subject in the decorative arts. However, in Scotland, where it will be seen alongside paintings and sculpture alone, it will look markedly different, for it is situated in a neoclassical city, in a neoclassical building, surrounded by neoclassical masterpieces, many of which would have been familiar to Canova himself.

The acquisition of *The Three Graces*, with its appeal campaign, was hard work and wearisome. Its happy outcome could not have been achieved were it not for the steadfast support of Angus Grossart and Lord Armstrong of Ilminster, Chairmen of the Trustees of the two institutions. Many others who were deeply involved deserve special recognition, notably Marcus Binney of 'Save Britain's Heritage', Anna Somers-Cocks of *Apollo Magazine* and later *The Art Newspaper*, Robin Simon of *Apollo Magazine* and Clive Aslet of *Country Life*. We also received solid support from The Scottish Office and from the Department of National Heritage.

I must, of course, acknowledge the special debt that we owe to our colleagues at the Victoria & Albert Museum – notably to Elizabeth Esteve-Coll, Director, Timothy Stevens, Assistant Director, himself a specialist in neoclassical sculpture; Paul Williamson, Keeper of the Sculpture Collections; and Malcolm Baker, Head of the Research Department – all of whom have shared in the anguish and delights of acquiring, displaying, and interpreting this ravishing sculpture. Joint ownership of the group has already borne fruit in the highly stimulating symposium *Surpassing the Ancients? Canova and his Reputation*, held at the Victoria & Albert Museum earlier this year.

I would like to take this opportunity to express our thanks to the following people who have helped in various ways during the campaign, the organisation of this exhibition and the preparation of its catalogue: Graciela Ainsworth, Christopher Allan, Brian Allen, Sir Geoffrey de Bellaigue, Alessandro Bettagno, Hilary Bracegirdle, Manlio Brusatin and the staff of the Gipsoteca at Possagno, Alastair Cherry, Jane Clifford, Richard Cook, Anne Crookshank, Jane Cunningham, Peter Day, Silvano De Tuoni, Ben Dhaliwal, Attilia Dorigato, Philippe Durey, David Ekserdjian, Lord Elgin, Michael Evans, Francis Farmar, Geoffrey Fisher, Wendy Fisher, Desmond FitzGerald the Knight of Glin, John Fleming, Sarah Jameson, Alex Kader, Alastair Laing, David Law, Timothy Llewellyn, Stuart Lochhead, Gordon McNicoll, Avril Martindale, Jim Moyes, Caroline Paybody, Emma Phillips, Elizabeth Powis, Laila Quintano, Giandomenico Romanelli, Pierre Rosenberg, Francis Russell, Philip Ward-Jackson, Lord Weir, Sarah Wimbush, Karin Wolfe Grifoni, Alison Yarrington. Mario Guderzo and Fernando Rigon of the Museo Civico in Bassano del Grappa deserve special recognition for their unstinting assistance and enthusiasm for this project.

A particular debt of gratitude is owed to those who have written the excellent contributions for the catalogue at very short notice: John Kenworthy-Browne, whose tireless pursuit of photographic material has done much to enhance this publication; Iain Gordon Brown; and above all to Hugh Honour, who has not only provided the excellent core essay of the catalogue and the transcriptions of letters published here for the first time as an appendix, but has expertly vetted all other contributions and has been unfailingly helpful and patient over many other matters connected with the exhibition.

Neither the exhibition nor its catalogue would have been possible without the co-operation of the staff of all departments of the National Galleries of Scotland. Special thanks are due to Michael Clarke, Margaret Mackay, Janis Adams, John Dick, Keith Morrison, Anne Buddle, Alastair Patten, Susanna Kerr, Morag Kinnison, and to Sally Groom who, by way of induction to exhibitions at the National Gallery of Scotland, has dealt capably and cheerfully with the mass of multi-lingual paperwork involved. The exhibition could not have happened without the dedication and sheer hard work of my colleague Aidan Weston-Lewis, who has selected the exhibits, edited the catalogue and compiled the entries on exhibited works.

Finally, we are deeply grateful to all those institutions and private individuals who agreed at such short notice to lend often precious and fragile works to our exhibition, and to Daniel Katz, John Lewis, the Weir Foundation, General Accident, Momart, Forth Wines, and the Patrons of the National Galleries of Scotland for their financial support.

TIMOTHY CLIFFORD
Director, National Galleries of Scotland

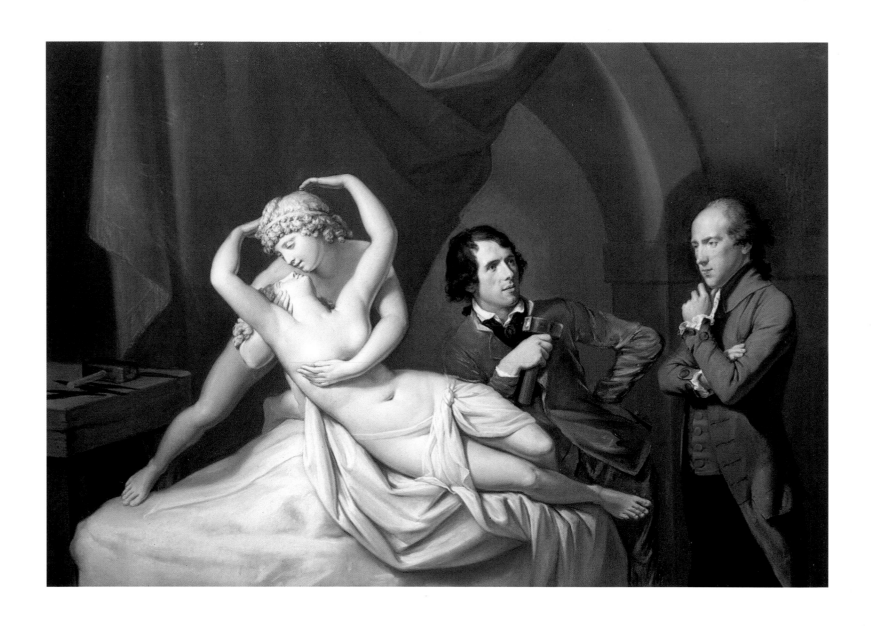

fig. 1 Hugh Douglas Hamilton,
Canova in his Studio with the Painter Henry Tresham and a Plaster Model for the 'Cupid and Psyche',
1788–9, pastel on paper, 93 × 117cm, Private Collection

Timothy Clifford

CANOVA IN CONTEXT

The Sculptor, his Reputation, his British Patrons
and his Visit to England

Perhaps no artist in Italy since Titian was more admired during his lifetime than Canova, but such was the cult of Canova that his sculpture was bound to attract criticism after his death. Imagine, here was an untutored youth, son of a humble stone-cutter from the small town of Possagno in the foothills of the Dolomites who, through his astonishing ability, rekindled singlehandedly not just the glories of Venetian art but of Italian art itself which, to contemporary observers, had seemed doomed to perpetual decline. Canova's father died in 1761 when his son was just four. The boy's prodigious talent was later to be recognised and nurtured by a local Venetian Senator, Giovanni Falier. After having been apprenticed to a Venetian family of sculptors, the Bernardi, who specialised in garden sculpture, Canova came to Venice in about 1768 to learn. While employed by the Bernardi workshop in Santa Martina, during his free time he drew after casts from the Antique and from Baroque terracottas, then on public display in the Farsetti collection at the Palazzo di San Luca, and from the classical masters in the Biblioteca Marciana. The young sculptor also joined the life classes of the Venetian Academy. The Farsetti terracottas provided the young Canova with a heaven-sent opportunity to learn about *seicento* Roman sculpture, with choice examples of works by Bernini, Algardi, Duquesnoy, and their contemporaries and followers.[1]

For his first patron Falier, Canova carved from 1773 to 1776 figures of *Orpheus* and *Eurydice* for his villa at Pradazzi di Asolo (now Correr Museum, Venice).[2] These tall flame-like figures, captured in a moment of intense passion, are far removed from contemporary Venetian works by, say, Corradini or Morlaiter. They betray an avowed admiration for Gianlorenzo Bernini's *Apollo and Daphne* in the Villa Borghese, a respect for Jacopo Sansovino (1486–1570) and possibly, notably for *Eurydice*, even the late oils of Palma il Giovane (1544–1628). The *Orpheus* was exhibited at the annual *Fiera della Sensa*, Venice (Ascension Day Fair) in 1777 and the Vicenza *Giornale Enciclopedico* for July observed:

> According to the Intendants who scrutinised the statue at the Ascension Fair, the work is equal in
> design, attitude and in the virile gentleness of such an Apollonian figure as is befitting for Orpheus,
> to the fine statues of Vittoria and Sansovino, famous sixteenth-century Veneto sculptors; it may even,
> indeed, surpass them in elegance and refinement. Of this young man it is said that, with respect to
> the Italian School, he need just make one final step to take his place beside Michelangelo Buonarotti,
> the most famous of Italian sculptors.[3]

This was indeed heady praise for a young sculptor. Within two years he travelled south to Bologna, Florence and Rome and there, we learn from his *Quaderni di Viaggio* (1779–80), Canova especially noted and admired certain *cinquecento* artists – Giambologna, Cellini, Vincenzo de' Rossi, Francavilla, Bandinelli and, of course, Michelangelo.[4] The poses of Canova's later sculptures like the *Hebe*, the *Perseus Triumphant* (fig. 66), *Hercules and Lichas*, *Theseus Fighting with the Centaur* and the *Sleeping Endymion* (fig. 70) demonstrably betray such influences.[5] He also remarked on the notable Florentine Mannerist painters Bronzino, Salviati and Vasari. Certainly Canova was principally influenced by the Antique, but he clearly responded also to the Florentine *cinquecento* interpretation of classical sources. Just as Giambattista Tiepolo (1696–1770), perhaps the last really great painter of Italy, harked back in his pictures to the golden age of Venice, using sixteenth-century costumes and the imaging of Veronese, so Canova relished the neatly counterbalanced poses, the refined *linea*

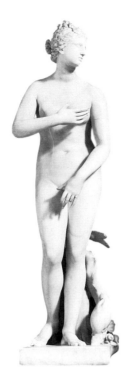

fig. 2 Innocenzo Spinazzi, *The Medici Venus* (after the Antique), 1784, marble, 163cm high, Edinburgh, National Gallery of Scotland

fig. 3 Carlo Albacini, *Lucius Verus* (after the Antique), c.1780, plaster cast, 88cm high, Edinburgh, National Gallery of Scotland

fig. 4 Christopher Hewetson, *Portrait Bust of Gavin Hamilton*, 1784, marble, 58cm high, Hunterian Art Gallery, University of Glasgow

serpentinata, the elaborately coiffed nymphs and the muscular heroic poses of male athletes common to sixteenth-century Florence.

On his 1779–80 journey Canova visited not only the great churches, palaces and archaeological sites, but also the studios and workshops of established contemporary painters and sculptors. For instance, in Florence on 23 October 1779 he called on Innocenzo Spinazzi (1726–1798), court sculptor to Pietro Leopoldo de' Medici, at his workshop in Borgo Pinti. This Roman sculptor was then working on a part-time basis restoring antiques, mainly for the Boboli Gardens, but also on the celebrated Niobid group in the Uffizi Gallery. At the time of Canova's visit he was carving a figure of his own invention, which did not impress the younger sculptor. A fine copy by Spinazzi, with variations, of the *Medici Venus*, signed and dated 1784, was recently acquired by the National Gallery of Scotland (fig. 2).[6]

In Rome, on 12 June 1780, Canova visited 'Monsieur More Inglese', the Scottish landscape painter Jacob More (1740–1793). Among several canvases recorded by Canova in his diary was 'one representing Vesuvius as described by Pliny' – almost certainly *The Eruption of Mount Vesuvius*, also in the National Gallery of Scotland, which is signed and dated in that year, 1780.[7] Three days later Canova called on Carlo Albacini (1734–1815), in whose workshop he witnessed many youths restoring antiques, and especially remarked on a colossal head of *Lucius Verus* copied from an original in the Casa Borghese, which was taking a great time to carve. A cast by Albacini of this head is in the National Gallery of Scotland (fig. 3), acquired along with over 250 others in 1838 from the Albacini studio.[8]

Like all young artists of consummate talent, Canova oscillated between a myriad of different artistic influences. About 1779 he is believed to have modelled a terracotta relief of *Danae* (signed *A Canova scul.*; now in Berlin, Staatliche Museen) after the celebrated composition by Correggio (c.1489–1534) formerly in the Orléans collection and now in the Galleria Borghese, Rome.[9] On 8 November 1779, accompanied by the Venetian Procurator, Lodovico Rezzonico (1726–1786), Canova visited the studio of Pompeo Batoni (1708–1787) who much impressed him and whose private academy he joined. There he executed bas-reliefs, such as the Berlin terracotta, under Batoni's guidance. Canova also much admired Batoni's drawing style.[10]

On 5 January 1780 Canova visited for the first time the studio of the Scottish painter Gavin Hamilton (1723–1798; fig. 4). Hamilton, from Lanarkshire, who had been resident in Rome since 1756, was also a noted archaeologist and dealer in classical antiquities. 'Amilton – an excellent painter who I like extremely',[11] as Canova put it, was to exert a most powerful influence over him. It was Winckelmann who greatly praised Hamilton to Batoni, and it was clearly through Hamilton's influence – and not that of Anton Raphael Mengs (who had died in July 1779) – that Canova really became a fully fledged neoclassical sculptor. Gavin Hamilton introduced him to the writings of Edmund Burke, most importantly to *A Philosophical Enquiry into the Origins of our Ideas on the Sublime and the Beautiful* (1757), and to Shaftesbury's *Characteristicks* (1714), and Stuart and Revett's *The Antiquities of Athens* (1762). He also became the leading figure of Canova's circle in Rome, which included the engraver Giovanni Volpato, the painter Giuseppe Cades (see fig. 5), the sculptor and restorer Giuseppe Angelini and the Venetian Ambassador Girolamo Zulian.

Hamilton demonstrably influenced the form of Canova's ground-breaking group of the seated *Theseus and the Minotaur*, originally commissioned by Zulian in 1781.[12] The complex pose was based on several prototypes, including a *Hermes* in Naples, a torso discovered by Hamilton at Hadrian's Villa, a Pompeiian fresco and Hamilton's own *Achilles Dragging the Body of Hector around the Walls of Troy*. This most classical of Canova's early marbles was acquired between 1814 and 1822 by the Marquess of Londonderry and is now in the Victoria & Albert Museum. Canova had settled in Rome in 1781 and, through the assistance of Abate Giuseppe Foschi, began to learn English and French.[13]

In 1783 a rich merchant Carlo Giorgio commissioned Canova to carve a sepulchral monument to Pope Clement XIV Ganganelli (Rome, Santi Apostoli) in recognition of many past Papal kindnesses. For the features of the dead pope Canova had recourse to a plaster bust

ABOVE fig. 6 Christopher Hewetson, *Bust of Lorenzo Ganganelli, Pope Clement XIV*, 1772, marble, 75cm high, Edinburgh, National Gallery of Scotland

RIGHT fig. 5 Giuseppe Cades, *Gavin Hamilton Leading a Pary of Grand Tourists to the Archaeological Site at Gabii*, 1793, pen and ink and wash over pencil on paper, 45 × 58cm, Edinburgh, National Gallery of Scotland

BELOW fig. 7 Antonio Canova, *Model for a Figure of Piety or Humility*, c.1783, terracotta, 38.5cm high, Private Collection

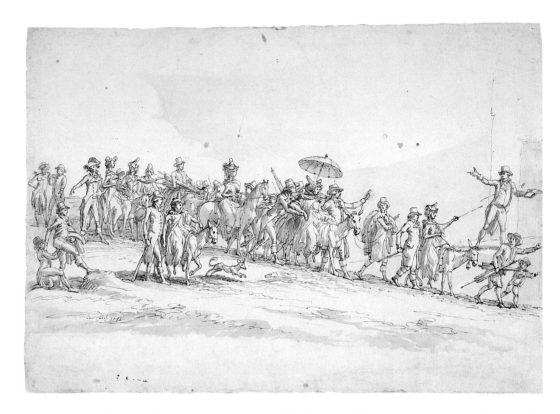

(now in the Museo Civico at Bassano) by Christopher Hewetson (1739–1798), an Irish sculptor and friend of both Hamilton and Canova. The Victoria & Albert Museum and the National Gallery of Scotland have excellent autograph marble examples of this bust (fig. 6). A discarded terracotta study of a draped standing mourner – *Piety* or *Humility* – for a figure at the foot of this tomb was acquired by Henry Blundell of Ince (1724–1810) and now belongs to his descendants (fig. 7).[14]

One of the first of Canova's British patrons was John Campbell (known to Italian contemporaries as 'Colonello'), created Baron Cawdor in 1796 (1755–1821). He was a Whig politician who gave great support to Prime Minister Pitt in his war policy. A Scottish aristocrat of Cawdor Castle, Nairn and a distant cousin of the Argyll Campbells, he also inherited a fine house, Stackpole Court, in Pembrokeshire. Colonel Campbell first met Canova in May 1787, and again shortly afterwards in Naples with the Irish painter Henry Tresham (1751–1814; see fig. 1). From then on, but for the intervention of the Napoleonic wars, Campbell was Canova's constant friend, admirer, correspondent, and patron. He collected antiquities avidly, especially vases, and when in Rome – like Pope Clement XIV and Gavin Hamilton – sat for his portrait bust to Christopher Hewetson (fig. 4). For Campbell, Canova carved his *Amorino* (1787–9; cat. no. 19). He also commissioned the group of *Cupid and Psyche (Reclining)* (1787–93, now in the Louvre; see fig. 1), the *Cupid and Psyche (Standing)* (1796–1800, also in the Louvre), the second version of the same group (1800–3, now in St Petersburg), a version of *Hebe* (1808–14, now at Chatsworth), a *Bust of Peace* (1814, delivered in 1816, now lost) and the statue of a *Reclining Naiad* (1815–17; now in Buckingham Palace).[15] Sadly, Cawdor was not adept at paying his bills but others were always eager to acquire the works that he had commissioned.

Other British Grand Tour travellers became aware of Canova early in his career. Mary Berry, the young blue-stocking friend of Horace Walpole and a cousin of the Fergussons of Raith in Fife, first met Canova on 28 March 1784, when she was only twenty-one and he twenty-seven. She noted: 'with Mr Bononi to a sculptor's who is making a Monument for Pope Ganganelli. He is a young man who was the son of a peasant near Venice. Untaught he did wonders in the way of sculpture; he has been the last two years in Rome, and has already made such progress and surprises everybody of his profession. A Theseus sitting triumphantly over the Minotaur might almost rival some of the chefs d'oeuvre of Antiquity'. On 1 May 1784 she noted: 'To take leave of the Capitol, the Colosseum, with Canova the sculptor'.[16]

In 1783 Canova was commissioned by Prince Abbondio Rezzonico to carve a great funerary monument in St Peter's to his uncle, the Venetian Pope Clement XIII Rezzonico (1693–1769). The Rezzonico Pope had been a major patron of Canova's fellow countryman Giambattista Piranesi (1720–1778), the architect and printmaker, and had promoted many archaeological excavations. The monument was completed in 1791 and inaugurated on 6 April 1792. While engaged on this monument he carved a figure of *Psyche* for Henry Blundell of Ince near Liverpool (1789–92; cat. no. 20), a finely wrought marble of a young maiden, looking down at a butterfly that has settled in her hands. This sculpture was remarked upon by the Scot, Sir William Forbes, on 30 April 1793, when he saw it in Canova's studio (recorded in his diary, now in the National Library of Scotland).[17] The unaffected modesty embodied in this statue was to excite emulation in generations of sculptors, notably Bertel Thorvaldsen, John Gibson, and Richard Westmacott.

Canova's range and repertoire were constantly expanding, his sketchbooks teeming with new images and his order books brimming over with commissions. His reputation continued to soar during the 1790s, and many of his major commissions were now by order of General Bonaparte, later First Consul and Emperor of the French, or of his Imperial family. Canova was at first flattered by the attentions of Napoleon, but became increasingly distressed by Napoleon's harsh treatment of the Pope and his outrageous plundering of Italy's artistic treasures. Canova himself was becoming progressively famous. In 1792 when he returned to Possagno he was met by forty young men crowned with flowers and mounted on horses adorned with laurels and roses. In 1795, *Le sculture e le pitture di Antonio Canova* by Faustino Tadini, the first biography of the sculptor, was published in Venice.

Pietro Giordani, when inaugurating the *Biblioteca Italiana* (1816), claimed: 'From any standpoint in our century, Canova is a miracle verging on the fantastic. Literature should have a Canova: if not, it will never succeed in putting people on the right path'.[18] In the preface to Canto IV of *Childe Harold's Pilgrimage* (1818), Byron wrote 'Italy has great names still: Canova, Monti, Ugo Foscolo, Pindemonte, Visconti, Morelli, Cicognara, Albrizzi, Mezzofanti, Mai, Mustoxidi, Aglietti Vacca, will secure to the present generation an honourable place in most of the departments of Art, Sciences and Belles Letteres; and in some the very highest: Europe – the world – has but one Canova!'.[19] His rise to fame was viewed with jealousy by the sculptors in Rome, who at first blocked his entry to the Accademia di San Luca, but he was in due course elected its President in 1810 and in 1814, an unprecedented honour, made Perpetual President. In 1801 Canova was created Knight of the Golden Spur by Pope Pius VII who later, in 1816, elevated him to the peerage as Marchese d'Ischia.

Keats's *Ode to Psyche* was based on Canova's sculpture. Stendhal placed him amongst the three greatest men he had met, the others being Napoleon and Byron. Dickens described his works as 'beyond praise', while Balzac named him as the very 'type' of a great artist. Heine dreamt that he was making love to Canova's *Venus Italica*, while Flaubert was unable to resist the temptation to kiss the *Cupid and Psyche* (under the armpit of Psyche). Contemporaries acknowledged him as the one heir to Italy's lost greatness: 'such as the great of Yore, Canova is today', proclaimed Byron.[20]

However, not everyone succumbed to Canova fever. Carl Ludwig Fernow, in *Über den Bildhauer Canova und dessen Werke* of 1806,[21] criticised the emotion of Canova's *Lieblichkeit*, with its wide variety of viewpoints and naturalism, as opposed to the fixed metaphysical isolation of Thorvaldsen. In his criticisms Fernow, a strict follower of Kant, subscribed to the letter to Goethe's conception of the beautiful and disapproved of Canova's debt to Bernini and to his naturalism. Canova particularly strove for what he called *carnosità*, the emulation of the naturalistically fleshy qualities of Antique sculpture. John Ruskin was clearly repelled by Canova's love of flesh, and wrote: 'The admiration for Canova I hold to be one of the most deadly symptoms in the civilisation of the upper classes in the present century'.[22] It was as the true heir of Ruskin that Sir Kenneth Clark echoed such criticism, and he was particularly hostile to the Vatican *Perseus* (fig. 66).[23]

In 1797 Canova was distressed by the French invasion of Italy and the fall of the Venetian

Republic. On 12 May Napoleon wrote to Canova assuring him that the stipend that he already received from the Serenissima would still be paid, and guaranteeing him the protection of the Army of Italy. The following year an Austrian army arrived in the Veneto and similar pledges were given. It was at this time that Duke Albrecht of Saxony commissioned a sepulchral monument to his late wife Maria Christina of Austria (Vienna, Augustinerkirche). The format was to follow the design that Canova had developed around 1790 for a tomb to Titian, with a massive pyramid entered to the left by a procession of mourning figures. This was perhaps the most affecting of his larger monuments. One of Canova's studies for the figures on the left has recently been bought by the National Gallery of Scotland (cat. no. 21).

The War with France blocked the flow of art works from Europe and Canova's British patronage effectively ceased. With the Peace of Amiens (1802–3) the situation changed. Sir Simon Houghton Clarke, Bart. (1764–1832) commissioned from Canova versions of the colossal sculptures of the boxers *Creugas* and *Damoxenos* (both in the Vatican Museums; see figs. 67 and 68) for his house Oak Hill, near High Barnet, London. In spite of a plenitude of British sculptors, British *cognoscenti* still yearned for Canova's work. In November 1803 Adam Fergusson (1723–1816), celebrated figure of the Scottish Enlightenment, commissioned a life-sized marble statue of 'Mister Dundas', later 1st Viscount Melville, costing £2,000, for his house Hallyards near Peebles.[24] Neither the Dundas statue nor the Clarke boxers were executed, victims of the resumption of war with France. When Nelson fell at Trafalgar in 1805 there was an attempt a little later to commission from Canova a great free-standing sepulchral monument to the Admiral.[25] Drawings, monochrome sketches, and terracotta, plaster and wax *modelli* for this monument exist at Possagno and Bassano to show how far Canova's ideas were advanced (fig. 8), but the project came to nothing. In 1806 the University of Cambridge asked Canova to carve a statue to William Pitt for the Senate House but this, too, remained unexecuted. As Joseph Farington noted in his *Diary*, 'it was impossible at this period to employ foreign artists in preference to our countrymen'.

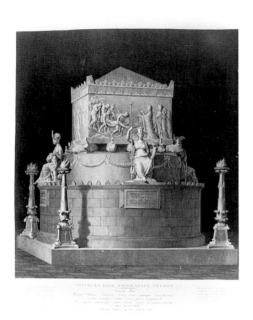

fig. 8 Pietro Fontana, *Antonio Canova's Design for a Monument to Admiral Nelson*, 1813, etching and engraving, Bassano del Grappa, Museo-Biblioteca-Archivio

With the defeat of Napoleon by the Allies in 1814, there were again opportunities to acquire Canova's works, and the Czar of Russia, the Emperor of Austria and the Prince Regent, as well as prominent members of their respective courts, all clamoured for special attention. Canova started on commissions again for Lord Cawdor: the *Hebe* and the *Bust of Peace*, as previously discussed. Canova offered a version of his *Terpsichore* to Sir Simon Clarke in October 1814 which was completed in 1816 and delivered to England (now Cleveland Museum of Art, Ohio); and in 1818–22 a *Dancer with her Hands on her Hips* (now National Gallery of Canada, Ottawa). In January 1815 he received the commission from the Duke of Bedford to carve *The Three Graces* group, the subject of this exhibition and of the next essay. He was also carving the figure of *Religion* for the sum of £1,350 for Earl Brownlow for his wife Sophia's tomb at the church of St Peter and St Paul, Belton, Lincolnshire (completed 1818; fig. 9), and at work on the *Reclining Naiad* begun for Lord Cawdor but passed on to the Prince Regent (completed 1819; Buckingham Palace).

In spite of this massive demand for his sculpture, Canova was to have even more pressing reponsibilities, for on 10 August 1815 he was nominated by the Pope to go to Paris as Papal delegate to sue for and supervise the return of the artistic booty plundered by Napoleon from Italy. In France, Canova was treated abominably by the representatives of the restored French Monarchy, and by Baron Dominique Vivant-Denon, Director of the former Musée Napoléon, and he was given little encouragement by the allied powers of Russia, Austria or Prussia. It was the British who, characteristically, insisted on fair play, at first through the agency of the diplomat William Richard Hamilton (1777–1859; not to be confused with Sir William Hamilton) – at that time Lord Castlereagh's secretary and formerly secretary to Lord Elgin – and later with the enthusiastic assistance of Lord Castlereagh, Charles Long (later Lord Farnborough) and the Duke of Wellington himself. The British paid 200,000 francs for the packing and transport of the treasures back to Rome, providing for the first part of the journey an escort of Royal Dragoons.[26]

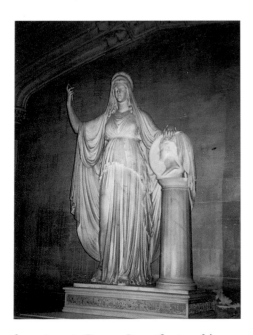

fig. 9 Antonio Canova, *Personification of the Protestant Religion*, 1815–18, marble, 375cm high, Belton, Parish Church of St Peter and St Paul

Canova had known of the masterpieces from the Parthenon through the publication of Stuart and Revett since the 1780s and he had also been in contact with their owner Thomas Bruce, Earl of Elgin (1766–1841) since 1803.[27] He eagerly wanted to see them now that they were in London and at the same time to show his gratitude to the British nation, who had so generously assisted in the return to Italy of Napoleon's plunder. According to *The Times*, 31 October 1815, 'The intended first visit of Canova to this country' was not 'to give his opinion of the National Monument', but was simply one of curiosity: 'the only object he has in view being to see the public buildings and monuments of London, its schools of art, its collections of statues and paintings and more particularly the gallery of statues and bassi rilievi bought from Athens by the Earl of Elgin'.

Canova arrived in London on 1 November 1815 with his half-brother the Abbé G. B. Sartori Canova. He stayed little more than a month, attending on 4 December a farewell dinner, given in his honour, where he was presented by Lord Castlereagh to the Prince Regent. He was given a diamond snuff-box by the Regent which, upon opening it, was found to contain a note for 500 pounds. In London he visited the British Museum to see the newly acquired Townley Marbles and Lansdowne House to see the marbles largely collected by Lord Shelbourne on Gavin Hamilton's advice. At Duchess Street, just around the corner, he admired the paintings, marbles and fine furniture collected by the banker Thomas Hope, himself a patron of Canova.[28] At High Barnet he went to see Sir Simon Clarke and he also visited Windsor Castle, Hampton Court, and Woburn Abbey. Canova visited the collections of Holland House, Devonshire House and the private houses of William Richard Hamilton, Charle Long, the Misses Mary and Agnes Berry and probably Samuel Rogers and Richard Payne Knight.[29]

The sculptor inspected the Elgin marbles which were then on display at Burlington House, Piccadilly, and was thrilled by them – as is evident from his letters to Lord Cawdor (7 November), Quatremère de Quincy (9 November), and above all to Lord Elgin (10 November): 'I admire in them the truth of nature united to the choice of finest forms. Everything here breathes life with a veracity, with an exquisite knowledge of art, but without the least ostentation or parade of it, which is concealed by consummate and masterly skill. The nudes are real and most beautiful flesh'.[30]

Canova made his own notes on the visit – *Appunti sul Viaggio in Inghilterra 1815* (Bassano, Museo Civico). The British artisitic community were flattered and intrigued that Canova had visited Britain and noted his every movement, his conversations and opinions. At the dinner given in his honour in the Council Room of the Royal Academy on 4 December he was placed on Benjamin West's right and on the left of Henry Fuseli.[31] Canova was asked by Benjamin Robert Haydon 'How do you like West?'. Canova replied «Comme ça»; to which Haydon replied «Au moins il compose bien». «Non, Monsieur», said Canova, «il met des modèles en groupes.»[32] At this dinner, sitting opposite him but one to the right, was the sculptor John Flaxman (1755–1826). C. R. Leslie, the genre painter (1794–1859), observed: 'the British aristocracy, with the exception of Lord Egremont, patronised Canova … rather than Flaxman, the greatest of all'. Leslie continued: 'Canova, who was a noble minded man, took every opportunity of pointing out the merits of Flaxman: "You English", he said, "see with your ears".'[33]

All who met Canova remarked on his most modest and charming personality and his generous nature. Farington, for instance, observed: 'Robert Smirke who knows Canova the celebrated Italian sculptor spoke of the perfect indifference he showed to the accumulation of money. He never desired more than what is sufficient to defray His present expenses, and leaves to others the management of what arises from the execution of His numerous commissions'.[34]

On 6 November Canova called on the sculptor John Bacon, Junior (1777–1859) at no.17 Newman Street; he penned in a little notebook: 'When the parlour door was opened by the servant, instead of one, *four* gentlemen presented themselves, uttering no other word than CANOVA'.[35] Bacon then discussed with Canova the monuments in St Paul's Cathedral,

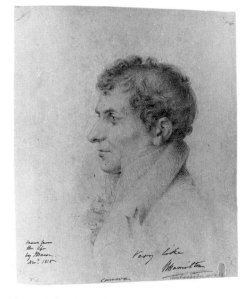

fig. 10 John Bacon Jr.,
Portrait of Antonio Canova, 1815, pencil on paper,
Private Collection

OPPOSITE fig. 11 Antonio Canova,
Monument to the House of Stewart, 1817–19,
marble, 560cm high, Rome, St Peter's

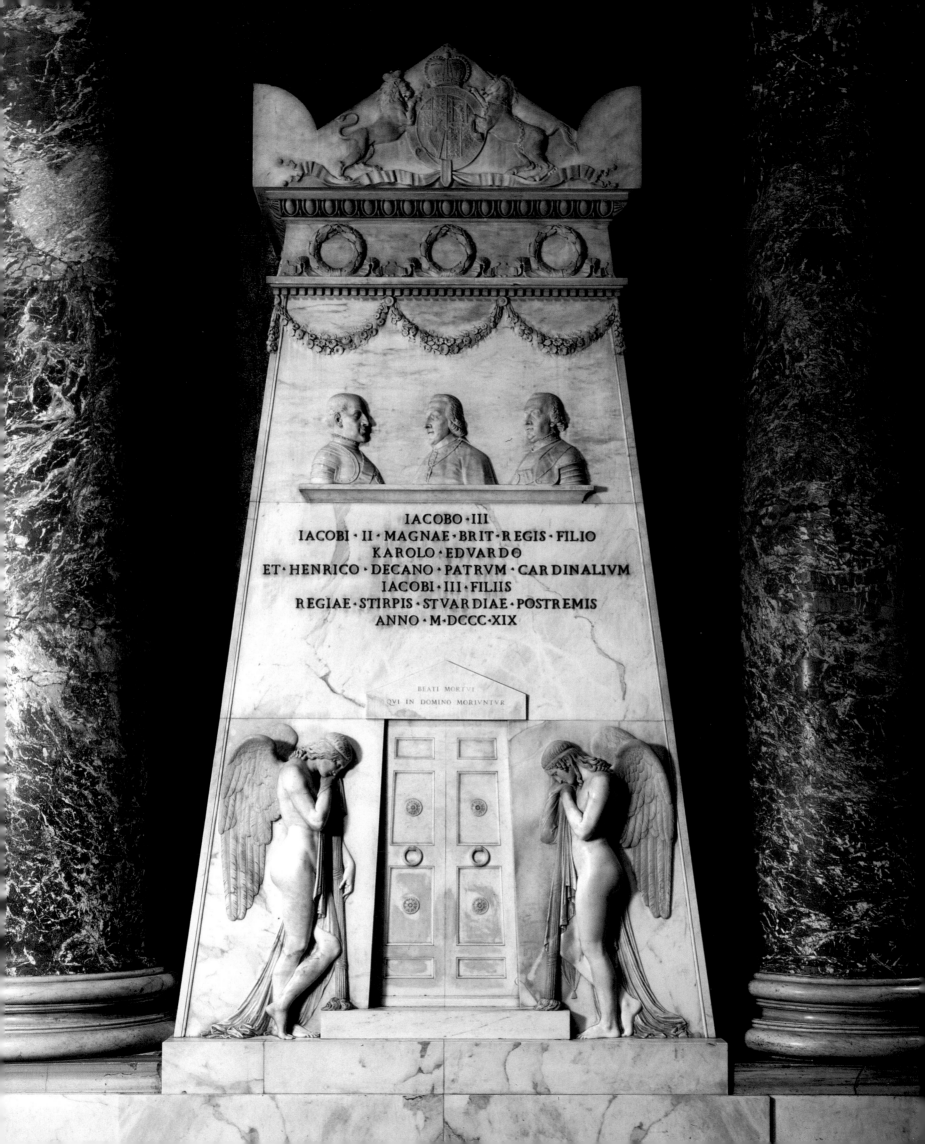

IACOBO · III
IACOBI · II · MAGNAE · BRIT · REGIS · FILIO
KAROLO · EDVARDO
ET · HENRICO · DECANO · PATRVM · CARDINALIVM
IACOBI · III · FILIIS
REGIAE · STIRPIS · STVARDIAE · POSTREMIS
ANNO · M · DCCC · XIX

BEATI MORTVI
QVI IN DOMINO MORIVNTVR

which he had visited the day before, and also the monument in Westminster Abbey (these he had 'seen for a short time, but being entirely by himself he came away without knowing what he had seen, intending to go again when attended by friends and interpreters'). Bacon asked Canova about the pyramidal form for monuments. Canova was reluctant to criticise the national arrangement for the placing of the monuments in St Paul's. He singled out for special praise Bacon's father's *Monument to Dr Johnson* as well as John Bacon junior's *Monument to Sir John Moore*. Bacon was thrilled by Canova's visit, noting 'but who is the man that shall come after the King. I felt that I had at that time the greatest of all kings with me, namely the King of Sculptors … the time was now drawing near at which I was to loose him and he was in haste; but Dido herself did not besot the Trojan hero with more excuse for detention than I did Canova; … I insisted upon his letting me sketch his profile' (fig. 10).[36]

Canova continued to be greatly admired by the British. The Prince Regent commissioned him in 1815 to carve a group of *Mars and Venus* as an allegory of Peace and War. The model was completed in 1816 and the marble exhibited in 1822 (now in the collection of Her Majesty The Queen at Buckingham Palace; fig. 69). In 1817 he had modelled a sepulchral *stele* to the last three members of the House of Stewart for St Peter's in Rome, which was completed in 1819 and in large part paid for by the Prince Regent (fig. 11). He was also commissioned in 1817 to carve a statue of the seated young *St John the Baptist* for the Marquess of Douglas (later the 10th Duke of Hamilton), but this commission was eventually transferred to the Duke de Blacas. In 1817 he completed four ideal heads as gifts of gratitude to those who had helped him in Paris: Lord Castlereagh, Charles Long, William Richard Hamilton and the Duke of Wellington (the latter now belonging to the Victoria & Albert Museum but sadly unavailable for this exhibition; fig. 12). The 6th Duke of Devonshire purchased the enthroned *Statue of Madame Mère* in 1818 (fig. 13), and the *Bust of Laura* (cat. no. 25) the following year, when he also commissioned the marble of the *Sleeping Endymion* (fig. 70), and he was later to acquire the *Hebe* and the *Bust of Madame Mère* (cat. no. 22).[37] All are still at Chatsworth. To his close friend Miss Mary Berry, Canova gave three terracotta models, two of which are exhibited here, the study for *Maria Louisa Habsburg as Concord* (fig. 14; cat. no. 23) and the study for the Romanzov *Peace* (fig. 15; cat. no. 24), both now at Castle Howard, Yorkshire.[38]

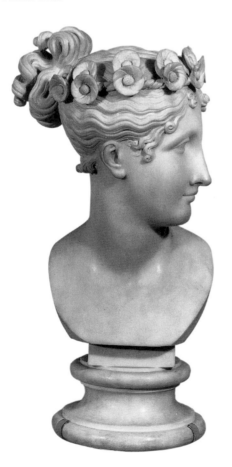

LEFT fig. 12 Antonio Canova, *Ideal Head*, 1816–18, marble, 53cm high, London, Apsley House, The Wellington Museum (The Trustees of the Victoria & Albert Museum)

RIGHT fig. 13 Antonio Canova, *Letizia Ramolino Bonaparte (Madame Mère)*, 1805–8, marble, 145cm high, Chatsworth House, The Duke of Devonshire and the Chatsworth House Trust

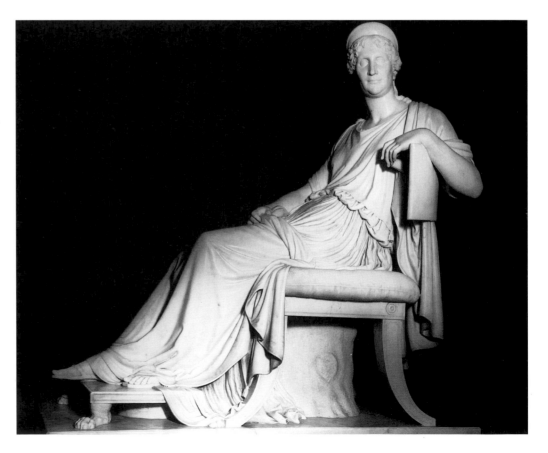

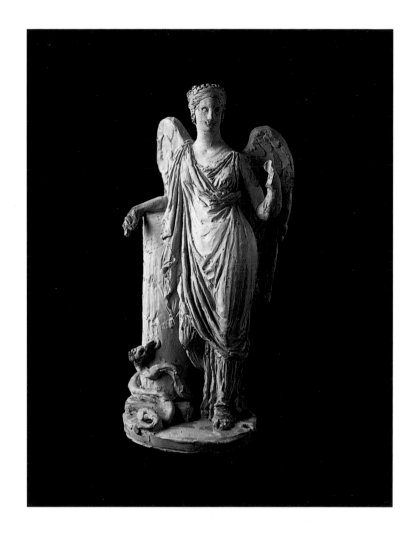

LEFT fig. 14 Antonio Canova, *Model for Maria Luisa Habsburg as Concord*, The Castle Howard Collection, Yorkshire (cat. no. 23)

RIGHT fig. 15 Antonio Canova, *Model for a Figure of Peace*, The Castle Howard Collection, Yorkshire (cat. no. 24)

At 7.43 on the morning of 13 October 1822 Canova died in Venice, much mourned by the world of art. William Etty referred to him as 'Rome's brightest ornament … a man no less celebrated for the virtues of his heart than the splendour of his talents'.[39] Miss Mary Berry wrote to Mrs. Damer from Rome on 24 October 1822:

> The first thing one must talk of in a letter from Rome is the death of Canova. The news of this event which took place in Venice, arrived here on Sunday last. You can hardly imagine the effect it has produced. The poor lament him as their liberal benefactor; the artists, universally, as their kindest patron and protector, the Roman public in general as the honour of their age and country; and all enlightened minds who knew him well, as one of the purest spirits that ever adorned human nature.[40]

Sir Thomas Lawrence, who had been one of Canova's greatest admirers and whose handsome and much copied portrait of him is preserved in the Casa Canova at Possagno (frontispiece), made a generous private donation to Canova's tomb.[41]

In an album compiled by Lady Cawdor (now in the Victoria & Albert Museum), Lady G. S. Stanley contributed an ode *On the Death of Canova*:

> Genius of Italy, what means this gloom? …
> And youthful Hebe's graceful modest form,
> And Love and Beauty's captivating Queen,
> Here bloom like Nature's tints and colours warm,
> For fancy paints the blush alone unseen …
> Not these alone proclaim Canova's fame,
> Fain would the Muse record his private worth,
> Dwell on these Virtues which adorn his name,
> And haloed th' exulting Land which gave him birth.[42]

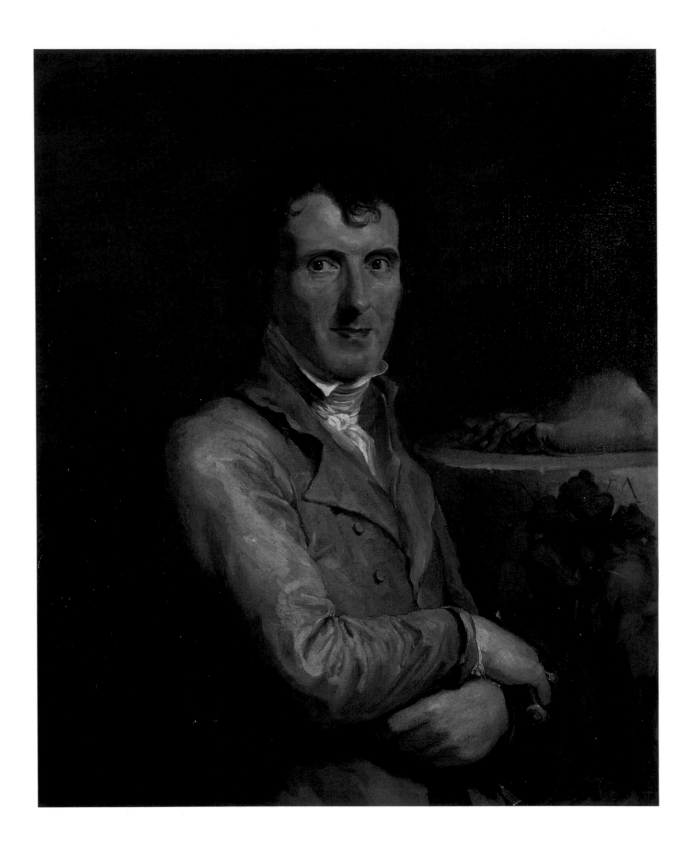

fig. 16 George Hayter, *Portrait of Antonio Canova*,
The Government Art Collection (British Embassy, Paris)
(cat. no. 16)

Hugh Honour

CANOVA'S THREE GRACES

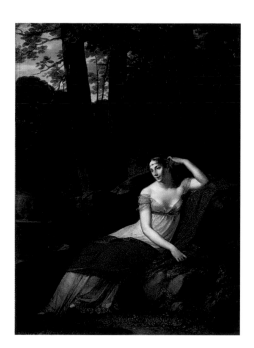

fig. 17 Pierre-Paul Prud'hon, *The Empress Josephine de Beauharnais*, 1805, oil on canvas, 244 × 179cm, Paris, Musée du Louvre

fig. 18 Joseph Nollekens, *Bust of John Russell, 6th Duke of Bedford*, Her Majesty The Queen, Windsor Castle (cat. no. 13)

Sculptors, even famous and very successful sculptors, were as reluctant in the nineteenth century as they had always been, and still are, to set about carving large-scale works in marble or other time-consuming and costly materials unless assured that at least their expenses would be covered. So Canova might never have carved his two groups of *The Three Graces* had he not had commissions for them, first from the Empress Josephine de Beauharnais (fig. 17), divorced wife of Napoleon, and secondly from John Russell, 6th Duke of Bedford (fig. 18; cat. no. 13). To both of them, however, Canova was to owe rather more than just the opportunity to carve large-scale works in marble. It was Josephine who proposed the subject to him in the first place and his exceptional and passionate involvement in the work must have owed something to the interest and flattering attentions paid him by the Duke, as well as by the greatly admiring Josephine and later by her son Eugène de Beauharnais.

Josephine first saw sculptures by Canova when she was in Venice in September 1797, his early *Daedalus and Icarus* being then in Palazzo Pisani Moretto where she stayed and his *Psyche* in Casa Mangilli which she visited.[1] Recently married to 'General Bonaparte', she was hardly in a position as yet to launch out as a collector and patron of the arts. But five years later, when Napoleon had become First Consul, she saw Canova's two groups of *Cupid and Psyche* (one reclining, the other standing) which his brother-in-law Joachim Murat had just recently acquired and she determined to have similar sculptures for herself. The classical scholar Ennio Quirino Visconti, an acquaintance of Canova since the 1780s who had been director of the museum of antique statues in the Vatican and was now employed at the Louvre in Paris, was charged with the negotiations.[2] By 28 September 1802 he had obtained Canova's agreement to carve for Josephine a second group of *Cupid and Psyche* (standing) for 1,000 *louis d'or* and a statue of *Hebe*, a second version of that carved for the Venetian Giuseppe Vivante Albrizzi.[3] Canova was at that moment on his way to Paris, summoned to model a portrait of Napoleon, and in early October he was presented to Josephine. Not until six years later, however, did the two works reach Paris: both were exhibited in the 1808 Salon and then installed in the Château de Malmaison. This marked the beginning of Josephine's passion for his work and of the valuable commissions she was to give him over the next few years. Meantime, Canova had made full-scale models of statues of a *Dancer with her Hands on her Hips* and of *Paris*, though whether he had a patron in mind for them is unknown.[4] But by the end of 1808 he had agreed to realise both of them in marble for Josephine.[5] When he was in Paris again, in 1810, commanded by Napoleon to model a portrait of his second wife, the Empress Maria Louisa, Canova found time to go out to Malmaison and call on the divorced Josephine. She was greatly touched by his visit and, it was said by contemporaries, had been moved to tears when she saw him.[6] Eventually, in the summer of 1812, her statues of the *Dancer* and *Paris* were sent off from Rome. But before they had even reached Paris, Josephine was asking Canova for yet another and even more ambitious work.

On 11 June 1812, Josephine's secretary for commissions, J. M. Deschamps, wrote to Canova: 'Her Majesty has instructed me to submit to you an idea for a subject that could perhaps be represented in a work still more precious, one that she believes has not been treated by the ancients except in low reliefs nor by any modern sculptor apart from Germain Pilon. This subject is the Three Graces. Her Majesty thinks that this group would embody simultaneously three different expressions and, especially if executed by you, would be

attractive and also have great success. If you share this opinion and if you agree to execute it Her Majesty requests this work for herself, and in this case you should let her know before beginning it'.[7] Canova replied promptly, tactfully making no reference to Josephine's ignorance of the several antique groups of the Graces then known, saying only that he found her idea 'interesting and novel but at the same time extremely difficult and thorny' (*extrèmement delicat et épineuse*). He would need to think about it before agreeing and if he could devise a composition would submit it to Her Majesty's 'exquisite and enlightened judgement'.[8] In fact, as we shall see, he set to work on sketches almost immediately. He appears to have informed her of this and on 20 February 1813 she wrote to him that nothing would be wanting in her sculpture gallery at Malmaison if she could have *The Three Graces* – to be placed between the *Paris* and the *Dancer*.[9]

The difficulty of the subject arose not from the scarcity so much as the superabundance of images of the Graces in Renaissance and post-Renaissance art, and the weight of allegorical symbolism that had been imposed on them. The name was itself ambiguous, signifying an aesthetic quality – gracefulness – as well as three mythological beings. It derived, in the latter sense, from the Latin *Gratiae* or the three beautiful sisters called *Charites* in ancient Greek (a word that passed into English as charity and also charisma, nowadays said to pertain to politicians and others who are usually anything but graceful). In the *Iliad* only one Charis is mentioned, married to Hephaestus, the deformed artificer employed by the gods on Olympus – a union of beauty with manual work. But Hesiod wrote of three *Charites*, daughters of Zeus and Euryonome: their names Euphrosyne, Aglaia and Thalia were to be retained in later literature. They were also to be inscribed on the prints which Canova commissioned to illustrate his two groups of *The Three Graces* (figs. 48–50). Hesiod was quoted by Pausanias who, in the *Itinerary of Greece* (a work known and used by Canova), listed a number of paintings and sculptures of the Graces, including a group supposedly carved by Socrates at the entrance to the Athenian acropolis. Pausanias described also three statues in a sanctuary at Elis, in a passage that was to provide the programme for numerous Renaissance and later paintings: 'The first one has a rose, the middle one has a knuckle bone and the third has a smallish branch of myrtle: one may reasonably conjecture this is because the rose and myrtle are sacred to Aphrodite and linked with the legend of Adonis, and the Graces belong more with Aphrodite than with any other goddess, and the knuckle-bone is the play-thing of young lads and virgin girls whose games are uncontaminated by age.'[10] According to Aristotle, shrines for the Graces were set up in public places 'to remind men to return a kindness, for that is a special characteristic of grace, since it is a duty not only to repay a service done to one but also to take the initiative in doing a service oneself.'[11] This interpretation was expanded by Chrysippos, a minor Greek writer of the third century B.C., and influentially quoted by Seneca. For Seneca the Graces symbolised generosity or benevolence: 'they are young because memory of favours should never grow old, smiling because benefits bring pleasure to the benefactor as well as to the recipient, nude or transparently clad because the beauty of benefits cannot be hidden but shines forth for all to see.'[12] This concept was to be gradually and variously elaborated until by the fifth century A.D. the Graces had attained in Pagan art and culture their accepted form and meaning. The late fourth-century A.D. writer Servius recorded how and why they were depicted: 'one of them pictured from the back while the other two face us, because for one benefit issuing from us two are supposed to return.'[13] It was in this moralised form that they passed into the Christian culture of the middle ages, when the doctrine of Grace as a divine gift began to absorb something from the Pagan concept of the three daughters of Zeus.

In fifteenth-century Florence, however, the Graces were Neoplatonised as attributes of Venus by such humanist writers as Marsilio Ficino who named them *Pulchritudo, Amor, Voluptas* – beauty, love, pleasure (in a mystical sense). These words are inscribed beneath figures of the Three Graces on the reverse of a medal portraying Pico della Mirandola and cast in about 1484–5.[14] They were changed to *Castitas, Pulchritudo, Amor* – chastity, beauty, love – on another medal cast from the same model but portraying on the front Giovanna

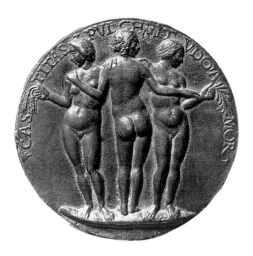

fig. 19 Attributed to Niccolò Fiorentino, *The Three Graces* (reverse of a Portrait Medal of Giovanna Albizzi Tornabuoni), *c.*1485, bronze, 7.6cm diameter, London, The British Museum

Tornabuoni, the Florentine noblewoman most closely associated with the Neoplatonists (fig. 19).[15] What these attributes all have in common is their being aspects of beauty – understood as an influence which operates in human beings to regenerate and sanctify, and therefore itself a divine gift and thus akin to Grace in a theological sense.

Traces of Neoplatonism survived in theories of ideal beauty from the sixteenth to the early nineteenth century. But the significance of the Graces as an allegory of generosity transmuted into friendship – of giving, receiving and returning – was preserved in iconographical manuals used by artists, notably in Cesare Ripa's *Iconologia* published in numerous editions from 1602 to 1766. The Graces are described by Ripa under the heading *Amicitia*, friendship, in a passage that elaborates the remarks of Aristotle, Pausanias, Seneca and Servius, and plays on the several meanings of the word *grazia*: grace, a favour, gratitude. The three figures embrace one another, according to Ripa, because one kindness gives birth to another and friends must always be mutually grateful; they are nude and virginal because a favour should always be sincere and disinterested; one is shown from the back and the other two frontally because a benefit given should always be duplicated; they are young and joyful as all should be in giving and receiving.[16]

Artists did not, however, always follow Ripa's and others' manuals of iconography. Painters especially adopted other interpretations of the Graces. In allegories of the arts, for example, the Graces frequently appear personifying painting, sculpture and architecture, or painting, poetry and music, or the three essentials of the art of painting – drawing, colour and chiaroscuro. It was in these and similar contexts that the Graces came to symbolise also the elusive notion of grace in the sense of Alexander Pope's: 'Nameless graces which no methods teach / And which a master hand alone can reach'.[17]

An engraving of an elaborate allegory of the arts by Carlo Maratta of about 1680, dedicated to 'young students of drawing', includes the Three Graces seated on clouds beneath the words '*senza di noi ogni fatica è vana*' (without us all labour is vain).[18] Charles-Nicholas Cochin, permanent secretary of the French Royal Academy declared: '*Sans les Graces, la Beauté n'offre point ces attraits touchans, ce charme invincible qui lui assurent les voeux & les hommages mortels*' (Without the Graces, Beauty has none of that touching appeal, that invincible charm which inspires mortal wishes and respect).[19] The grace of a figure, in art or life, was most often and easily defined by its antonyms, as in a poem dedicated to the Graces by Cardinal de Bernis (an acquaintance of Canova):

Un geste, un sourire, un regard,	[A gesture, a smile, a glance,
Ce qui plait sans peine et sans art,	What pleases without trouble or art,
Sans excès, sans airs, sans grimaces,	Without excess, airs or grimaces,
Sans gêne, et comme par hazard,	Without care and as if by chance,
Est l'ouvrage charmante des Graces.[20]	Is the charming work of the Graces.]

In contemporary aesthetic theory, on the other hand, grace was that aspect of beauty which gives pleasure to the senses or, according to Winckelmann, that which delights the mind and is 'agreeable according to reason'. Schiller drew a distinction between charm and grace (*Reiz und Anmuth*), the latter appreciated only by people of cultivated taste.[21]

Images of the Graces were expected to exemplify this indefinable quality while respecting, or at least attending to, iconographical conventions derived from Antiquity. And this naturally presented a problem. In Canova's time no more than a few antique images of the Graces were known. The most famous was a badly damaged group with figures less than life size, which had been in the Biblioteca Piccolomini of Siena cathedral since the fifteenth century and provided a model for several Renaissance works of art, including the two medals mentioned above. In the eighteenth century it was regarded as one of the most notable 'sights' of Siena. A French traveller who echoed received ideas, noted that it was '*très joli … ingénieusement pensée, & de l'exécution la plus satisfaisante, c'est dommage qu'il soit aussi cruellement mutilé*' (very pretty … ingeniously conceived and executed in the most satisfying way; it is a pity that it should be so cruelly mutilated).[22] Canova, on his first journey to Rome

in 1779, went to see it but mentioned it without comment in his travel diary and is not known to have seen it again.[23] He was probably more familiar with two similar groups in Rome. One, in the Casino Borghese until 1808, when it was included among the ancient marbles bought by Napoleon for the Louvre (where it has remained), was thought to be of good workmanship though the heads were modern – *'neu und hässlich'* to Winckelmann.[24] The other was in Palazzo Ruspoli, and after Rome had lost to the French most of the more famous antique statues it was much admired. All foreign visitors went to see it, according to an acquaintance of Canova, Frederike Brun, though she herself was not greatly impressed, finding the figures cold and flat (fig. 20).[25] By 1815 it had passed into the hands of the engraver Pietro Vitali, an old friend of Canova who presumably approved its subsequent acquisition for the Braccio Nuovo of the Vatican Museum.[26] Canova must also have known the famous Pompeiian painting of the Graces, if only from the engraving of it by Tommaso Piroli (fig. 21).[27]

All these images, and also a few reliefs from Roman sarcophagi – one in the Museo Pio-Clementino of the Vatican, another at Sans Souci, Potsdam, both of which Canova may well have seen[28] – showed the figures as described by Servius, that is, nude, the central one with her back turned and the other two facing the spectator. They were of great antiquarian interest, but none was included among the so-called 'most famous statues' that were very frequently reproduced in casts, marble copies and bronze or porcelain statuettes.[29] Were they, perhaps, felt to be deficient in the very quality of grace they were supposed to embody?

More highly regarded, if the number of copies in circulation is a reliable indication of taste, was a piece of antique decorative sculpture in the Casino Borghese (removed in 1808 to the Louvre, where it remains), a sacrificial bowl in the form of a dish held aloft by three nude female figures sometimes identified as the Graces (fig. 22).[30] One copy, adapted as a candelabrum, was acquired by Canova's first British patron John Campbell (later Baron Cawdor) while in Italy in the 1780s, and is now at Cawdor Castle. But when it was installed in his house, Stackpole Court in Pembrokeshire, it gave one visitor, a certain Mrs Morgan, 'some very unpleasant sensations.' The figures, she remarked, are 'all in exactly the same position, with their backs towards you. Their arms are lifted up on the full stretch. Their legs seem to be up in the stretch likewise, as if putting forth all their strength, to bear up the weight of the sconce which they have in their hands. This position is surely better suited to display the tendons of a porter, when carrying a heavy burden, than the soft flexible muscles of beautiful

LEFT fig. 20 Roman, 2nd Century A.D., *The Three Graces*, marble, 133cm high, Vatican City, Musei Vaticani

CENTRE fig. 21 Tommaso Piroli, *The Three Graces*, engraving after a Pompeiian Wall-Painting of the Early 1st Century A.D., from *Le Antichita di Ercolano: Pitture*, Rome, 1789

RIGHT fig. 22 Roman, *c.*2nd Century A.D., *Three Nymphs Supporting a Sacrificial Bowl ('The Borghese Graces')*, marble, 77cm high, Paris, Musée du Louvre

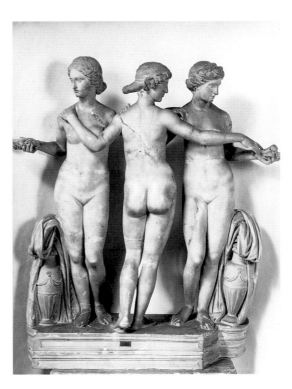

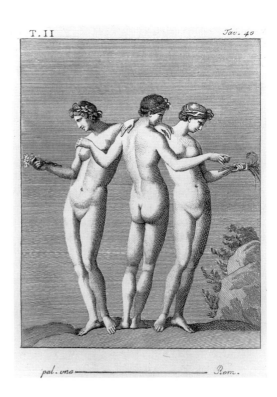

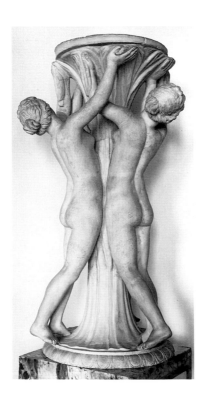

nymphs.'[31] To judge by the number of copies and adaptations, however, this display of soft flexible muscles and buttocks had considerable appeal, though perhaps largely to the male gaze.[32]

The Graces were represented in a completely different way, fully clad, with hands linked and looking outwards from the three sides of an antique altar with a dedication to them in Greek, now known only from an engraving.[33] There is perhaps more than a coincidental similarity between this work and a drawing for an incense burner by Raphael, engraved by Marcantonio Raimondi, which provided a model for Germain Pilon's famous statues of the Graces on the *Monument for the Heart of Henri II* (fig. 23).[34] Pilon's exquisite carving, formerly in the church of the Célestins in Paris, had been rescued by Alexandre Lenoir and put on show in the Musée des Monuments Français. It was there when the Empress Josephine mentioned it in her letter to Canova quoted above.[35] Although it was not, as she supposed, the only group of the Graces by a 'modern' sculptor, it was one of quite remarkably few, in comparison with other mythological figures.[36] Of these a small-scale group, intended as a table ornament, by Johann Heinrich Dannecker is outstanding not only because of its relation to Pilon's work. Modelled in 1795 in Stuttgart, Canova may or may not have known of it, though he knew Dannecker well when he was in Rome in the 1780s.[37]

From the Renaissance onwards, the Graces were far more frequently represented in paintings than in sculptures. Raphael early in his career depicted them as in the Siena group and the fifteenth-century medal derived from it.[38] Correggio took liberties with the prototype, varying the poses of the lateral figures and giving the composition a whirling motion, in a lunette in the Camera di San Paolo, Parma.[39] Indeed, painters seem to have retained the symmetry of the antique only when treating the subject as an allegory of Friendship, of giving, receiving and returning. Almost invariably, however, one of the figures was shown from the back, for instance in a spandrel of the *Loggia di Psiche* in the Villa Farnesina, Rome, painted after a design by Raphael.[40] Canova must have known this famous work, which had been frequently reproduced in engravings, as he probably did also Tintoretto's *Three Graces and Mercury* in the Doge's Palace in Venice – holding the emblems mentioned by Pausanias in the description of the sanctuary at Elis,[41] one figure depicted from the back, one frontal and the third in profile. Rubens painted the subject several times, including one in monochrome which was on show at the Uffizi when Canova was in Florence, and in it, no doubt, he found ample confirmation of the great admiration for Rubens he expressed in his travel notes (fig. 24).[42]

One important variation in the treatment of the subject was introduced in the sixteenth century, that of incorporating the Graces in the toilet of Venus. Although Pliny mentioned a painting of Venus with the Graces and Cupid by a certain Nearchus,[43] and the adornment of a statue of Venus or of Venus herself by the Graces was described in classical literature – in the Homeric *Hymn to Aphrodite* and Ovid's *Fasti* – no ancient image of the subject was known. Renaissance and later artists thus felt free to depict the scene according to their fancy and according to contemporary ideals of cosmetics. Vasari, who set a premium on *grazia* (gracefulness) in works of art, seems to have been the first when he painted a small picture of the subject in 1532.[44] In a larger work of 1558, often reproduced in prints, he showed one of the Graces binding Venus's hair with pearls, another pouring scented water into a basin for her bath and the third holding a mirror in which she could admire herself.[45] In this context the Graces mediate between the beauty of nature and of art, as they do in paintings by Annibale Carracci and Guido Reni, among others. But in the eighteenth century the *Toilet of Venus* became popular mainly as a pretext for scenes of elegant lubricity in which four scantily clad young women disport themselves and display their fashionable coiffures, especially when depicted by François Boucher, despite the frequently expressed contention in contemporary art criticism that natural beauty had no need of artificial embellishment.[46]

That the Graces symbolised friendship was not, however, forgotten. They certainly have this significance in Joshua Reynolds's *Lady Bunbury Sacrificing to the Graces* of 1765[47] as also in a painting of 1810 by François-Guillaume Ménageot, *L'Amitié offrant des guirlandes de*

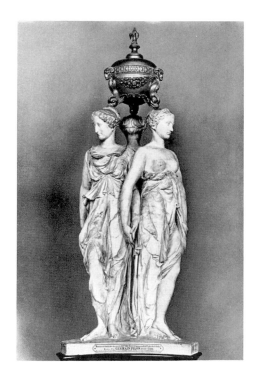

fig. 23 Germain Pilon, *Monument for the Heart of Henri II of France*, 1559–63, marble, 150cm high, Paris, Musée du Louvre

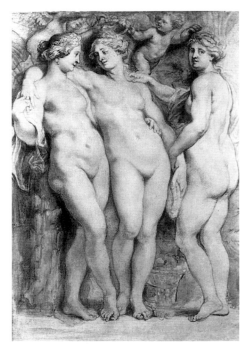

fig. 24 Peter Paul Rubens, *The Three Graces, c.*1620–3, oil on canvas, 47.5 × 35cm, Florence, Palazzo Pitti

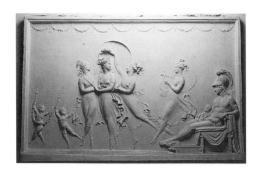

fig. 25 Antonio Canova, *Venus and the Graces Dancing in the Presence of Mars*, c.1795–7, plaster, 144 × 160cm, Possagno, Gipsoteca Canoviana

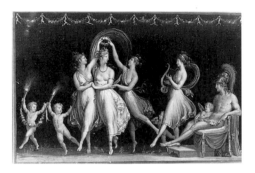

fig. 26 Antonio Canova, *Venus and the Graces Dancing in the Presence of Mars*, c.1794–9, tempera on paper, 25 × 39cm, Possagno, Casa Canova

fleurs aux trois Graces.[48] In both these pictures the Graces are shown as works of sculpture, though different in composition from the antique marble prototypes. The Austrian artist Josef Abel similarly ignored the antique precedents when, in Rome in 1807, he depicted Socrates carving the group of the Graces for the Parthenon as mentioned by Pausanias – in the widely accepted though erroneous belief that the sculptor was to be identified with the philosopher.[49]

Canova took up the theme of the Graces before the end of the eighteenth century, showing them dancing with Venus in the presence of Mars in a low relief and also in a small painting (figs. 25 and 26). The relief was one of the last of a series that he modelled in clay between 1793 and 1798 entirely on his own initiative. Subsequently plaster casts were made for a limited number of patrons and personal friends.[50] In these remarkable reliefs his often suppressed pictorial imagination could find release and he indulged his fancy freely, allowing it to play over subjects and themes which could not be treated in free-standing works of sculpture – scenes from the narrative of the last days of Socrates and incidents described by Homer and other classical poets. One of the first, inspired by a passage in the *Odyssey*, shows the sons of Alcinous dancing an air-borne *pas-de-deux*. For *Venus and the Graces Dancing in the Presence of Mars*, however, he seems to have had no precise literary source. And his rendering of the Graces is equally independent of all precedents. He broke away entirely from both the rigid postures of those in antique prototypes and the sensuality and overt eroticism of late eighteenth-century depictions of the *Toilet of Venus*. There were, in fact, no precedents in ancient or modern art for the Graces and Venus dancing together, with one very curious exception – Botticelli's *Primavera* – which Canova cannot have seen.[51] The originality of his conception becomes very evident by association with this now famous work that was totally ignored in Canova's day and indeed was to remain unknown and unseen until well into the nineteenth century.

So Canova's *Venus and the Graces Dancing in the Presence of Mars* was his own free invention: four dancing women on 'points' – Aglaia playing a lyre while her two sisters hold a floral crown over the head of Venus – with three light-footed *putti,* one of whom is carrying away the sword of the nude Mars, who sits impassively watching with Cupid beside him. Canova may have conceived it as early as 1795,[52] although the model was probably not finished until two years later when, as he told a correspondent, he was working desperately to keep his mind off contemporary events – the French invasion of Italy and their requisitioning of the most famous paintings and antique statues in Rome.[53] In these circumstances the subject may have had a special appeal for him, recalling happier times when it was possible to believe that music and dance had charms to soothe the savage breast of the god of war. A series of small paintings in tempera, apparently intended for the decoration of his own house, included several of dancing women: one, mentioned above, of exactly the same composition as the relief (fig. 26), as well as others of *The Graces Dancing to the Music of Cupid* and *The Graces Dancing before a Statue of Venus*, the former being anticipated or repeated in a larger monochrome painting on canvas (fig. 27, cat. no. 2).[54] These little pictures with black backgrounds recall and were no doubt inspired by Pompeiian wall paintings, though they are not directly imitative. They also reflect Canova's love of the theatre, even if he can never have seen such ballerinas on any Italian stage where they were required to be heavily clad and, in Rome, to wear black stockings![55] His dancing Graces were creatures of his imagination, quite simply exemplars of graceful movement.

In February 1798 Republican revolutionaries, aided by the French, seized power in Rome and obliged the Pope to leave. Three months later Canova retreated to his native village of Possagno in the Veneto, which had recently become a province of the Austrian empire. From July until November he accompanied his Venetian patron Prince Abbondio Rezzonico on a journey through Austria and Germany. On his way home to Possagno he wrote to ask his housekeeper to obtain materials for painting so that he could begin work immediately, stimulated no doubt by the pictures he had seen in the galleries of Vienna, Dresden, Berlin and Munich, especially those by Rubens which he had greatly admired for their naturalistic

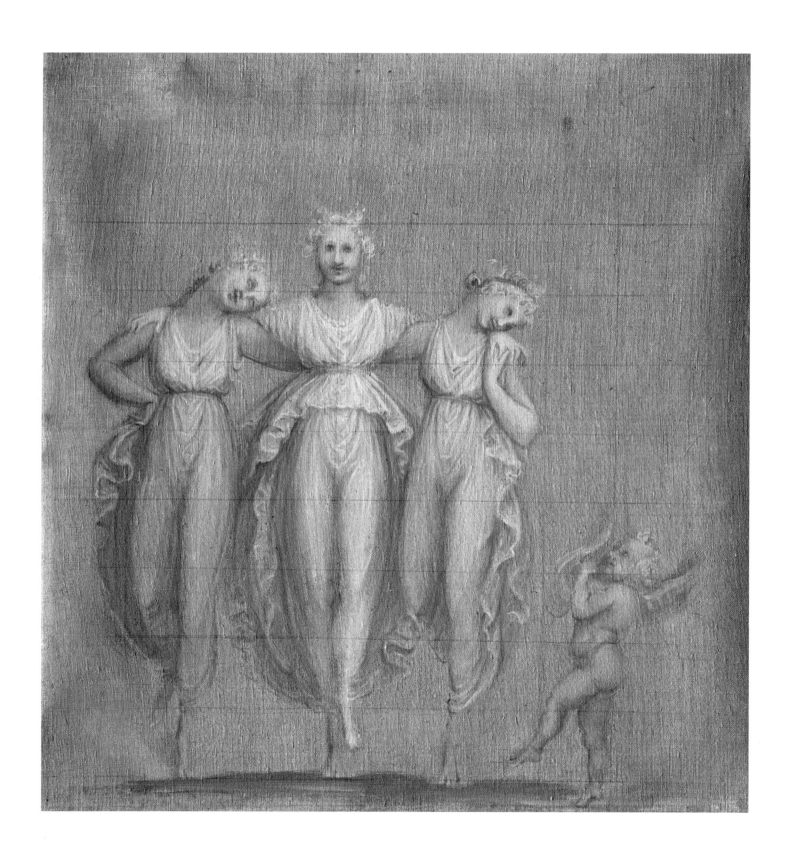

fig. 27 Antonio Canova,
The Graces Dancing to the Music of Cupid,
Bassano del Grappa, Museo-Biblioteca-Archivio
(cat. no. 2)

ABOVE fig. 28 Antonio Canova, *The Three Graces*, 1799, oil on canvas, 103 × 80cm, Possagno, Casa Canova

LEFT fig. 29 Antonio Canova, *Study for the Painting of The Three Graces*, Bassano del Grappa, Museo-Biblioteca-Archivio (cat. no. 3)

RIGHT fig. 30 Antonio Canova, *Two Sketches for The Three Graces*, Bassano del Grappa, Museo-Biblioteca-Archivio (cat. no. 4)

and sensuous rendering of flesh.[56] He had spasmodically painted in oils on canvas since 1787 but now he took up the medium in earnest while waiting to get back to his studio in Rome and work on the statues he had left unfinished, as well as on the large monument to the Archduchess Maria Christina of Austria for which he had just received the commission. Thus it was that in the course of the next twelve months he painted a huge altarpiece for the parish church of Possagno and five fairly large pictures, all of which he signed *A. Canova sc.*, as if to emphasise that he was a sculptor essaying another medium.[57] One of these paintings is of *The Three Graces*, half-length, life-size, figures locked in a close embrace, differing markedly from the Graces in his low relief and in his earlier monochrome and tempera paintings (fig. 28). He worked out the composition in a drawing which shows the figure on the right looking away from the other two, as in the antique examples (fig. 29; cat. no. 3). In the painting, however, he turned her head inwards, making a more compact group that might be carved from a single block of marble. One may wonder whether he did not already at this stage have at the back of his mind the possibility of such as work. One or two of the drawings usually associated with the marble group may, indeed, date from this time if not earlier (see cat. no. 4).

At this period Canova seems to have been more interested in grace or gracefulness than in the Graces as mythological figures. The antique statues that he, like most of his contemporaries, admired were those in what Winckelmann had called the 'beautiful style'. This 'beautiful' style – as distinct from the earlier and inimitable 'sublime' style – was the style of Phidias, Praxiteles and Lysippos and was 'characterised by grace' in the demeanour, gestures and movement of figures, in the flow of draperies and indeed in the whole design of the work.[58] In the eyes of his admirers Canova was to succeed in catching this elusive quality in a succession of statues including those of *Hebe* and the *Dancer*, carved for the Empress Josephine, which have affinities with the dancing Graces in his relief and tempera paintings. The Danish writer Frederike Brun called him in 1802 the '*Lieblings der Grazien*' – the darling of the Graces.[59] Even C. F. Fernow, the most hostile of his critics, was bound to concede that

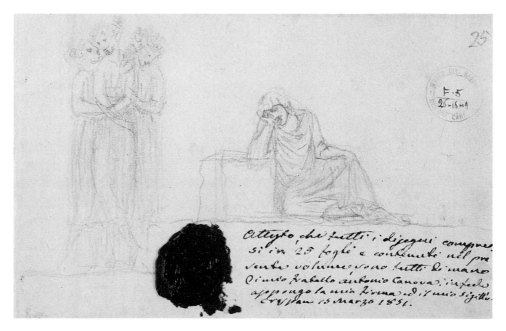

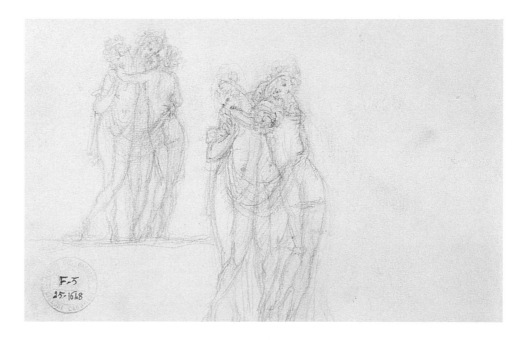

TOP fig. 31 Antonio Canova,
Two Sketches for The Three Graces,
Bassano del Grappa, Museo-Biblioteca-Archivio
(cat. no. 5)

CENTRE fig. 32 Antonio Canova,
*Sketch for The Three Graces and a Seated Female
Figure in Mourning*, Bassano del Grappa,
Museo-Biblioteca-Archivio
(cat. no. 6)

BOTTOM fig. 33 Antonio Canova,
Two Sketches for The Three Graces,
Bassano del Grappa, Museo-Biblioteca-Archivio
(cat. no. 7)

the *Hebe* was graceful (*anmuthige*).[60] Comparing the *Medici Venus* with Canova's *Venus Italica* (Italian Venus) which had taken its place in the Uffizi, the poet Ugo Foscolo wrote on 31 August 1812 that whereas the former was a remote goddess the latter was 'beautified with all those graces which exhale an indefinable earthly quality but more easily move my heart which is also made of clay'.[61] Foscolo, who has a literary status in Italy analogous with that of Keats in the English speaking world, was at the time writing the first version of his long but always fragmentary poem *Le Grazie* in which he called on Canova to join him in the worship of the Graces.[62] It is uncertain whether he knew at this date that Canova had just recently been asked to carve a group of *The Three Graces* but it may well have seemed to Foscolo very likely if not inevitable that he would eventually create such a work. When news of the Empress Josephine's request leaked out, while she was visiting her son Eugène de Beauharnais, Viceroy of Italy, in Milan in August 1812, the painter Giuseppe Bossi remarked in a letter to Canova that no subject could be more suitable for him.[63]

The idea that the Graces symbolised friendship as well as personifying gracefulness may, nevertheless, have had some personal significance for both Josephine and Canova at this juncture, the meaning of friendship and the loyalty of true friends never being more keenly appreciated than by Josephine just after she had been divorced by Napoleon. And to Canova, too, friendship was especially welcome just then: he had just extricated himself from an unusually intense flirtation with a young Basque woman, Minette de Bergue, who wanted to marry him.[64] As his friend and biographer Leopoldo Cicognara recorded, he was very much aware of the significance of the Graces as a symbol of friendship, beneficence and gratitude.[65] The challenge he now confronted was thus three-fold – to conceive a group that would be immediately recognisable as an image of the three figures from classical mythology, that would suggest by their poses, gestures and facial expressions their bonds of intimate sisterly affection, and one that would at the same time exemplify his own sense of and feeling for gracefulness in a work of free-standing sculpture.

Canova had not, however, put out of his mind his earlier images of the Graces. He commissioned prints of his relief of *Venus and the Graces Dancing in the presence of Mars* in 1802 and of his tempera paintings in 1810 and published the latter as *Scherzi de Ninfe / Grazie che danzano, pensieri di Antonio Canova*. And by a curious coincidence, on 1 June 1812, less than a fortnight before Josephine's secretary wrote to him, he paid an engraver to begin work on a copper-plate of his oil painting of *The Three Graces*.[66] Canova had also made drawings of the Graces nude and tightly embracing one another, quite unlike those in his relief and tempera paintings. In all of these he rejected the rigid symmetry of the antique images, their frieze-like disposition and static poses. He maintained the convention of showing one of the figures from the back in a drawing on a sheet with two others similar in theme to his tempera paintings of the 1790s (figs. 30, 71 and 72; cat. no. 4). In a sketchbook which includes a sheet dated 1806, however, he showed the three posed frontally (fig. 31; cat. no. 5). Three more drawings of the Graces in another sketchbook, probably used in the summer of 1812, may record Canova's first response to Josephine's request. One is essentially a full-length realisation of the design of the 1799 painting, with the figures frontally posed and partly clad (fig. 32; cat. no. 6). The other two, on a single sheet, revert to the idea of showing one figure from the back, but indicate a light swathe of drapery around the waists of all three (fig. 33; cat. no. 7). This solution to the problem of the composition evidently satisfied him well enough to try it out in three dimensions and he made a *bozzetto* modelled with excited spontaneity in the manipulation of the clay with fingers, scalpel and point, posing the figures as if caught momentarily in the rhythm of a dance (figs. 34 and 35; cat. no. 10). For some reason, he must have thought this composition unsuitable for realisation in marble and in two other, presumably later, drawings he showed the central figure frontally and the other two in profile but all three with their faces turned towards the spectator (figs. 36 and 37; cat. nos. 8 and 9).

However, in a *bozzetto* more highly finished than the previous one, they reappear wholly absorbed in their sisterly relationship and without so much as a glance outwards (figs.38 and 39; cat. no. 11). An inscription in Canova's hand states that this was modelled at Frascati in

OPPOSITE fig. 34 Antonio Canova, *Model for The Three Graces*, Turin, Giancarlo Gallino (cat. no. 10)

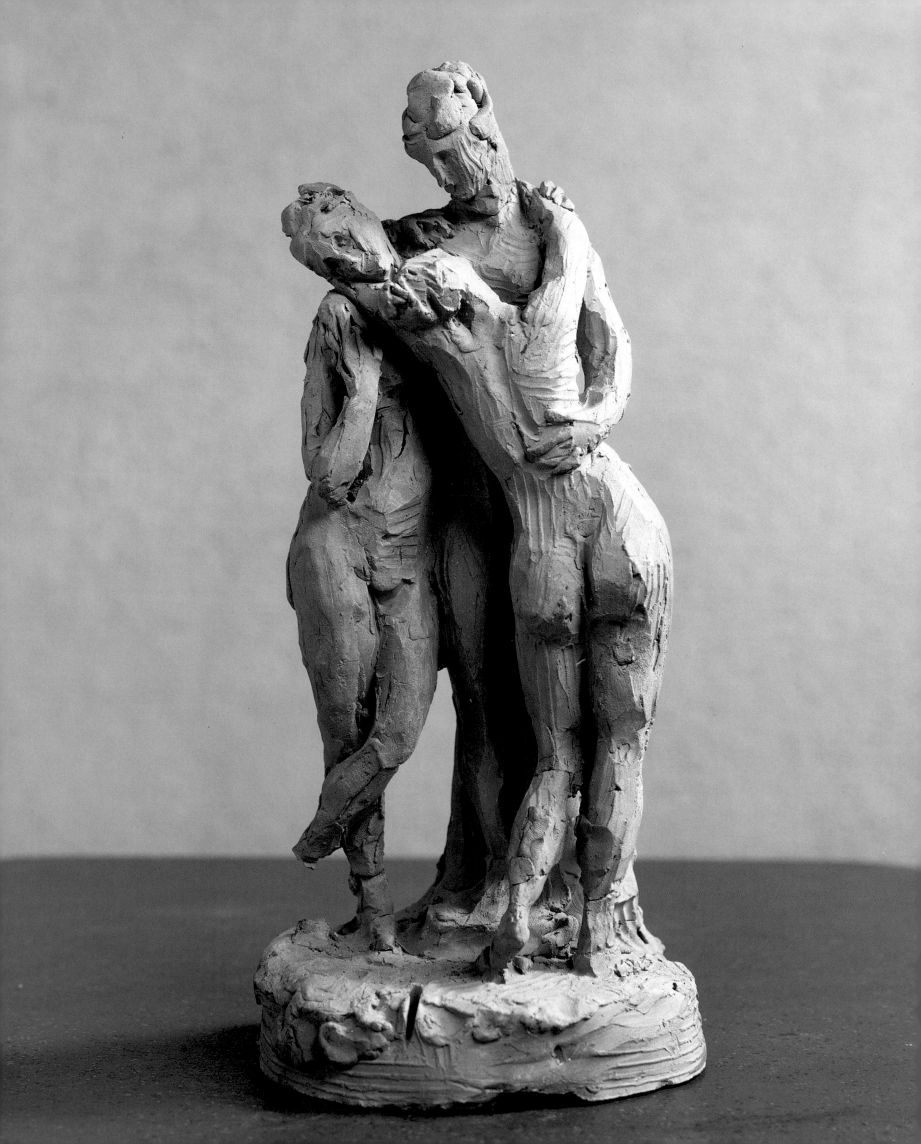

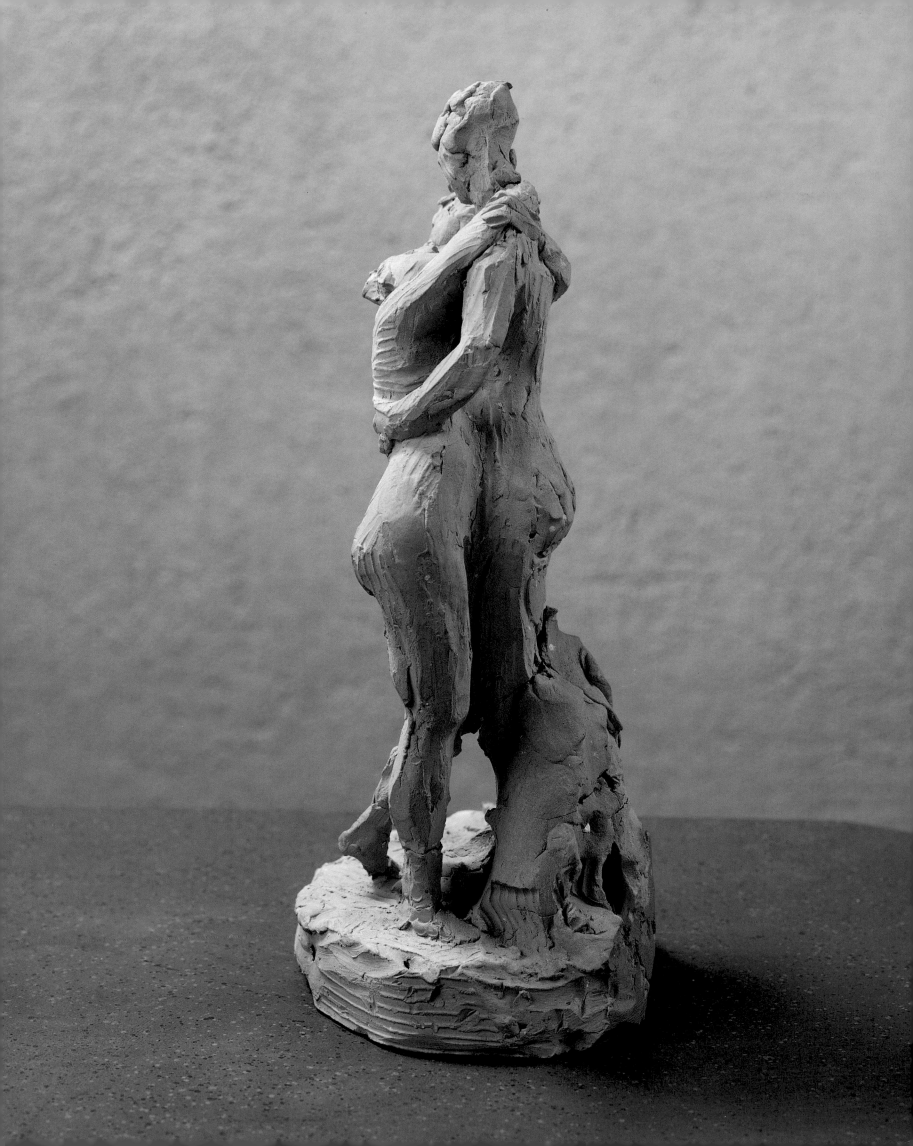

ABOVE fig. 36 Antonio Canova, *Study for The Three Graces*,
Venice, Museo Correr, Biblioteca (cat. no. 8)

OPPOSITE fig. 35 Antonio Canova, *Model for The Three Graces*,
Turin, Giancarlo Gallino
(cat. no. 10)

ABOVE fig. 37 Antonio Canova, *Sketch for The Three Graces and a Detail Study for the Grace at the Right*, Venice, Museo Correr, Biblioteca (cat. no. 9)

RIGHT fig. 38 Antonio Canova, *Model for The Three Graces*, Lyon, Musée des Beaux-Arts (cat. no. 11)

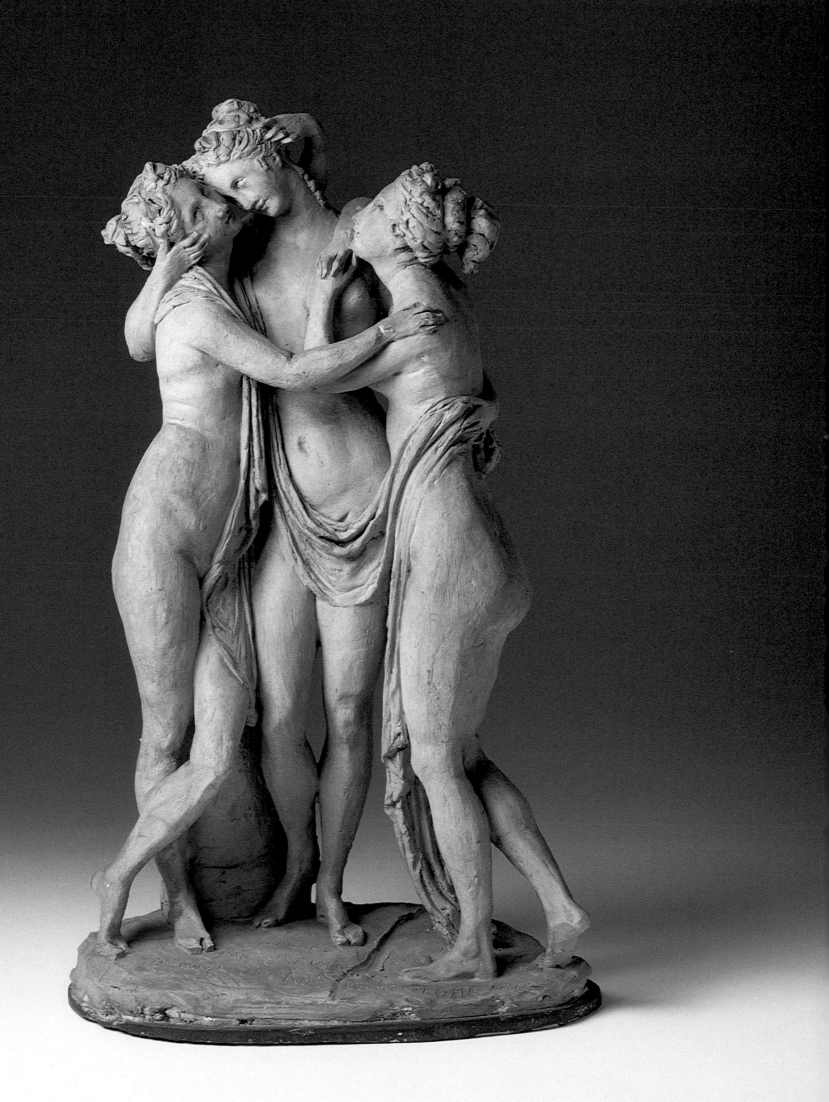

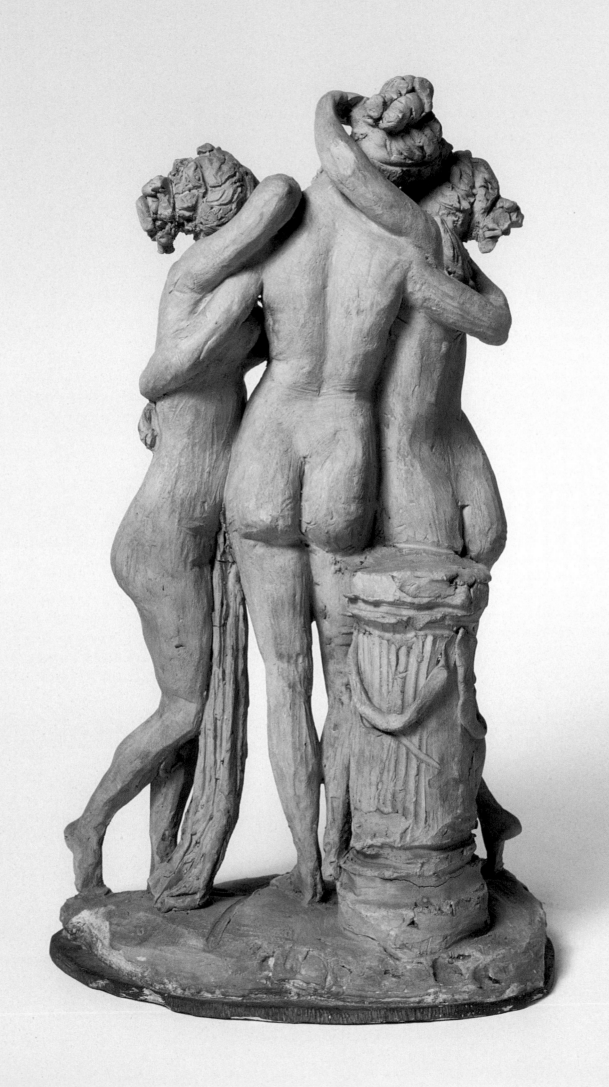

the house of 'Md. Tambroni 1812.'[67] This is presumably the *bozzetto* Canova referred to on 10 October 1812 in the draft for a letter to the Empress Josephine reporting that he had just despatched to her from Rome the statues of a *Dancer* and *Paris* with, as a gift, four plaster casts of busts, adding at the end that he had not forgotten her request for a group of the Graces, '*au contraire j'ai déjà exécuté une petite esquisse en terre*'. At this moment, however, he had a great deal of work on his hands, modelling statues of *Peace* and of Elisa Baciocchi, Grand-Duchess of Tuscany, as well as finishing the heroic scale marble group of *Hercules and Lichas*. It was not until the following summer that he was able, at last, to revert to *The Three Graces*.[68]

The second and more highly finished of the two *bozzetti* marked the end of the first stage in the creation of the group, that in which the general form was determined. Work then proceeded according to the system Canova had evolved between 1783 and 1787 when he was still under thirty years of age and was engaged on his first major undertaking, the monument to Pope Clement XIV for the church of the Santi Apostoli in Rome.[69] This involved making a metal skeleton or armature on which he could model in clay a figure of exactly the same size as that to be carved in marble. Before his time sculptors had occasionally made full scale models in stucco. He preferred clay which does not, like stucco, harden quickly but remains malleable so long as it is kept damp. Its great advantage for him was that it allowed him to work thoughtfully on a model over a period of several months, revising, reworking, building up and scraping away, endlessly adjusting details. The disadvantage of a figure in clay, especially if life-size or larger, is that once it has dried it is liable to disintegrate unless baked and transformed into terracotta with inevitable shrinkage and a high risk of fragmentation. Canova therefore employed a specialist craftsman *(formatore)* to make a plaster cast from the clay model, which was destroyed in the process. Moulds, necessarily taken in sections, were filled with plaster of Paris to make the casts and Canova had the chance at this stage to reconsider and if he wished revise the model yet again, this time in the form of detached limbs, heads, etc. before they were stuck together. When the cast had finally been assembled he marked it with points – pencilled crosses or metal studs – dotted over the entire surface. It was then placed beside the block of marble from which the sculpture was to be carved, each under a frame from which plumb-lines were suspended. The distance between these lines and the points on the model could be measured with compasses so that assistants could drill into the block to the same distance from the lines and then chisel away the material between the holes. This process of roughing out stopped short of making an exact replica of the model. (For exact replicas points were, and still are, much more closely spaced than on Canova's models.) The assistants left a kind of carapace on which Canova could work, using a considerable variety of chisels and gouges, some of his own invention, and judging by eye and not by any measuring instruments as he converted the forms he had originally modelled in a soft and opaque medium into one that was hard and almost translucent. In the process contours might be accentuated or softened, incisions deepened and textures modulated with carefully nuanced variations and gentle transitions in surfaces from those that absorb to those that reflect light.

A drawing by Francesco Chiarottini records the appearance of Canova's studio when the monument to Clement XIV was nearing completion in 1786 (fig. 40). On the right, the marble statue of the Pope and the model for it stand beneath wooden brackets from which plumb-lines are suspended. A recumbent figure works on the lower drapery of the marble with a drill rotated by a cord in the hands of a boy standing in front of the statue of *Humility* to the right of centre. A man standing on a ladder, presumably Canova himself, is working on this nearly finished statue, now separated from the model, which is shown on the left with the giant compasses for measuring propped against it.

Having organised his studio in this way Canova was able to concentrate on essentials, that is on the artistically essential. Mechanical tasks were entrusted under his direction to assistants who were usually skilled artisans rather than budding sculptors. This facilitated production but often resulted in bottlenecks and the studio was usually filled with a number of unfinished rough-hewn sculptures waiting for Canova to work on them. For nothing was

ABOVE fig. 40 Francesco Chiarottini, *Canova's Studio*, 1786, pen and ink and wash on paper, 41 × 58cm, Udine, Museo Civico

OPPOSITE fig. 39 Antonio Canova, *Model for The Three Graces*, Lyon, Musée des Beaux-Arts (cat. no. 11)

allowed to leave the studio until it had been finished by his own hand and to his satisfaction. As he grew older he was able to work personally on large and complex pieces in marble only in the winter, the hot summer months being spent by him in carving small-scale ideal heads or modelling in clay.

The plaster model for *The Three Graces*, marked with points, has an inscription scratched on the base, recording that it was begun in June and finished in August 1813 (figs. 41 and 42).[70] It differs from the Lyon *bozzetto* in several ways. Canova reduced the drapery to a much thinner swathe supported by the hand and on the elbow of the figure on the right. He adjusted the positions of the hands, most notably those of the figure on the right, no longer clasped together. To all three he gave greater substance, an *embonpoint* that is almost Rubensian. And he replaced the low column behind the figure on the left with a rectangular altar (some such support being necessary for stability). On 17 June he wrote to his friend Leopoldo Cicognara, who was then visiting Paris: 'You can tell the Empress that the model for the Three Graces that she commissioned from me progresses every day, and that I am working with ardour and the greatest love at the thought that she may see it and have it placed in her gallery where works of sculpture are marvellously illuminated and looked after with infinite care and delicacy.'[71] Josephine asked for a sketch or outline drawing of it and although Canova refused to provide one, saying that it would give no idea of the group, which must be 'either very well drawn or seen',[72] he was prevailed on to have an engraving made after a finished drawing.[73]

News of the model soon spread among Canova's friends. On 18 June a correspondent in Florence wrote to say that he had heard it was finished,[74] and a month later (21 July) the painter Giuseppe Bossi wrote to Canova from Milan: 'I hear you are immersed in the group of the Graces in which I am sure you will surpass yourself. I wish you a piece of marble worthy of you and the subject.'[75] By the middle of August the model, presumably the plaster cast, was on show in Canova's studio. The Roman sculptor Vincenzo Pacetti noted that he saw it on the 13th and found it 'molto bello';[76] the Danish painter Wilhelm Eckersberg saw it on the 31st;[77] and by early October the Empress Josephine was said to be asking for reports on it from every Roman who was presented to her.[78]

On 31 October 1813 Canova wrote to Josephine that he had heard from Cicognara of her desire to have the group and this emboldened him to ask for an advance of 20,000 francs, adding that he hoped to finish it in two years 'or a little more'.[79] She replied on 10 December saying how pleased she was to have news of *The Three Graces*: '*c'est un sujet charmant que je me félicite d'avoir indiqué à un aussi grand talent que le votre*' ('it is a charming subject which I am delighted to have suggested to a talent as great as yours'). And she gave the order for the first payment of 20,000 francs to be made to him in the coming April.[80] On 29 May 1814, however, Josephine died and her estate was divided between her two children, Eugène de Beauharnais and Hortense, who had married Napoleon's brother Louis, King of Holland from 1806 to 1814. By this time Napoleon had been forced to abdicate and the fortunes of all members of the Bonaparte family were in doubt. On 19 June Eugène's secretary, Soulange Bodin, wrote from Paris asking Canova if he had begun the group for which Josephine had agreed to pay a total of 60,000 francs,[81] to which Canova replied that it was already being roughed out in marble but he had not as yet received the promised first instalment of his fee.[82] In a letter to Eugène of 29 November (now lost), Canova apparently asked whether he still wanted the group. Some weeks earlier Eugène had, in fact, given Soulange Bodin instructions to continue negotiations with Canova, to whom Eugène wrote personally from Vienna on 9 December to say that he had no intention of giving up his claim to *The Three Graces*.[83] But a month later Canova had still received no payment and on 5 January 1815 wrote to Soulange Bodin asking for 20,000 francs 'as soon as possible'; he wrote again a fortnight later and repeatedly during the following months but received only excuses for the delay in payment.[84]

Rome was at this time flooded with British visitors enjoying continental travel for the first time for more than a decade. Canova's studio was 'by his order open in the most liberal manner to all strangers', wrote John Mayne on 19 November 1814. Mayne, a young Irishman,

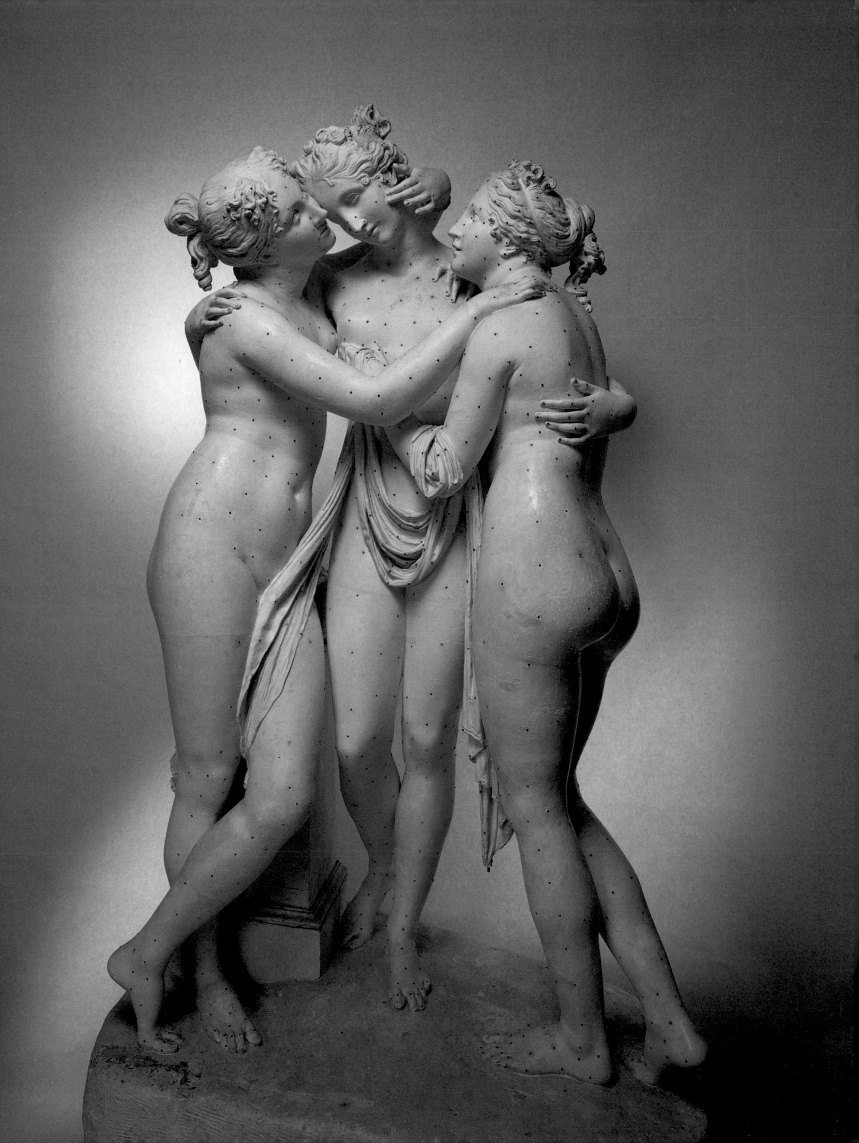

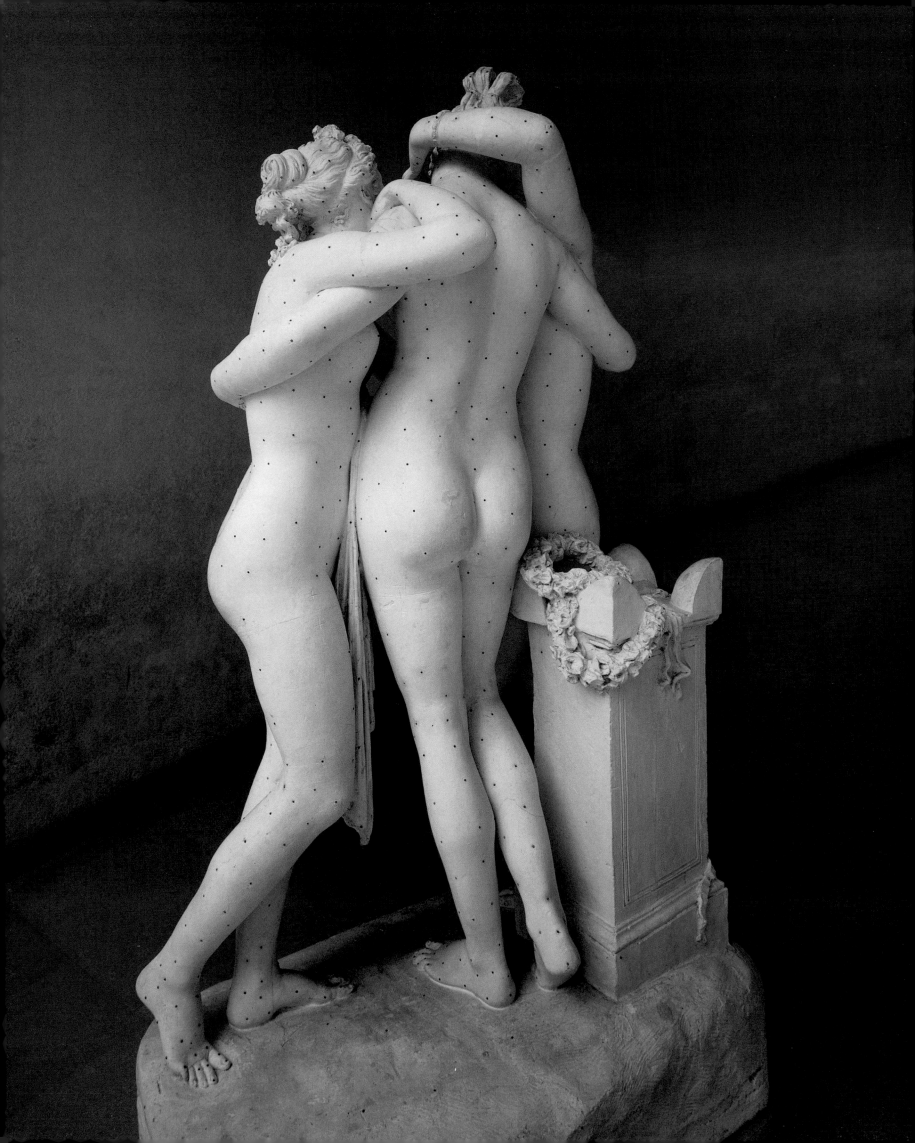

saw there 'works in every state, from the first placing of the rough block to the last finishing of the master', and noted that *The Three Graces* was 'in progress', adding that it was 'admitted to be superior to the ancient group.'[85] Canova's letter to Eugène of 29 November may have been prompted by some British visitor offering to buy the group, but it was not until mid-December that the Duke of Bedford came on the scene. He had probably been involved in 1802 in a project to commission from Canova a statue of his brother the 5th Duke, who had died in March of that year.[86] Charles James Fox spoke to Canova about it when they were both in Paris that autumn.[87] Nothing came of this, but soon after arriving in Rome the Duke met Canova, calling on him on 10 January 1815 with his friend Lord Cawdor.[88] And he set his heart on having *The Three Graces*. On 21 January he wrote to Canova:

> Since M. le Prince Eugène de Beauharnais has decided to take your inimitable statue of the Three Graces, I am delighted that you agree to make a group of the same *genre* for me, for I frankly declare that I have seen nothing in ancient or modern sculpture that has given me more pleasure than this beautiful work. I think myself happy to be in some way the means to immortalise the name of Canova in England as much as it already is on the continent of Europe and I dare to flatter myself that you might yourself bring the work to England next year and place it according to your taste in my house, where I shall be delighted to receive you and assure you in person of the very special esteem with which I beg you to believe me,
>
> > Monsieur,
> > Your very humble and very obedient servant,
> > Bedford.
>
> I leave the variations in the group and in the figures of the three Graces entirely to your judgement, but I hope that *the true grace* that so particularly distinguishes this work will be completely preserved.
> *(For a transcription of the French text of this letter see Appendix, p.99).*

The Duke and Duchess of Bedford soon struck up a cordial personal relationship with Canova. On 24 January, 'after dinner at the Duke of Bedford's', noted Samuel Rogers in his journal,[89] 'the Dss waltzed and danced with castanets before Canova'. By no means wanting in the social graces, Canova was regarded as socially as well as artistically superior to other sculptors and painters in Rome – as was Sir Thomas Lawrence in London – and although he refused all invitations to dine, he often put in an appearance at the parties given by the British aristocracy in Rome. The Duke therefore raised the question of payment very tactfully and not until 4 April, when he was on the point of going to Naples: 'I hope that you will have the goodness to tell me the sum you will allow me to pay in advance for the group of the Three Graces so that I can settle this debt to you before leaving Italy'. He renewed his invitation for Canova to visit him in England, adding 'rest assured of the very sincere feelings with which you have inspired me, not only of esteem for your great talents but of friendship for your person'.[90] In a letter of 9 April, Canova replied no less amicably that although Prince Eugène had agreed to pay 6,000 *zecchini* in three equal instalments, he would be satisfied if the Duke would pay part of this sum immediately, or later, or the total when the work was completed.[91]

After witnessing (and regretting) the fall of Murat's régime in Naples and doing their best to help his wife, Napoleon's sister, the Bedfords paused for a short while in Rome on their way back to England. While there the Duke wrote to Canova (on 4 June) to say that he had arranged for his banker to pay the first instalment for the group and would transmit the second as soon as he returned home, adding 'I was charmed to see the progress that you have already made and the fine block of marble that you have been happy enough to find for this interesting work', and going on to mention that he was thinking of having a temple built for the Graces in his garden but would like to have Canova's advice before beginning it.[92] While in Italy the Duke bought a number of antiquities including six large reliefs from Roman sarcophagi, the finest ever to pass into a British collection, and he asked Canova's help with their export from the Papal States.[93] He did not altogether neglect contemporary artists, sitting to Ingres for a portrait drawing (fig. 43) – one of the many characterful and quite

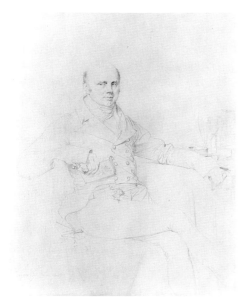

ABOVE fig. 43 Jean-Auguste-Dominique Ingres, *John Russell, 6th Duke of Bedford*, 1815, pencil on paper, 38.6 × 28.9cm, St Louis, Missouri, The Saint Louis Art Museum

OPPOSITE fig. 42 Antonio Canova, *Full-Scale Model for The Three Graces*, 1813, plaster (with metal points), 170cm high, Possagno, Gipsoteca Canoviana

unidealised portraits by Ingres of the British nobility who passed through Rome in these years[94] – and buying from Bertel Thorvaldsen, Canova's main rival in Rome, a relief, *The Anger of Achilles* (a subject treated by Canova twenty years earlier and in a different manner), and commissioning as a pendant *Priam Pleading with Achilles* (both still at Woburn Abbey).[95] In a letter from Rome of the 6 February 1815 the German Nazarene painter Friedrich Overbeck, commenting on the extraordinary avidity for sculpture of British visitors, remarked that 'Canova has sold a highly mannered group of the Graces for 9,000 ducats. Thorvaldsen has also sold several works to the English but for modest prices that he and others regret'.[96]

Before the Duke left Rome the marble block for his group was already in Canova's studio, as we have seen, and the work of roughing it out seems to have been begun. This would take many months if not more than a year and the group originally commissioned by the Empress Josephine must have been far more advanced. As he had as yet received no payment from Prince Eugène, Canova wrote to him on the 29 July 1815 suggesting that he might allow the Duchess of Bedford to have it and accept a second version for himself.[97] By this time Napoleon had been defeated at Waterloo, the allies had entered Paris and the fortunes of the whole Bonaparte clan seemed more precarious than ever. Canova may even have known that his works at Malmaison were soon to be sold by Eugène and his sister to Czar Alexander I of Russia.[98] But Eugène was determined to have *The Three Graces* and his man of affairs in Italy arranged immediately for Canova to be paid a thousand *scudi* (approximately 500 *zecchini*).[99] So work went on that summer on both versions of the group simultaneously.

The work in progress on the Duke of Bedford's group is specifically mentioned by Canova's cousin and assistant Domenico Manera in a letter to the Venetian architect Gianantonio Selva of 2 September.[100] But the main point of this letter was to pass on the secret that Canova was being sent by the Pope to Paris to retrieve works of art taken from Rome by the French, and that he was planning to go on to London. And in fact, after having carried out his mission in Paris, with some help from his British friends there, Canova and his half-brother Giovanni Battista Sartori braved the Channel crossing and arrived in London on 1 November. Two days later the Duke of Bedford wrote to him from his house in Hamilton Place, Piccadilly, to ask how he could be of service and invited him to dine.[101] He wrote again on 12 November to say that he was awaiting him impatiently at Woburn.[102] Accompanied by the architect Jeffry Wyatt and the sculptor Richard Westmacott, Canova and his inseparable half-brother went to Woburn about 21 November.[103] The purpose of the visit is unrecorded but it may be presumed that the placing and lighting of *The Three Graces* at Woburn, as well as the projected temple to house them, were discussed in some detail. Of all the many people who fêted Canova on this visit to England none were more friendly and attentive than the Duke and Duchess of Bedford, and after he left Woburn for London the Duchess sent him a friendly note to wish him a *buon viaggio*.[104]

Canova returned to Rome on the 3 January 1816 after an absence of four months, during which his assistants had been active roughing out marble blocks under the eye of his studio manager Antonio D'Este. There was much for him to do. But he seems to have given precedence to *The Three Graces*. In a letter to his old and admiring French friend E. C. Quatremère de Quincy, 22 February, he said that he was mainly occupied on this group, and in another letter of 2 March: 'I am working on the three Graces which should be finished soon.'[105] This was presumably the version for Prince Eugène, but the Duke of Bedford's seems to have been roughed out also by the beginning of July 1816, when Canova remarked in a letter to Richard Westmacott that it was 'advancing every day' and that he would continue working on it in his impatience to finish it and comply with the Duke's wishes.[106] A progress report he sent to the Duke at about this date has not survived and the Duke's only comment, in a letter acknowledging its receipt, concerned the quality of the marble which he was glad to hear was satisfactory, though that was, he added, 'a secondary consideration in a work from the hand of Canova.' (In fact disfiguring black veins sometimes became apparent only at a late stage in roughing out a block which had then to be discarded.) The temple for

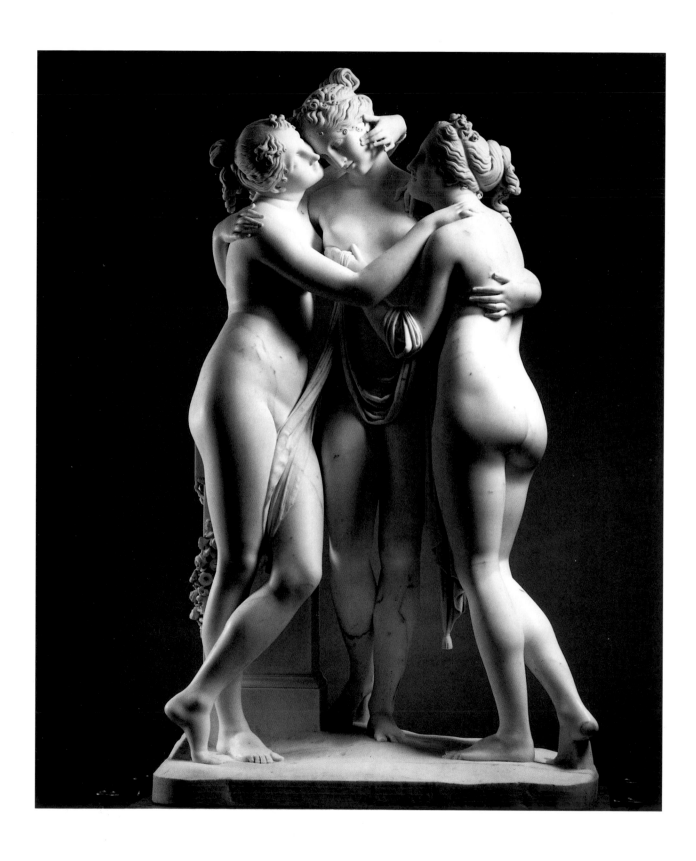

fig. 44 Antonio Canova, *The Three Graces*, 1813–17,
marble, 182cm high, St Petersburg, Hermitage Museum

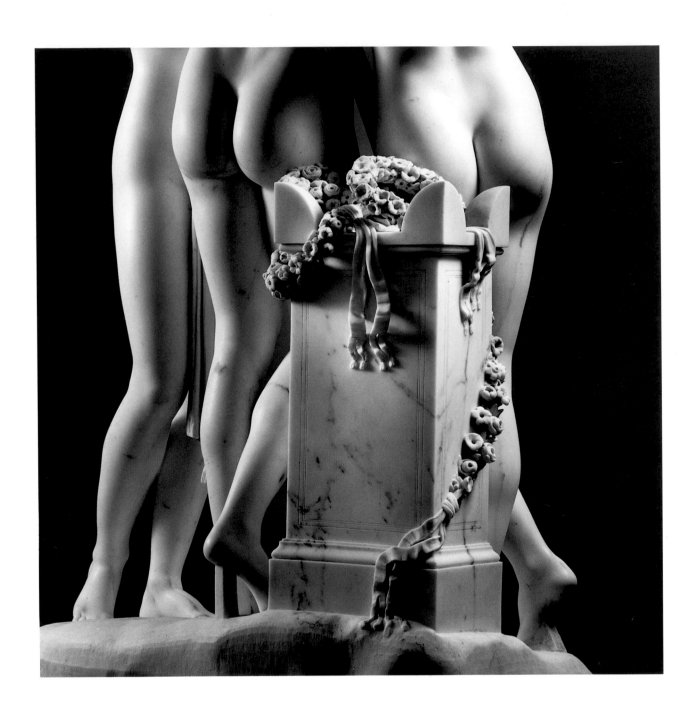

fig. 45 Antonio Canova, *The Three Graces* (detail), 1813–17,
marble, 182cm high, St Petersburg, Hermitage Museum

the group was due to be finished in the following August, the Duke wrote, and he was hoping that Canova might then come to Woburn and instal it, adding that he had arranged for a further 2,000 *zecchini* to be transmitted to Rome.[107]

On 3 March 1817 the Duke sent a tactful reminder of the end of the two years estimated for the completion of the sculpture, which he was as impatient as ever to receive. In a postscript he added that it was said that Canova used some colouring to give his works in marble a mellow tone but he would 'prefer to see the genuine lustre of the pure Carrara marble.'[108] Canova's reply has not been traced and the Duke wrote again on 4 May, glad to hear of the 'continued favourable progress of the Graces.' On the previous day he had dined at the Royal Academy, seen Canova's statues of *Hebe* and *Terpsichore* in the summer exhibition and satisfied himself that no artificial colouring had been applied to them apart, he wrote, from 'a slight tint of vermilion on the cheeks and lips of *Hebe*, which however, as you justly observe may easily be taken off with a wet sponge.'[109] He asked for the dimensions of the base of the group so that he could order a plinth and on the 14 March Richard Westmacott wrote that the Duke thought this should be simple and carved in England to save the expense of transport and customs duty. Canova was asked to give instructions as to the material to be used – bardaglio and two types of granite were available for Woburn – and on the height, bearing in mind the height of the temple.[110] Subsequently, however, a suitable and supposedly antique plinth was found in England.[111]

By the end of March 1817 Prince Eugène had settled the account for his group (figs. 44 and 45).[112] A licence for its export was obtained and it was despatched to Munich.[113] And Canova continued working on the version for the Duke of Bedford. At last, on the 31 December 1817, the Duke wrote that he had heard it was finished (figs. 50 and 51, and numerous details).[114] His informant was the young artist George Hayter, who had gone to Rome the previous year provided with a letter of introduction to Canova from the Duke, who had commissioned him to paint Canova's portrait (fig. 16; cat. no. 16).[115] By 6 August 1818 the Duke learnt that the Graces were embarked on their journey north, but not until the following May did they reach England.[116] The group was installed that summer in the temple built for it and 'excited universal admiration', as the Duke remarked in his last surviving letter to Canova, whom he once again invited to visit Woburn.[117]

The finished group carved for the Duke of Bedford differs from that commissioned by the Empress Josephine most conspicuously in the form of the support behind the figure on the left (compare figs. 45 and 51). Reverting to the *bozzetto* modelled in 1812 (fig. 39), Canova rejected the rectangular altar in favour of a low column. The altar was perhaps intended to evoke that on which sacrifices to the Graces were made and thus to stress the ancient symbolism of the figures.[118] Quatremère de Quincy, who had been on friendly terms with Josephine, remarked that it was 'an accessory analogous to the subject'.[119] The column is, however, much less obtrusive and fits in much better with the curved forms of the whole composition. Canova slightly modified the base, making its surface less uniformly smooth and reducing the width so that the supports for the heels of the figures are less evident. To the back of the central figure, the eldest and most mature of the sisters, he allowed greater width, realising that he had cut away too much in the previous version, making her look almost as is she were fashionably wasp-waisted. He also had a piece of marble of finer quality, free of dark veins as prominent as those in the earlier version, and he worked on it with all his love for the material, smoothing the flesh of the figures, combing their hair and gently ruffling the swathe of drapery. As on other occasions, he took advantage of a second commission to improve on his first version.

Canova's preference for the second version is clearly revealed by prints executed under his direction. Early in 1814 he engaged Domenico Marchetti to make engravings after drawings by Giovanni Tognoli of the front and back of the group commissioned by Josephine, necessarily from the plaster model as the marble had not yet been finished (figs. 46 and 47). The prints were published in the summer of 1815, dedicated to the Czarita Elizabeth, wife of Alexander I who was soon to acquire Canova's statues from Malmaison. But after the second

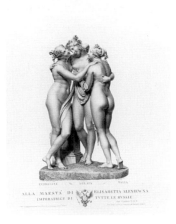

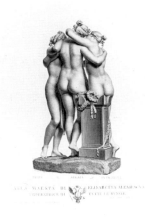

figs. 46 and 47 Domenico
Marchetti, *The Three Graces (after
Antonio Canova)*, 1814–15, etching
and engraving, both 49.5 × 34cm,
Bassano del Grappa, Museo-
Biblioteca-Archivio

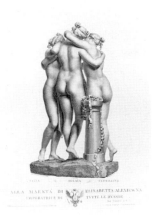

fig. 48 Domenico Marchetti and
Bernardino Consorti, *The Three
Graces (after Antonio Canova)*,
1814–18, etching and engraving,
49.5 × 34cm, Bassano del Grappa,
Museo-Biblioteca-Archivio

version of the group had been finished, Canova paid another engraver Bernardino Consorti
in October 1818 for making 'various alterations to the copper-plate of the group of the
Graces'. The rectangular altar was erased and the column substituted in its place (fig. 48).[120]
As a result, no further impressions showing the back of the first version of the group could
be printed. Canova – who was well aware how much his international reputation owed to
prints, which were accessible to a vast public with few opportunities to see his marble
sculptures – tried to ensure that *The Three Graces* would be known from the improved
second version carved for the Duke of Bedford.

Proud of his new acquisition, the Duke of Bedford gave prominence to *The Three Graces*
in a sumptuously produced catalogue issued for private circulation in 1822, entitled *Outline
Engravings and Descriptions of the Woburn Abbey Marbles* (cat. no. 15). The descriptions were
written by the Rev. Philip Hunt who, as chaplain to Lord Elgin at the British embassy in
Constantinople, had been very closely involved in the removal of the famous 'marbles' from
the Parthenon in Athens and was, indeed, described as being 'the life and soul of the
undertaking.'[121] For the account of *The Three Graces*, however, he had the collaboration of
not only the Duke, who supervised the whole publication, but also the poet Ugo Foscolo,
who provided information about the role of the Graces in mythology.[122] Foscolo contributed
also a 'Dissertation on an ancient hymn to the Graces', printed as an appendix and including
the final versions of extensive fragments from his poem *Le Grazie* which he fictitiously
claimed to be a translation of ancient Greek verses. At this date Foscolo was a political exile
in England and had been befriended by the Duke's third son Lord John Russell, who was
later to be one of the most ardent British advocates for Italian unification and independence.
Canova was never greatly concerned with politics, but in the early nineteenth century he was
a kind of symbol of Italian nationalist aspirations, living proof of the survival of Italian
genius. As Byron put it, addressing divided Italy in 1818:

> … thy decay
> Is still impregnate with divinity
> Which gilds it with revivifying ray;
> Such as the great of yore, Canova is today.[123]

As we have seen, Canova was modelling his *bozzetti* for *The Three Graces* while Foscolo
was, quite independently, beginning his great poem *Le Grazie*. Indeed at one stage, in 1813,
it had been dedicated to Canova, whose *Venus Italica* was a source of inspiration. But Foscolo
did not see either version of *The Three Graces* until the second was installed at Woburn.[124]
By this time his and Canova's concepts of Grace, which had never been very close, were
further removed from one another than ever, and it is perhaps significant that Foscolo
omitted the invocation – 'vieni, O Canova' – from the fragments published in the *Outline
Engravings*. (He may also have omitted them partly in order to preserve the fiction of an
ancient Greek original, although at the end of his *Dissertation* he remarked that Canova's
group, inspired by Greek mythology, might 'in its turn inspire the fancy of some Poet with
the most universal and, at the same time, the least metaphysical notion of whatever is lovely
and beautiful in nature).[125] Poet and sculptor had been united originally in seeking to
translate classical ideals into modern idioms[126] and Canova's group is one of the finest and
fullest realisations of the new ideal of beauty he had created, what Stendhal called the 'beau
idéal moderne.'

The description of the group in *Outline Engravings* very clearly reflects how it could be
seen by admiring contemporaries:

> The great merit of Canova consisted in his having departed from that individuality and those
> imperfections which meet the eye in common life – in his having produced almost aetherial figures
> of delicate female beauty, – and in his having embodied the conceptions which we form of those
> superior Beings, who, in the language of poetic fiction, are said to inhabit Olympus – where their
> youth is eternal, their food ambrosia, the serenity of their minds never disturbed by the shock of
> violent passions, nor their frames subjected to the attacks of disease.

Canova's knowledge of and admiration for antique sculptures, including the *Elgin Marbles*, was mentioned; but the group was described as an essentially modern work of art. Attention was drawn to the

> judicious manner with which he has varied the attitude of each figure, so as to present at one view so many different contours of beautiful form, without violating the repose and tranquillity which belong to their divine character – in the constrained flexibility with which their arms are entwined round each other, – in the perfect symmetry of their limbs, – in the delicacy of detail, and exquisiteness of finish, in the feet and hands, – in the *morbidezza*, – in that look of living softness given to the surface of the marble, which looks as if it would yield to the touch … This great sculptor has also shewn the utmost delicacy and judgement by the means in which he has concealed the mechanism of his art, and veiled his profound knowledge of all those sources, from whence arise beauty and gracefulness in the female form; thus furnishing a higher gratification, and a more unmixed delight to the admirers of what is simply beautiful, by divesting his marble of all appearance of that care, and *limae labor,* which have actually been bestowed on it; and by suppressing all ostentatious display of scientific skill.[127]

Apparent effortlessness was, of course, regarded as a characteristic of grace in the manners as well as the movements of human figures. And Hunt's remarks on the surface of the marble may be paralleled by Cicognara's comment on the statue of *Paris* carved by Canova for the Empress Josephine: 'if statues could be made by stroking marble rather than by roughly cutting and chipping, I would say that this one had been formed by wearing down the surrounding marble by dint of kisses and caresses.'[128]

Some years later Quatremère de Quincy wrote that Canova, whom he had known well since the 1780s, aimed at representing not so much the Three Graces as an idea or conception of grace which resists definition: not the symbols of grace but the visible manifestation of an abstract quality. This he achieved by 'the novel and ingenious entwining of three female figures which, from whatever side they are seen as one walks round them, reveal, in different configurations, nuanced varieties of forms, of contours and of human affections and sympathy.'[129] As a daringly complex sculptural composition of contours flowing imperceptibly into one another in an unending rhythm, not of perpetual motion but rather of eternal merging, the group holds not only the eye but the mind and senses. For it cannot be appreciated simply in formalist terms like a work of non-representational sculpture: it is much more than that.

Numerous copies, large and small, testify to the popularity of the group in the nineteenth century[130] – and they are still being carved alongside copies of Michelangelo's *David* and Canova's own *Venus Italica* in the workshops at Pietrasanta near Carrara. It was illustrated in numerous prints, though the aforementioned copper plates for the finest of them, commissioned and supervised by Canova himself, were altered after his death to veil the nudity of the figures.[131] The Italian Post Office marked the 150th anniversary of Canova's death in 1972 with *The Three Graces* on a 50 *lire* stamp. Other sculptors modelled and carved the subject, from Thorvaldsen to Maillol. Thorvaldsen's severely static group of 1817–9 (fig. 49), a direct response to Canova's with the figures less closely entwined and apparently engaged in intellectual conversation rather than caressing affection, is closer to the antique in the Vatican Museum (fig. 20), especially in the heads and the texture of the marble, and came to be preferred by North European aesthetic theorists. But Canova impressed on the European consciousness an image that has never been effaced. References to it crop up in the most unexpected places. Francis Galton, the explorer of South Africa, noted some Ovampo women in 1853 'in groups with their arms round each other's necks like Canova's Graces.'[132] Until quite recently, however, few Western Europeans had the chance to see either the group in St Petersburg or the revised version formerly at Woburn Abbey, which reveal as do no other works Canova's consummate mastery of the art of sculpture.

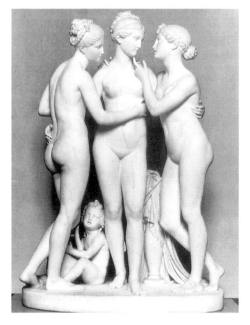

fig. 49 Bertel Thorvaldsen, *The Three Graces with Cupid*, 1817–19, marble, 173cm high, Copenhagen, Thorvaldsens Museum

FOLLOWING PAGES figs. 50 and 51 Antonio Canova, *The Three Graces*, Edinburgh, National Gallery of Scotland, and London, Victoria & Albert Museum, front and back view and details (cat. no. 12)

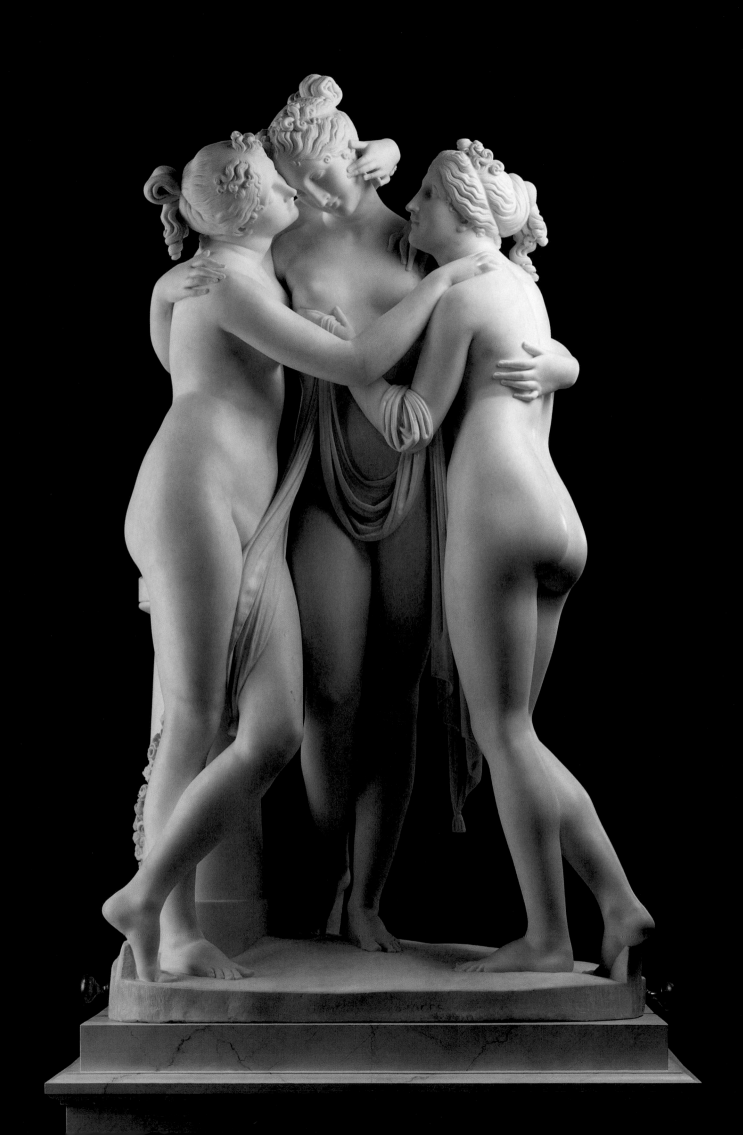

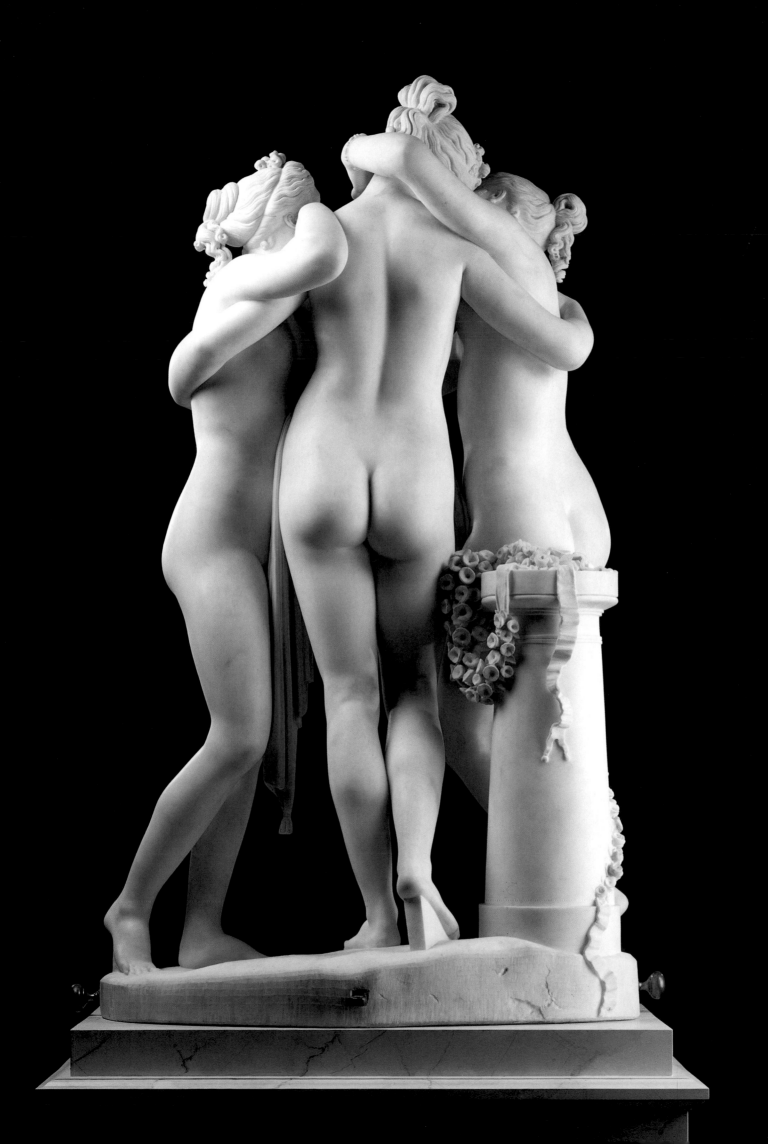

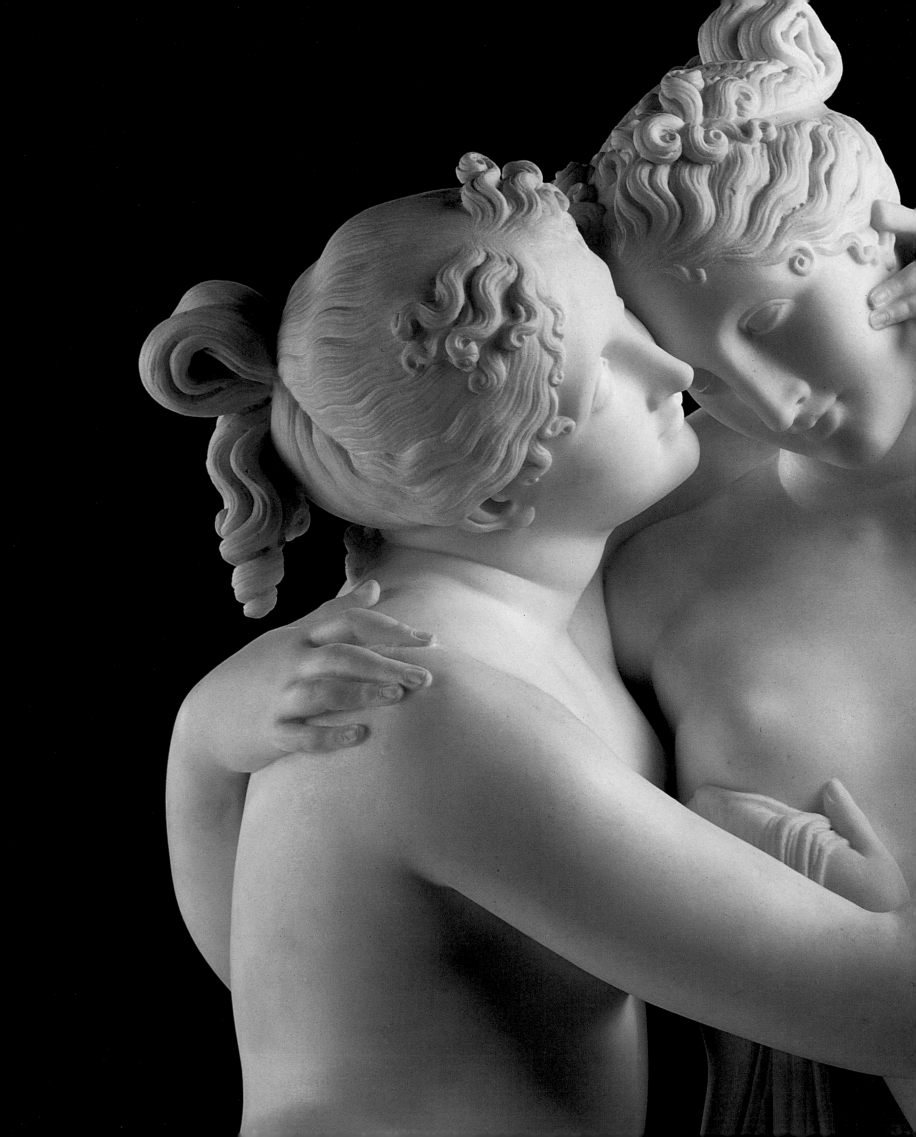

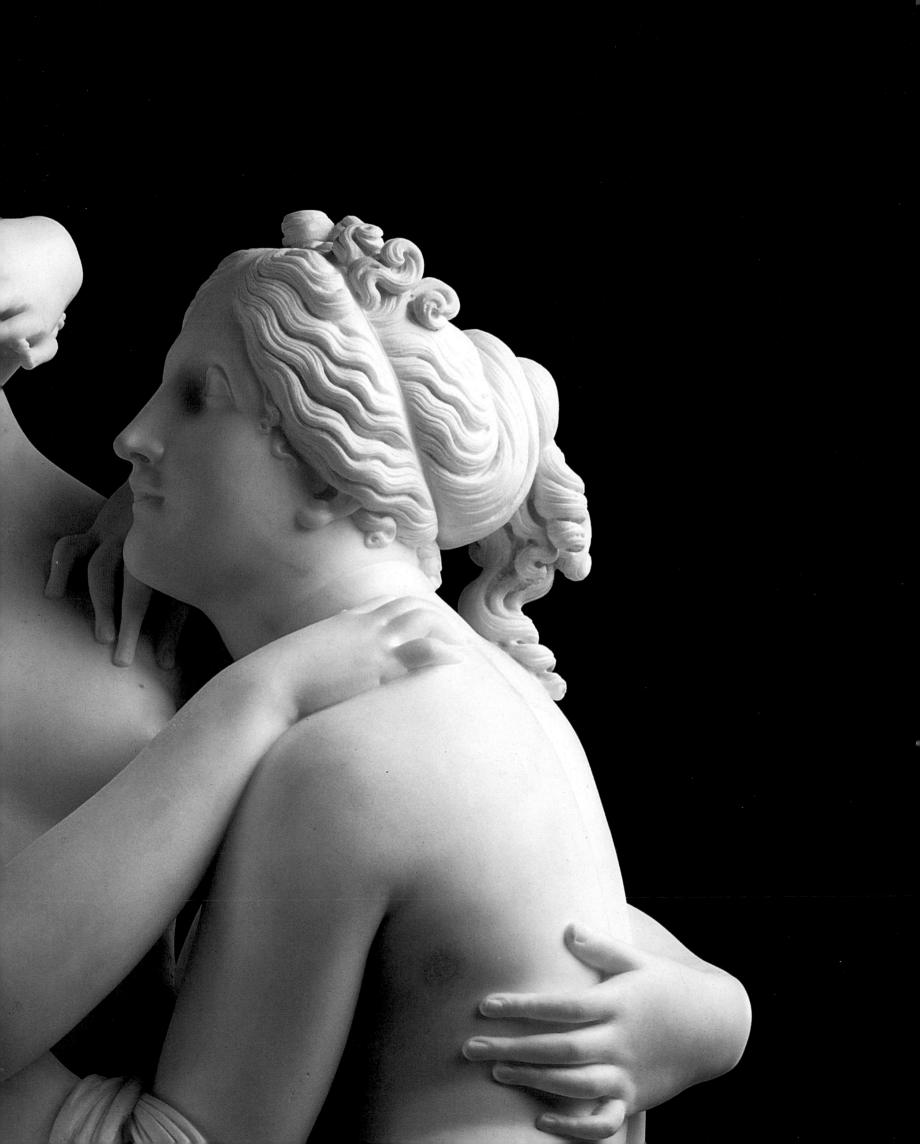

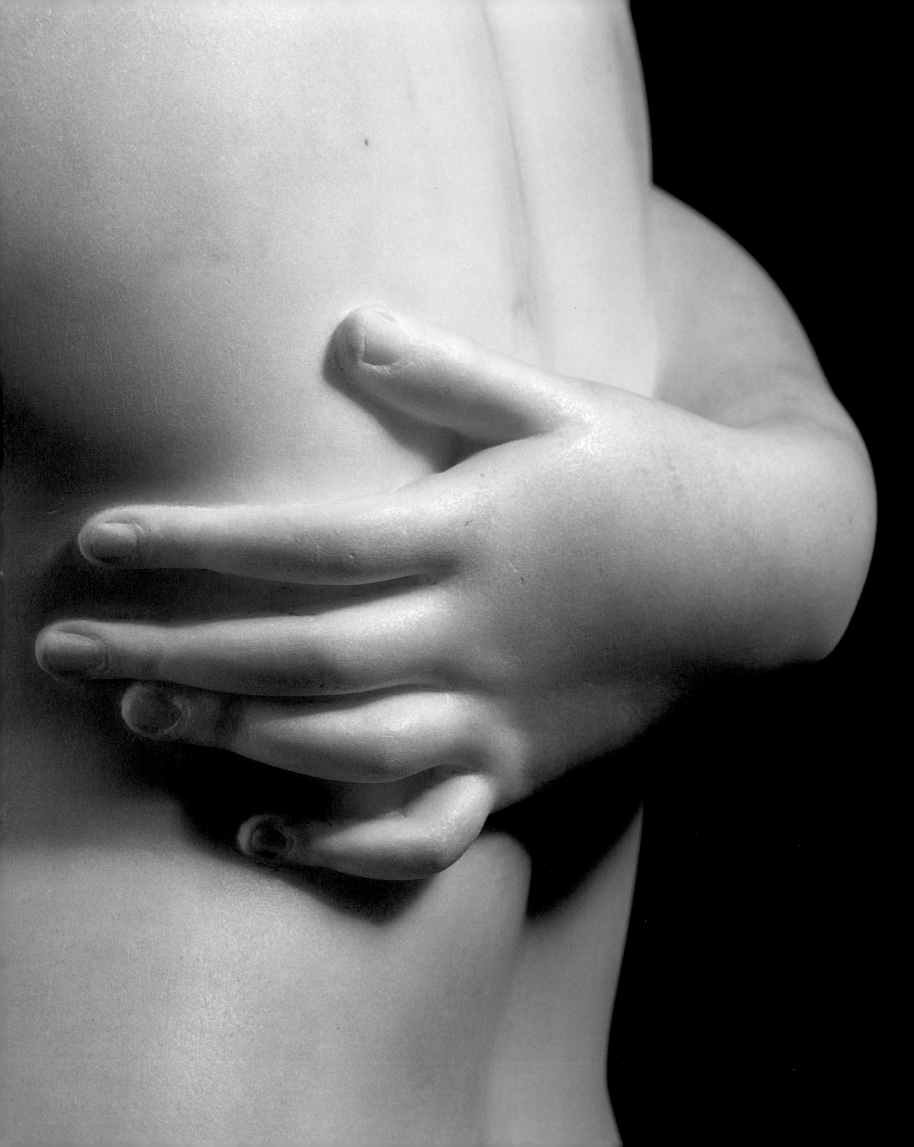

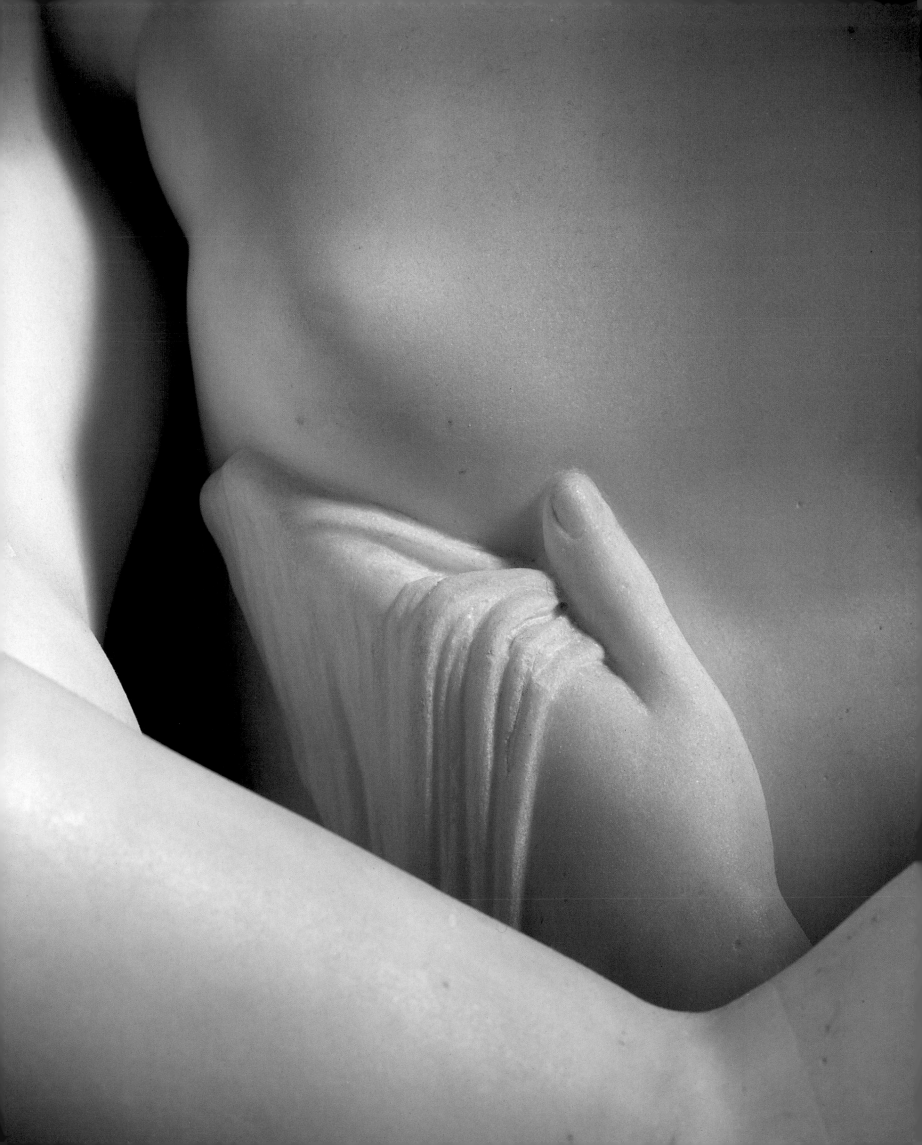

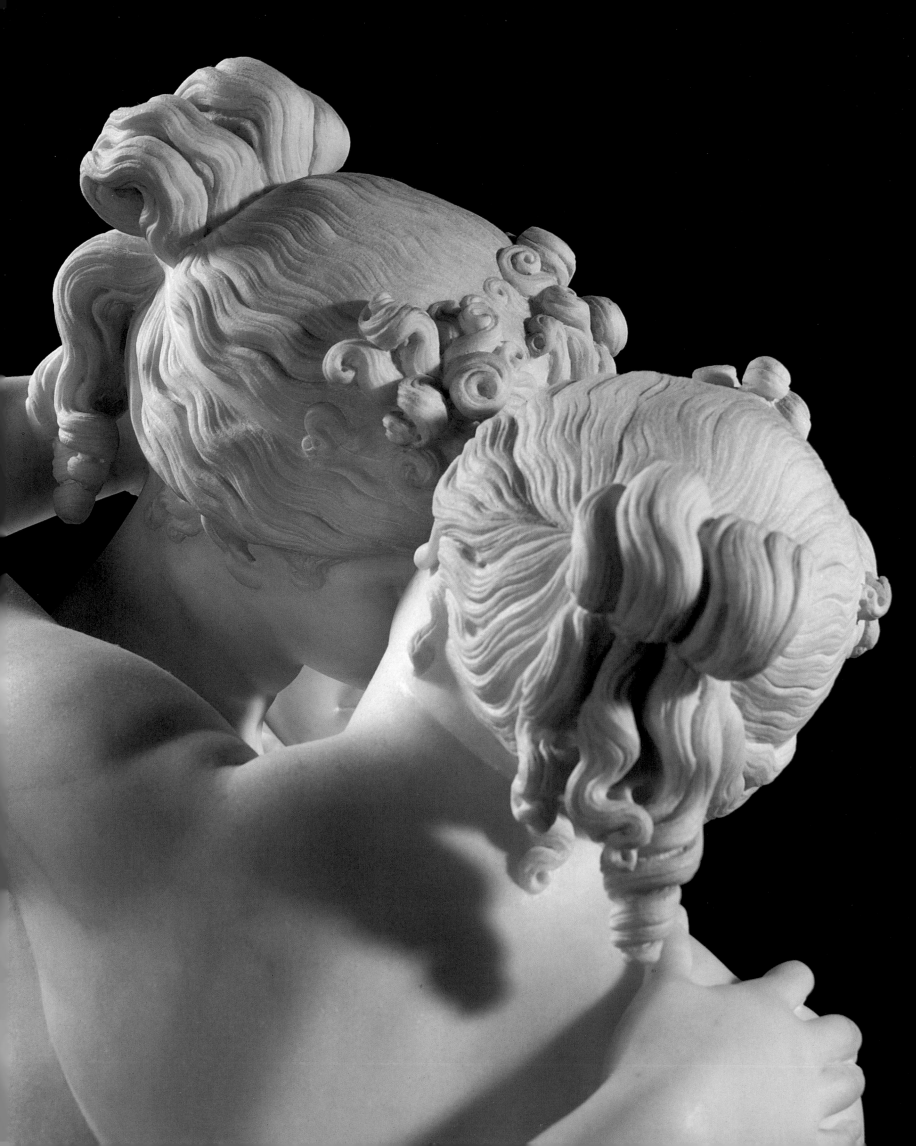

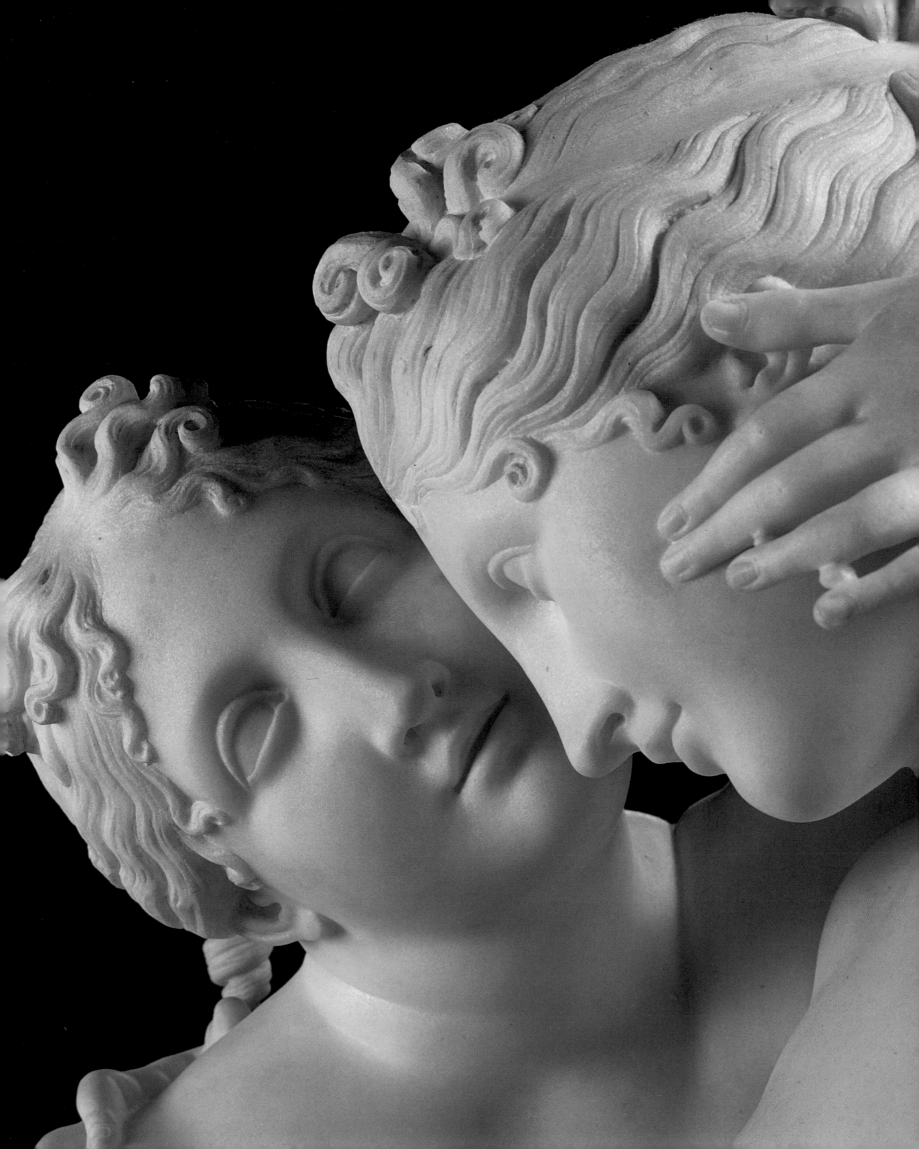

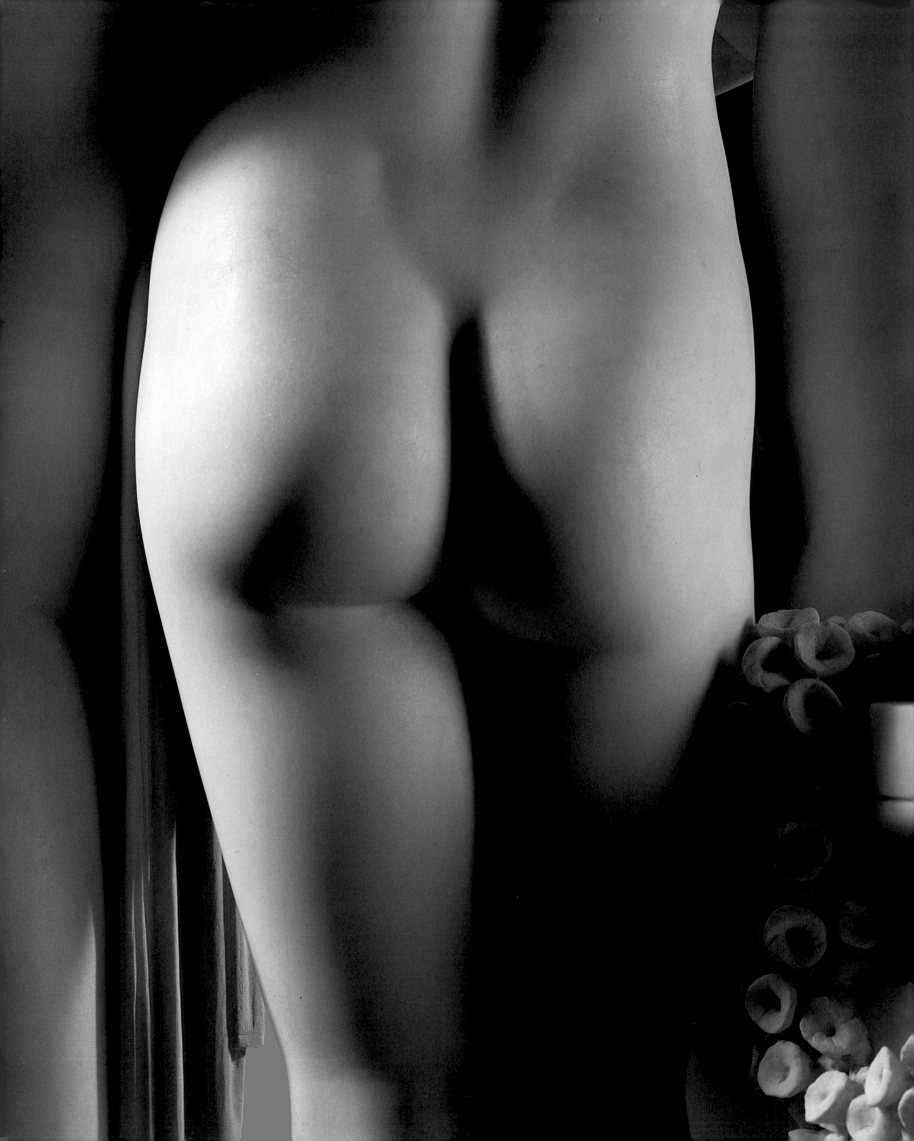

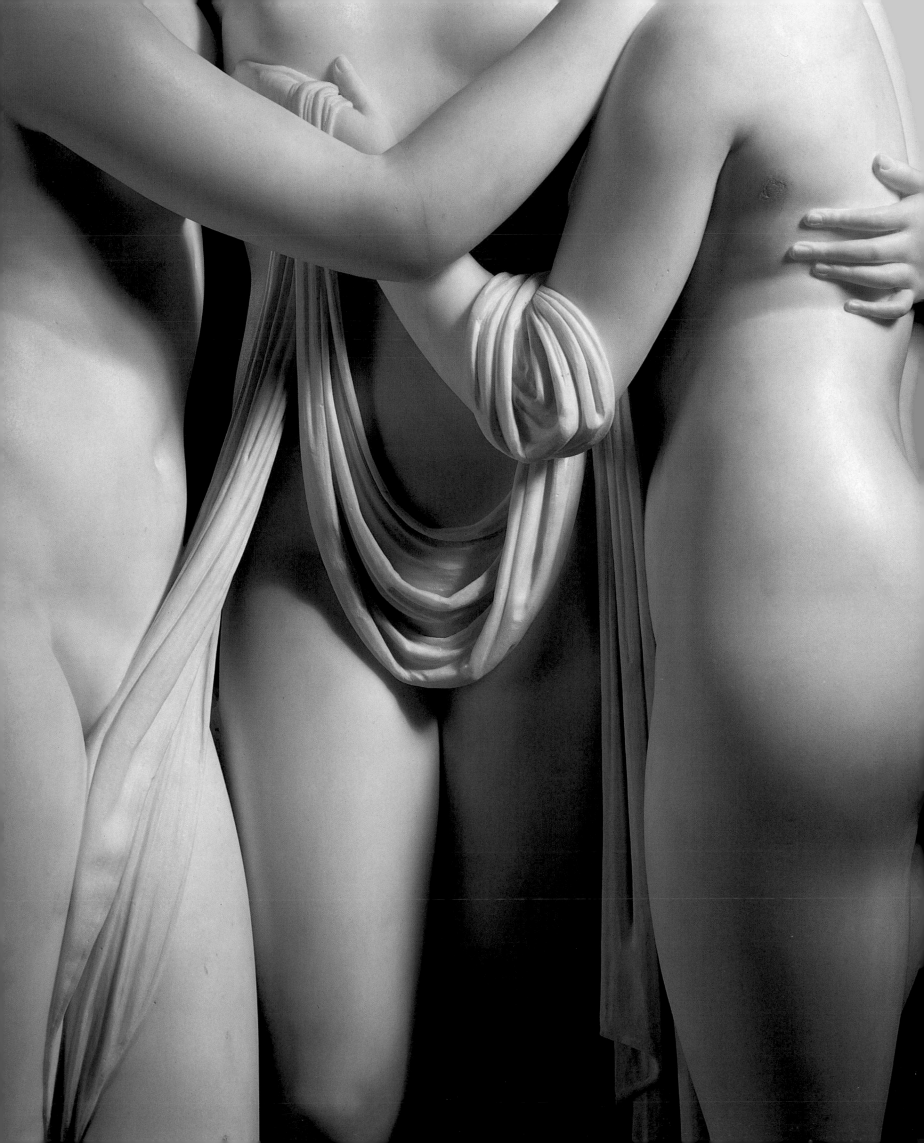

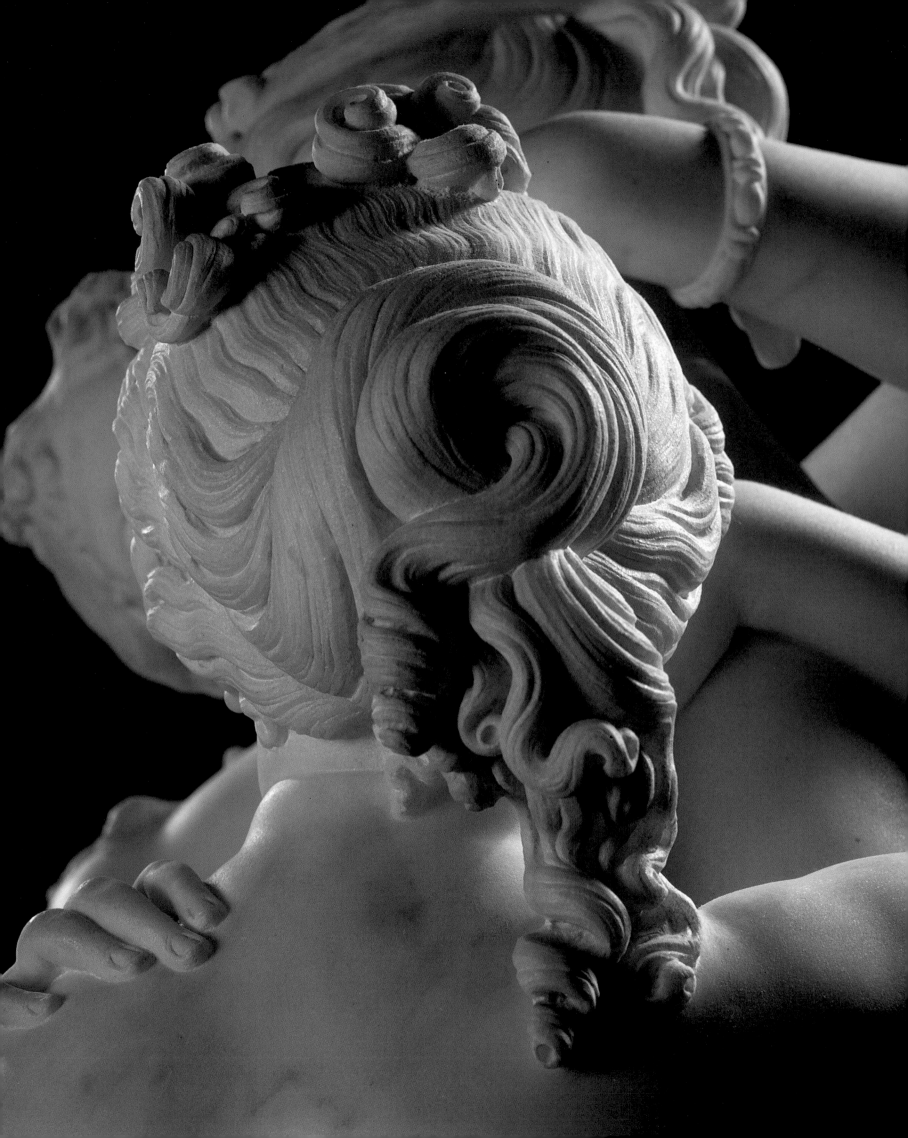

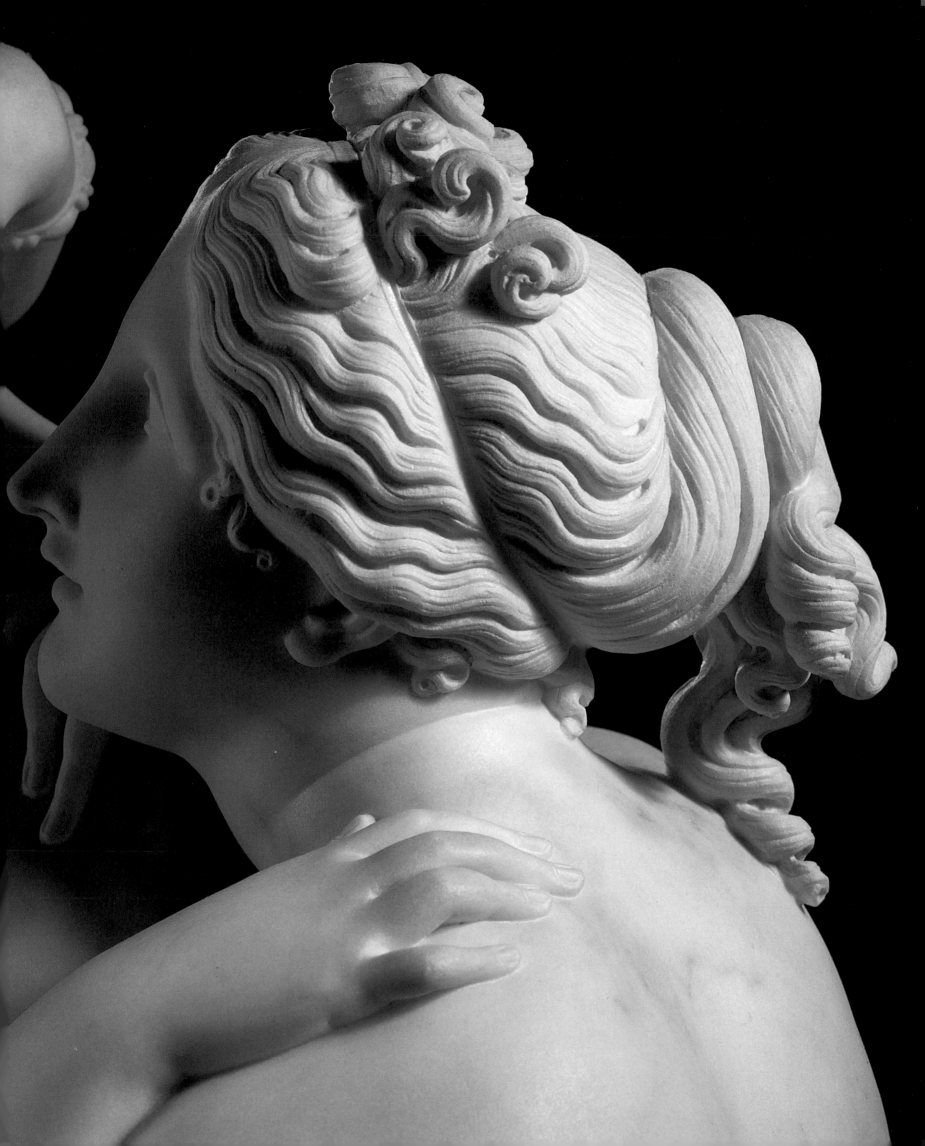

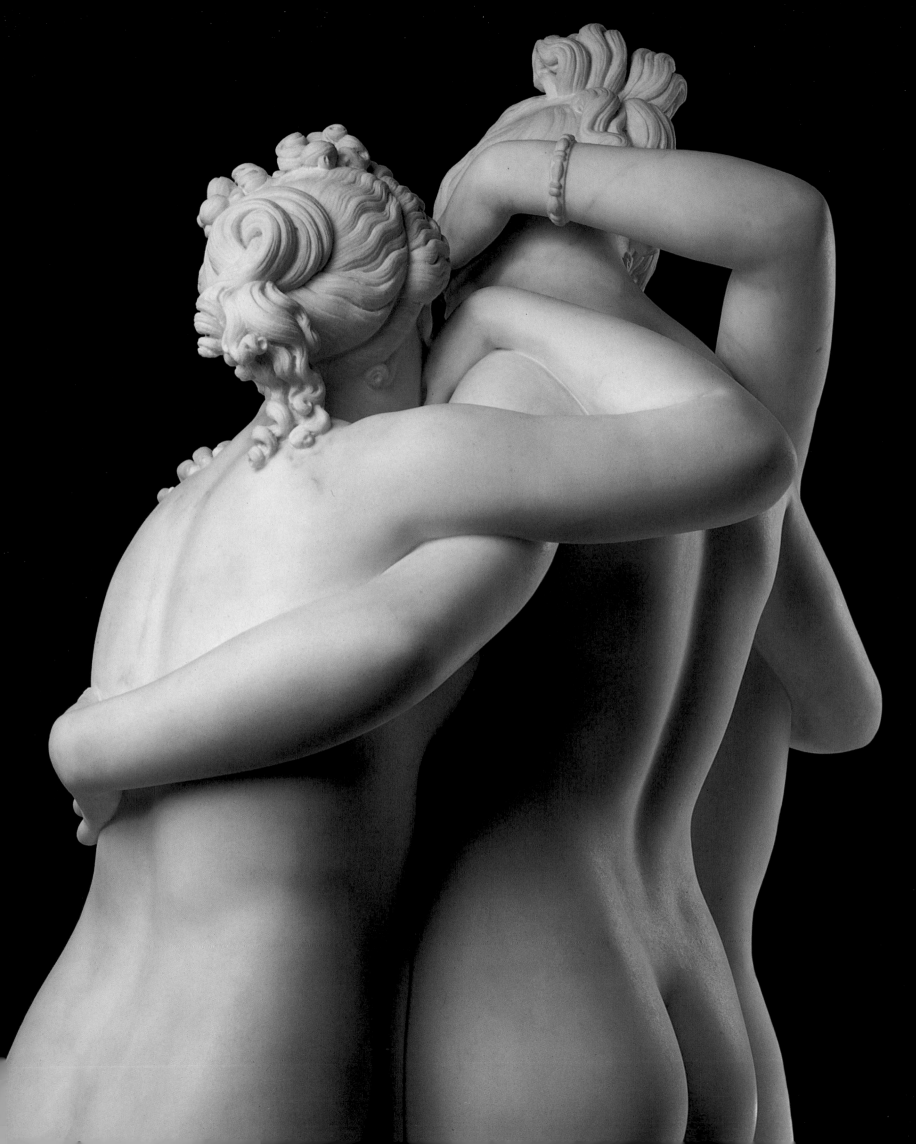

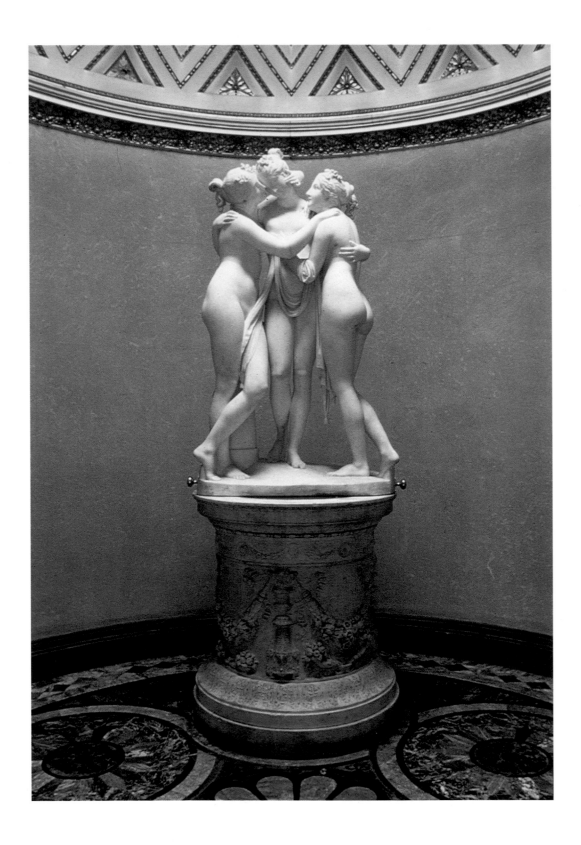

fig. 52 *The Three Graces* in the Temple of the Graces at Woburn Abbey

John Kenworthy-Browne

THE SCULPTURE GALLERY

*at Woburn Abbey and the Architecture
of the Temple of the Graces*

When Woburn Abbey was opened to the public in 1955, the sculpture gallery had a curious appearance (fig. 53). Every available piece of sculpture (apart from some portrait busts) seemed to have been brought in. Long tables filled up the centre, pedestals and gaily coloured *rocchi* the sides. Marble, bronze, plaster, pottery and wood filled all available space, invading the Temple of Liberty and even the sanctuary of the Graces. There was no system and little congruity. Like an ideal junk shop, the gallery fascinated the visitors, who would wander there bemused.

The attraction of the place can be seen by the large number of photographs taken by *Country Life* and the National Monuments Record. This wonderland lasted only a dozen years. By 1967 everything moveable had been taken into the house, and the gallery was given up to other purposes. A little later the marble reliefs on the long walls were removed and replaced by tapestries. Today, four of the modern reliefs, the *Lante Vase* and the *Apollo Belvedere* remain in place.

The gallery (fig. 54) was created over nearly forty years, from 1790 to 1828, by the 5th and 6th Dukes of Bedford. Since the seventeenth century the family had been front-line Whigs, and these two Dukes, who were brothers, were radical – what later would be called advanced liberal. Staunch followers of Charles James Fox and *soi-disant* republicans, they supported the principles of the French Revolution, opposing at one time the war against the French and against Napoleon.

They were very wealthy, and ready to overspend on their buildings and pleasure grounds, furnishings and works of art. Much thought was given to the formation of their sculpture gallery, and yet we know little about the motives or principles behind it, for the reason that very few of their personal documents survive. The 6th Duke of Bedford, replying to Lady Holland who had asked for the loan of any letters he might possess from Charles James Fox, remarked:

> (17 May 1808) The habit I have of destroying all private letters has left me without any written previous to my going to Ireland [1806]; and my brother's papers were at his express desire committed to the flames.[1]

Estate documents, which include the building accounts, survive, but not much relating to the two Dukes' private affairs. Works of art were paid for out of their personal accounts and not from the estate office. Accordingly, we have little documentary evidence about the sculptures. A characteristic of the Woburn gallery is that it showed both ancient and modern sculpture together. This was unusual but not unique. The gallery at Petworth is contemporary with Woburn, and its creator, Lord Egremont, who had inherited a fine collection of antiquities, was also a notable patron of living British sculptors.

The formation of Woburn's sculpture gallery falls into four phases. Up to 1800 the building was a greenhouse or conservatory. Then sculpture was introduced, the Temple of Liberty was built, and certain architectural improvements carried out. Between 1814 and 1822 the 6th Duke of Bedford bought antiquities and modern sculpture, most notably *The Three Graces* and, eliminating the plants, he created the sculpture gallery. Finally, in 1823–4 his son, Lord William Russell, bought further antiquities from Rome, and the gallery was set up in what we can take to be the definitive arrangement.

ABOVE fig. 53 The Sculpture Gallery at Woburn Abbey, photograph taken by *Country Life*, 1960s

BELOW fig. 54 Ground Plan of the Sculpture Gallery and Temples at Woburn Abbey, engraving by Henry Moses after Henry Corbould, from *Outline Engravings and Descriptions of the Woburn Abbey Marbles*, 1822

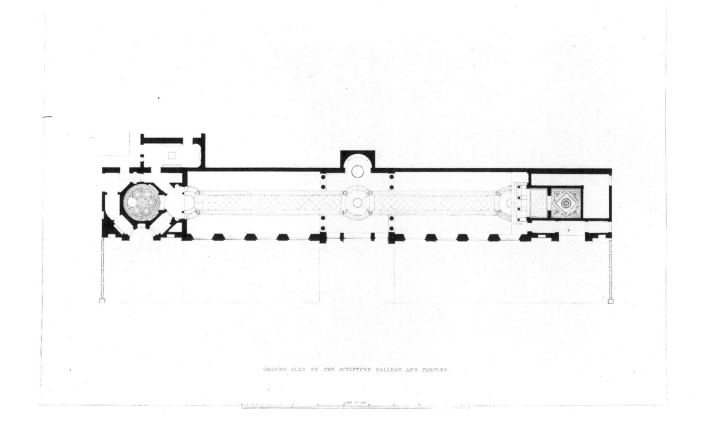

GROUND PLAN OF THE SCULPTURE GALLERY AND TEMPLES.

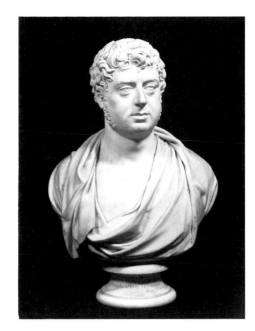

fig. 55 Joseph Nollekens, *Bust of Francis Russell, 5th Duke of Bedford*, 1802, marble, 75cm high, Woburn Abbey, The Marquess of Tavistock and the Trustees of the Bedford Estates

Francis Russell, 5th Duke of Bedford (1765–1802), had grown up without much education (fig. 55). Somewhat ungainly in person, he had firm convictions of right and wrong, and a strong and open-hearted character. Everything he did was on a grand seigneurial scale: entertaining, racing and gambling; his Foxite liberal politics; great improvements to agriculture; and his alterations to Woburn Abbey. These last were begun in 1787 when he was twenty-two years old, and he followed the example of other great Whigs, including the Prince of Wales, in choosing Henry Holland (1745–1806) as his architect.

Holland's work at Woburn is among his best achievements. At the Abbey he redesigned the library and all the south and east sides of the court. Outside the house he built a greenhouse or orangery looking over the pleasure ground (masking the south stable block designed fifty years earlier by Henry Flitcroft); a great building containing a riding house and tennis court; and a dairy further to the north. These additions were linked by a covered way which ran from the south west angle of the house to the greenhouse, emerging from which it continued across the riding house round to the dairy (fig. 56).

The greenhouse was very grand. The nine-bay south façade was constructed by Holland's London mason Henry Wood (fig. 57). For the central bay, attractive medallions of *Spring* and *Summer* were carved in 1790 by a French sculptor called Le Maison. As greenhouses went it was very large, the internal measurements being 138 × 25 feet and 22 feet high (42 × 7.62 × 6.9m). This is only slightly smaller than the orangery built at Kew by Sir William Chambers in 1757–61.

There is indeed a freak orangery at Margam Castle, Glamorgan, which is worth considering because it is exactly contemporary with Woburn. Despite its immense length (327 feet or 100m), the Margam orangery had a hypocaust heating system and a series of stoves at the rear, below floor level. At Woburn there were heating flues, but whether under the floor or in the wall is not clear; nor is it known where stoves were placed. The heating may have been minimal, and with the restricted light from the windows the building's use as a greenhouse was probably limited. John Britton wrote in 1801 of 'many valuable plants,' but no descriptions or lists have been preserved, even from the time of the Duke's successor, the 6th Duke, who was a keen botanist. Most likely the floor was paved to take in tubs containing orange trees during winter.

The change from greenhouse to sculpture gallery began in 1800, when Bedford House in London was demolished, and a group of sculptures came to Woburn. There were eight

fig. 56 General Plan of Woburn Abbey, engraving by John Roffe after J. G. Jackson, 1827, from P. F. Robinson, *New Vitruvius Britannicus: A History of Woburn Abbey*, 1833

fig. 57 South Elevation of the Sculpture Gallery and Temples at Woburn Abbey, engraving by Henry Moses after Henry Corbould, from *Outline Engravings and Descriptions of the Woburn Abbey Marbles*, 1822

marbles by Laurent Delvaux, which had been bought by the 3rd Duke in the 1730s.[2] They consisted of two busts and four statues after the antique, and two other statues (the most interesting were copies of Bernini's *David,* of the pseudo-*Salmacis and Hermaphroditus,* and a reduced *Hermaphrodite*). There were also three works which the 5th Duke's father, the Marquess of Tavistock, had bought in Rome in 1762: two, *Ceres* and *Minerva,* were antique; the other an excellent full-size copy of the *Apollo Belvedere* by Pietro Pacilli. The pedestal for the *Apollo* had been designed by Sir William Chambers.

At Lord Cawdor's sale, in June 1800, the 5th Duke bought the large, splendid antique *Lante Vase* for 700 guineas – a very high price to pay for an antique at that time (fig. 58).[3] The vase stands nearly six feet high, and is nearly six feet in diameter (1.83m). He also bought a good but rather weathered antique relief and some so-called 'Etruscan' vases at the same sale.

It was in or about 1800 that the Duke instructed Henry Holland to design the Temple of Liberty to be inserted at the east end of the greenhouse (see fig. 54).[4] This little building expressed without ambiguity the liberal ideals of Charles James Fox and, up to some unstated point, those of the French Revolution. With its tetrastyle portico of pure Greek Ionic, and a cell twelve feet (3.66m) square, the construction was well forward at the time of the Duke's tragic death on 2 March 1802. A new bust of Fox was commissioned by the Duke from Joseph Nollekens (1737–1823). Dated 1801, it proved to be more popular than Nollekens's portrait of ten years earlier. It was repeated many times and is the best known likeness of Fox.

One of the best of the improvements to the greenhouse was then introduced. Either the Duke or his architect found eight antique marble columns with composite capitals, bought in Rome by Thomas Brand in 1778, which lay unused at Kimpton Hoo (Hertfordshire). They were inspected only a few days before the Duke's death and were built into the greenhouse the next year. The wide centre bay was now marked off by two columned screens (see fig. 53), and it had a broad apse-like niche on the north side. A shallow dome above the centre rose internally to thirty feet (9.15m). These magnificent columns, repaired and polished by Richard Westmacott Snr., are twelve-and-a-half feet (4.13m) high and consist of four pairs of different coloured marbles.

All the masonry and building work in 1800–3 seems to have been carried out by John Wing of Bedford, including the carving of the Ionic order on the Temple of Liberty. But for other decorative work, including plaster ornaments, Holland brought craftsmen down from London. Richard Westmacott Snr. lined the walls of the temple with yellow and black marble (*giallo di Verona* and *nero antico*) and laid a fine mosaic floor of white, yellow and black marble. After his bankruptcy in 1802, the work was completed by Lancelot Wood. Of the other craftsmen, André Delabrière painted all the ceilings with a blue and white cloudy sky.

In this 'aromatic museum', as John Britton described the greenhouse in 1801,[5] the sculpture was disposed thus: in the great niche stood the *Apollo* on its pedestal and the *Lante Vase* was under the dome in the centre. Other pieces were arranged around it, including some of the Delvaux copies. A surviving plan, dated 1802, shows an arrangement of flower beds in the western arm of the greenhouse. We do not know how the eastern arm was used, but it seems to have had a paved floor, as was usual then in greenhouses.

The 5th Duke died on 2 March 1802 aged thirty-six after an accident on the tennis court. His brother John, a year younger and now 6th Duke of Bedford, had promised faithfully to complete the Temple of Liberty in accordance with the dying Duke's intentions. Shortly after the tragedy, certain new sculptures were ordered for the greenhouse, some of which (but not necessarily all) had probably been intended by the 5th Duke. George Garrard, a sculptor whom Henry Holland liked to employ and who had already done work at Woburn, carved a *Bacchic Bull* in high relief in the ashlar of the exterior south pediment. To go inside, above the west or entrance door, Garrard made in plaster a fine *Eagle of Jove,* bearing laurel and thunderbolts (fig. 59). In May 1802, John Flaxman received an order from the new Duke to make a group to be placed in the pediment to the Temple of Liberty, the suitably Whig subject being *Liberty, Peace, Agriculture and Commerce.*[6] It was made in plaster and set up the

fig. 58 The Central Niche in the Sculpture Gallery at Woburn Abbey showing the *Lante Vase*, Reliefs by Richard Westmacott and the Mosaic Pavement, photograph taken by the National Monuments Record, 1949

next year. For the Temple of Liberty, it is known that the Duke considered asking Canova for a statue of his late brother.[7] However, the place of honour in the temple cell was actually given to Nollekens's 1801 bust of Fox and the 6th Duke gave the same sculptor orders to make heads in marble of six of Fox's closest friends and political associates.

The greenhouse remained thus for a dozen years, until the 6th Duke visited Rome. There is no evidence that he was thinking seriously during the intervening period of completing the transformation from greenhouse to sculpture gallery. During the Napoleonic wars Italy was inaccessible, but there were opportunities in England to buy ancient sculpture, either in salerooms or privately, and to commission modern works. Lord Egremont, for instance, did both. In 1803, during the Peace of Amiens, the Duke spent a few months in Paris where he bought a considerable number of decorative objects – candelabra and clocks, bronze and porcelain – but not works in marble.[8]

John Russell, 6th Duke of Bedford (1766–1839), was hospitable, genial and intelligent (fig. 18, cat. no. 13). Though his politics were stongly Foxite, he lacked the massive character and conviction of his elder brother. Shy and reticent by nature, his reputation today unfairly rests

fig. 59 The Entrance to the Temple of the Graces showing George Garrard's *Eagle of Jove* and the Homeric Reliefs by Francis Chantrey

on an uncharitable outburst by the diarist Charles Greville, written as late as 1839, in which he is described at length as uninteresting, weak-minded and selfish.[9] However, his artistic taste was finely developed and inclined towards that of Napoleonic France. Apart from the arts, he early developed a passion for botany and published expensive, scholarly folios on specialised aspects of the Woburn horticulture. Late in life he had a great deal to do with preserving Kew Gardens for the nation. Sir William Hooker, whom he helped to place as Keeper at Kew, wrote that the Duke pursued botany 'with the ardour of a young man and the liberality of a Prince', and described his death as 'a national loss'.[10]

The Duke of Bedford was forty-eight years old when, at Christmas 1814, he visited Rome. Lord Cawdor, on the same route, met the Duke at Florence in November, and their paths crossed many times when at Rome. Lord Cawdor (see cat. no. 18) is of particular interest, because when on his grand tour twenty-five years earlier, he had been rather prodigal in buying sculpture – hence the necessity for his 1800 sale. In particular he had made friends with Canova, bought a statue, the *Amorino* (cat. no. 19), from him, and had ordered another that never reached him. Now he was about to commission two additional statues. There can be no doubt that he spoke to the Duke about Canova, and of his pleasure at the prospect of meeting the great sculptor again.

The Duke of Bedford's party included the Duchess, his son Lord William Russell, his two young daughters, eight servants and a cow. His name appears in certain other travellers' journals – for example, those of Samuel Rogers and Lord Cawdor – but they give few details.[11] We know that in January 1815 Canova agreed to make him a version of *The Three Graces*. It is likely that the Duke described his greenhouse to Canova and that the sculptor suggested that he should visit Thorvaldsen's studio. For long back-wall of the greenhouse at Woburn was clearly well suited for showing bas-reliefs, and Bertel Thorvaldsen (1768/70–

LEFT fig. 60 Bertel Thorvaldsen, *Lady Georgiana Russell*, 1815–18, marble, *c.*96cm high, Woburn Abbey, The Marquess of Tavistock and the Trustees of the Bedford Estates

RIGHT fig. 61 Francis Chantrey, *Lady Louisa Russell*, 1817–18, marble, 117cm high, Woburn Abbey, The Marquess of Tavistock and the Trustees of the Bedford Estates

66

1844) was the acknowledged master of the modern relief. At Thorvalsden's, the Duke bought an *Achilles* relief (an abandoned order from another client), commissioned another as a pendant to it, and also ordered a portrait statue, nude, of his four-year-old daughter Lady Georgiana (fig. 60).

As for ancient sculpture, he bought eight large marble reliefs from the Villa Aldobrandini at Frascati. The purchase was made through the dealer Pietro Camuccini, and they were destined to fill up the long walls of the greenhouse. Seven of the eight were sarcophagus reliefs of remakably high quality; Gustav Waagen was later to write that 'no private collection in England … can compare [with Woburn Abbey] for fine reliefs'.[12] Apart from these, the Duke's activity in buying does not seem to have been systematic. A large Bacchic vase from the Villa Adriana, two torsos and a small sarcophagus apparently make up the total of ancient sculpture in marble.

There is a well-known story about the Duke's acquisition of a small bronze herm of a satyr. When staying at Naples, he went to a breakfast at Pompeii given by Queen Caroline Murat, who promised he could keep any 'find' he might make in the ancient town. This interesting bronze was certainly planted for his discovery.[13] Caroline's generosity was well calculated. The occasion, 10 April 1815, was just six weeks after her brother Napoleon's escape from Elba. The Murats, far from secure on the throne of Naples, looked to English goodwill in order to keep it. By now the Bedfords were moderate Napoleonists, but they were travelling with the Hollands, and Lady Holland was quite outspoken in support of Napoleon and his family.

Decorative pieces also caught his eye. From the Villa Aldobrandini he acquired a large tazza, four feet (1.2m) in diameter, of *breccia Africana* marble. He was delighted by the rare coloured marbles so redolent of ancient Rome, and bought many *rocchi* (round pedestals and low columns), vases and other objects, of porphyry, granite and marble; also sixteen large vases of Carrara marble, of the 'Medicean' shape, which had been made for Empress Josephine; a somewhat meretricious bust of Napoleon, based on Chaudet; and reduced copies of three famous antique statues *(Castor and Pollux, Silenus with the Infant Bacchus,* and *Atlas Supporting the Globe).* All these, and decorative works in alabaster, were dispatched in forty-seven cases in June 1815; another thirty-six cases sent in July were captured by pirates, and to recover them the Duke was obliged to pay a large ransom.

The Duke's party returned home after midsummer. In November Canova came to London to see the *Elgin Marbles,* and was invited down to Woburn (Joseph Farington records the visit on 22 November 1815). The Duke certainly looked to the sculptor for ideas on how to show *The Three Graces,* because he asked his new architect Jeffry Wyatt (later Sir Jeffrey Wyatville, 1766–1840) and the sculptor Richard Westmacott (1775–1856) to join the party. He would also have wanted Canova's opinion of his gallery, and Canova, who had been in constant touch with the Bedfords while they were at Rome, probably knew just what had been bought. It is likely that many of the objects may not yet have arrived at Woburn: it seems, for instance, that Camuccini was keeping back the Aldobrandini reliefs for restoration. The change from greenhouse to gallery began soon after Canova's visit. The next year, 1816, Wyatt produced plans for the Temple of the Graces, and work started once again on the building.

Jeffry Wyatt designed a chaste rotunda of fifteen feet (4.57m) internal diameter, with a dome lit from above by an oculus (fig. 62). The approach was through a columned screen, and an exedra or vestibule (see fig. 59). The new columns, of *verde antico* marble twelve feet (3.66m) high, very fine and certainly antique, were said by Dr Hunt (for whom see cat. no. 15) to have been 'brought from Rome', but when and by whom is not known. Their Ionic capitals are modern, probably supplied by Westmacott. Above, Garrard's *Eagle of Jove* fits perfectly in the lunette.

The masonry work, by John Wing of Bedford, included the garden elevations of both temples, their arched openings (which are now glazed in) giving access to the gallery. The panels above these arches contain bas-reliefs by Westmacott: at the Graces' temple there are cupids or 'loves, who are generally joined with the Graces, and Hours, in the train of Venus',

dancing to a three-boy band. At the Temple of Liberty there is one of Westmacott's 'progress' reliefs, the boys here acting out the Progress of Man, from rude hunter to 'the Genius of Liberty abolishing Slavery, expelling Tyranny, and establishing Government founded on equal laws'.[14] Behind the Temple of the Graces, the old covered way now led into an ante room, which gave onto the gallery.

Decoration of the Temple of the Graces, delayed until 1818, was carried out by Wyatt's craftsmen. The mahogany doors with their bronze ornaments exactly copy those on the Temple of Liberty, and they include a small grill through which the Temple may be viewed without opening the doors. Inside the rotunda, the glazed iron ceiling-light is five feet (1.53m) in diameter (see fig. 62). Below it, the plaster ornaments came from Francis Bernasconi of Bedford Square. The flowers within the diamond coffering contain tiny, scarcely distinguishable heads of Venus, Bacchus and Mercury. The leaves and frieze ornaments are part-gilded, giving a lighter and more pleasing effect than the oppressively solid gilt ceiling in the Temple of Liberty. The walls are of veined yellow scagliola (a composition imitating marble), presumably from Messrs Brown and Young, who worked in scagliola and marble at Euston Square, London. They will also have made the circular plinth at floor level, which is of granite.

The finest feature of the Temple is the floor (see fig. 52), which was laid by John or Edward Shepherd of Plymouth. Less formally geometrical than that in the other Temple, it is of coloured marbles from Sandygate, Bickerton and other places on the Duke of Bedford's estates in South Devon. It contained '1238 pieces of marble further enriched by 102 brass figures'.[15] The circular pedestal for *The Three Graces* fits so perfectly into this delicate pattern that it must surely have been acquired before Wyatt designed the floor around it.

The pedestal is forty-five inches (1.14m) high. The Duke wrote about it to Canova in 1820: 'I was fortunate in meeting with a pedestal for the group which had been brought from Rome 60 years ago by one of our celebrated architects. It is *antique* but suits the subject admirably'. The 'celebrated architect' who was in Rome in about 1760 might conceivably have been Robert or James Adam. The pedestal is in fact modern, and carved in an Italian limestone. In 1819, that is after *The Three Graces* group had arrived from Rome, John Wing sent in a modest bill for work that included altering the pedestal for *The Three Graces*, fixing a brass plate and mounting the statue on it. In fact, the pedestal has also been fitted with bearings, and the base of the statue with brass knobs so that the group could be rotated. Presumably this was done separately.

The whole gallery was paved with Portland stone, some of it re-used from the existing floor, and Shepherd inserted a two-foot border of Devon marbles along each side of the central path, taking 'a circular sweep at the centre and extremities'.[16] By 1819 the name of the building had changed from 'greenhouse' to 'sculpture gallery'.

In the centre bay the arrangement of objects was changed. The *Lante Vase* was put into the niche, with the *Apollo Belvedere* opposite, its back against the window; and thus they remain today. In the ante room the Bacchic vase bought at Rome stood in the centre. There were also portrait busts of Nollekens by Francis Chantrey (1781–1841) and of Holland by George Garrard; engravings of works by Canova; and 'Etruscan' vases.

Apart from Canova, the Duke bought his contemporary works principally from three sculptors. In Rome, Bertel Thorvaldsen delayed starting on the second Achilles relief and had to be hastened by a letter from the Duke in January 1817.[17] When eventually all the reliefs, both ancient and modern, had come in, they were set in the long walls to grand effect. The Thorvaldsen reliefs were in the centre of the walls, at eye level; the ancient reliefs were put higher up.

As a pair to Thorvaldsen's statue of Georgiana – an infant Venus – Francis Chantrey was commissioned in 1817 to make another of her sister Louisa, by then also aged four (fig. 61). The two were charmingly placed in niches in the vestibule to the Temple of the Graces. To English taste, Chantrey's affecting sentiment in his *Lady Louisa* was more attractive than Thorvaldsen's more classical *Georgiana*, but Dr Waagen was quite severe in criticising

Louisa's drapery. Indeed, he was critical of all the English works except Flaxman's relief of *Liberty*.

Two great Homeric reliefs by Chantrey were set on the western wall, flanking the vestibule to the Temple of the Graces (see fig. 59). From the sculptor's ledger, we know that the commissions were given in 1820, after Chantrey's visit to Rome. As 'poetical sculpture' they are unique in Chantrey's work, as the other four commissions for 'poetical' statues which he accepted at the same time were all abandoned. The Woburn reliefs were certainly modelled by 1822, as they were illustrated in Dr Hunt's folio, but their execution in marble was long delayed. Both reliefs are signed and dated 1828, and they were shown at the Royal Academy the next year.

The sculptor whom the Duke patronised most was Richard Westmacott. Of his two large marble reliefs, *Hero Receiving Leander* was exhbited in marble at the Royal Academy in 1820; *Hector Reproaching Paris* was made a year later but was not exhibited. There is no unity of subject between the two. The reliefs were set on the walls in the centre bay, on either side of the niche (see fig. 58). The three pairs of modern bas-reliefs seem to have been given more important positions than the ancient reliefs, and it seems that the Duke at this period was more interested in ordering modern works than selecting ancient ones.

Westmacott's statue of *Psyche* was admired by the Duke 'even before she had just begun to emerge from the rude block'. It was the first ideal statue that Westmacott made, and was exhibited in marble in 1822. *Cupid* was made independently of its companion; probably bought late in 1822, it was exhibited in 1823. The *Psyche*, but not the *Cupid*, was described and illustrated in Dr Hunt's 1822 folio volume. Another improvement was that Flaxman's pediment relief of *Liberty* was remade in marble. Apparently this was carried out by Westmacott in 1818.[18]

It was with pride that, in 1822, the Duke brought out the lavish folio, *Outline Engravings and Descriptions of the Woburn Abbey Marbles*, and copies were sent gratuitously to friends and important public bodies (cat. no. 15). The erudite, somewhat pedantic text was written by the Rev. Dr Philip Hunt, and the illustrations were drawn by Henry Corbould and engraved by George Corbould and Henry Moses. The actual arrangement of the sculpture is not described or illustrated, and perhaps there were still many spaces to fill. Everything

fig. 62 The Dome and Oculus of the Temple of the Graces at Woburn Abbey, photograph taken by the National Monuments Record, 1949

cited so far, except the Delvaux and other copies, is mentioned, with the addition of some half-dozen ancient busts which the Duke had bought since 1815, either in England or through his agent in Rome.

He might have continued for years to buy in a desultory way, but for a new circumstance. His second son, Lord William Russell, travelled in Italy for eighteen months, which included five months at Rome from October 1822. A year earlier the Duke had written, 'if you meet with anything very good and cheap at Rome buy it; but not without consulting some very good judge, but not Canova, for he is too jealous of good things going out of Rome'. In March 1822, he wrote: 'I should like to have two sculpture galleries, one for antiques and one for modern sculpture, but I must be content with what I have got, and "dream the rest"'.

Lord William, a shy, self-effacing young man, suddenly became active buying art in Rome, and at length the Duke abandoned his meanness and caution. The ancient marbles which Lord William sent to Woburn were enough nearly to double the total number in the gallery. They included no less than thirty-seven portrait busts and heads (many of good quality), a torso, an impressive made-up candelabrum, cineraria, seven reliefs, and so on. Also eight antique consoles, which were fitted into the window piers to hold busts.

In Rome, Lord William was friendly with the 8th Lord Kinnaird and accompanied him round the dealers and studios. Lord Kinnaird, delightful and urbane, was also collecting sculpture both ancient and modern. It must have been William who sent his father drawings of a *Cupid and Psyche* group by Thomas Campbell, a sculptor patronised by Kinnaird, but no commission resulted. However, he himself ordered a statue from another of Lord Kinnaird's sculptors, Cincinnato Baruzzi, lately assistant to Canova and, since the latter's death, manager of his studio. The statue of the nymph *Sylvia* (from Tasso's *Aminta*), completed in 1827, was a present from Lord William to his father the Duke.[19] It was given a place in the gallery, and from that day to now it seems that nobody (except J. D. Parry)[20] has taken notice of it. Lord William's not inconsiderable contribution to the gallery was treated in a similar way. It would seem that the Duke of Bedford never gave his son any credit for what he had bought, and its value can be assessed only now, by means of the recently published catalogue of the classical marbles at Woburn.[21]

Another piece that is mentioned in the lists after 1822 is the colossal portrait head of

fig. 63 The Sculpture Gallery at Woburn Abbey, engraving by Henry Moses after J. G. Jackson, 1827, from P. F. Robinson, *New Vitruvius Britannicus: A History of Woburn Abbey*, 1833

Canova. The Duke had often asked the sculptor for his portrait. This head (like one in the gallery at Chatsworth) is a version of Canova's *Self-Portrait* now at Possagno and was probably obtained by Lord William from the studio at Rome.

In June 1822 the Duke had a stroke and he never fully recovered his health. When on a visit to Woburn, Lady Holland wrote to her son (21 April 1824):

> The Duke passed a better night than usual. His cheerfulness & equanimity of temper is delightful … The sculpture gallery is a great amusement & resource to him. It really contains some very choice & curious things. Some of the modern rubbish, which was only left by way of stop gaps, will be removed. We have been looking over some very fine sketches of Flaxman's for two bas-reliefs from Milton; some of the number are very spirited and good.

An order for a bas-relief is entered in Flaxman's second account book, but the sculptor died before carrying it out.[22]

A numbered list of the sculptures, taken in clockwise order round the gallery, was printed in 1828, and this was followed by Rev. J. D. Parry in his description of Woburn which appeared in 1831.[23] The arrangement of the gallery was recorded in a drawing by J. G. Jackson, engraved by Henry Moses and published in 1833 (fig. 63).[24] Here, many of the objects mentioned above can be seen. The Aldobrandini tazza occupies the centre floor, and Lord William's candelabrum stands before the Temple of Liberty. The sixteen Carrara marble vases contribute to the effect of perspective. The incomplete sarcophagus of the *Trojan War* in the right foreground was bought at Sir Gregory Page Turner's sale (1824) at Battlesden Park, which is close to Woburn (these reliefs had been removed from the Gate of Persecution at Ephesus). Opposite, below Thorvaldsen's relief, Delvaux's reduced *Hermaphrodite* can be seen on a pedestal. Parry remarked that 'in keeping with the objects of white marble, [the walls] are of a pale pink hue and the ceiling is clouded in white and blue'. Delabrière's ceiling was actually preserved until the sculpture was removed in the 1960s, and it can be seen in many photographs. On the terrace outside, there were full-size bronzes of the *Fighting Gladiator* and the *Dying Gladiator*, both supplied by Westmacott, and copies of the Medici and Borghese vases. (The third bronze seen there today, of *Silenus with the Infant Bacchus*, is a later addition.)

One last object remains to be mentioned. Lord William Russell and Lord Kinnaird had shared in the purchase of a Roman mosaic pavement, whose discovery, just south of Rome, they witnessed in 1823. They divided the mosaic, and the Woburn portion was restored and completed under the direction of Westmacott. It was temporarily placed in the west hall at the Abbey.[25] Later, in 1865, it was recorded as having been laid down in the centre of the gallery, under the dome (see fig. 58). Recently it has been concealed under a temporary floor, but we know its appearance from a fine coloured photograph and Valadier's engraving of the original pavement.[26]

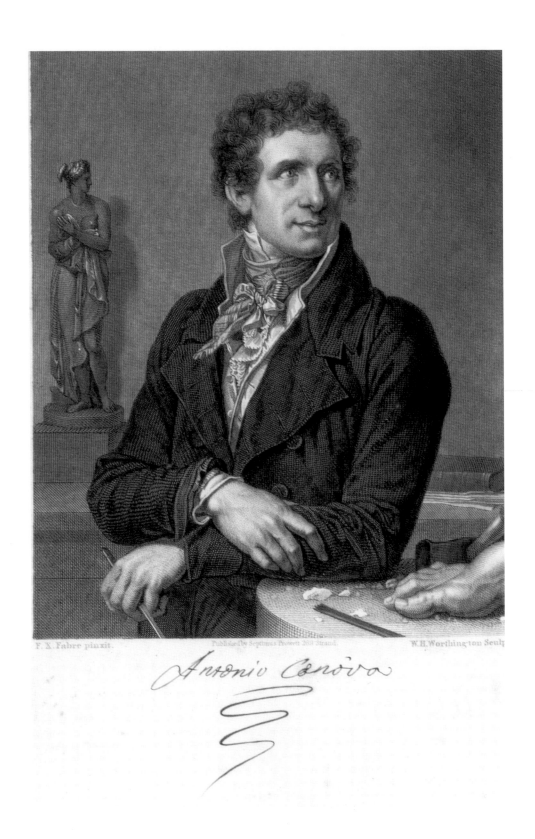

F. X. Fabre pinxit. Published by Septimus Prowett 260 Strand. W. H. Worthington Sculp

fig. 64 *Portrait of Antonio Canova*, etching and engraving by W. H. Worthington after F. X. Fabre, from Moses, Albrizzi and Cicognara, *The Works of Antonio Canova* ... 1824–8, Edinburgh, National Library of Scotland

Iain Gordon Brown

CANOVA, THORVALDSEN & THE ANCIENTS

A Scottish View of Sculpture in Rome, 1821–1822

The studios of Canova and Thorvaldsen were among the sights of the Grand Tour. Visits to the Via di San Giacomo off the Corso and to Piazza Barberini were obligatory for all would-be connoisseurs or men of taste. As the literature of early nineteenth-century travel shows, the workshops were to be mentioned along with the great monuments of Antiquity, the palaces of the Renaissance or the churches of the *Seicento*. Mrs Jameson wrote: 'It is one of the pleasures of Rome to lounge in the Studj of the best sculptors; and it is at Rome only that sculpture seems to flourish as in its native soil.'[1]

Although contemporary records of the works and practice of Canova and Thorvaldsen are not uncommon, and some highlight their similarities and rivalry, one Scottish diary, previously overlooked, contains accounts which are of particular interest.[2] Gilbert Elliot Murray Kynynmound (1782–1859), second Earl of Minto, succeeded his father, who had been Governor-General of India, in 1814. He was a Whig politician, and had a distinguished diplomatic career. Minto had taken his wife and children on the Grand Tour, and in Rome made the round of the sights with the celebrated topographer and antiquary Antonio Nibby. His circle there included Sir George Beaumont, Samuel Rogers and Alexander Baring, later Lord Ashburton, who bought sculpture in competition with the crown Prince of Bavaria (later King Ludwig I). For the period between the end of December 1821 and late April 1822 Minto's diary contains many important and fascinating references to Canova, Thorvaldsen and other sculptors working in Rome, and to the works of ancient art which were their inspiration and models for imitation.

Minto, writing in the year of Canova's death, was a perceptive critic. His initial enthusiasm for Canova was tempered by his discovery of 'Torwalson' (as he habitually called the Dane). Much criticism of Canova follows: he is generally compared unfavourably with Thorvaldsen, except in the matter of the finishing of statues – that is, the '*ultima mano*' – and in the portrayal of female subjects. Minto stresses 'the inimitable beauty of the old statues', and modern works suffer by comparison when ancient examples are taken into consideration – such as the Aegina marbles, themselves over-restored by Thorvaldsen. The ancient sculptures in the Museo Pio-Clementino of the Vatican, and the three Canovas in their *gabinetto* in the Cortile of the Belvedere, are examined by torchlight, and Minto gives his opinion on ancient and contemporary treatment of surface and muscular structure beneath the skin. What Minto regards as Canova's merits, but even more his faults, is strikingly revealed. In spite of his unfavourable comparisons between modern statuary and ancient examples of perfection, Minto decides to order a work from Thorvaldsen, who is himself, however, not free from searching criticism, though Minto praises his superior composition, design and natural expression. On a short visit to Naples, the Earl sees the moulds and casting preparations for Canova's massive equestrian statues. Back in Rome, Minto inspects some of Canova's last works in his studio (some of these remained unfinished at the sculptor's death that year), and delivers himself of further damning criticism while stressing Canova's real forte as master of the calmly-posed female nude. His account ends with the indication of an attempt to play Thorvaldsen off against Canova.

Lord Minto wrote at a time when the widely held opinion of Canova had been extremely favourable. He was seen as the truest heir of the ancients, and as the continuer of their tradition.[3] Minto's comments are therefore interesting because they are so often at variance

with the plaudits of Isabella Teotochi Albrizzi, or of Leopoldo Cicognara, who could write of Canova's 'beau ideal, founded on the antique … the exquisite representation of the flesh and appearances of the skin … those traces of reality, which his attentive observation of the natural supplied; these masterly strokes raised his figures into life, all the softness and delicacy of which were added by his last fine touches.'[4] Byron, writing just five years before, spoke for his age:

> What Nature *could* but *would not* do
> And Beauty and Canova *can*!

But taste was turning in some quarters against Canova and in favour of Thorvaldsen, and Byron recognised this: 'he is their best after Canova & by some preferred to him.'[5] The general dichotomy, of which the examples in Minto's journal are so instructive, was highlighted by the opinion of Sir Thomas Lawrence: Lawrence denied the alleged superiority of Thorvaldsen, yet praised his Alexander frieze – as Minto did – but asserted that the Dane had failed in female characters (which was Minto's opinion also).[6] Before long the poetess Margaret Sandbach would write of Thorvaldsen that

> Genius has raised a throne
> And bid him sit thereon.[7]

Minto would have taken issue with Flaxman's judgment, so soon afterwards to be delivered as a memorial oration for Canova: 'His figures are graceful, his forms grand, muscle, tendon or bone most naturally distinguished and the flesh seems yielding to the touch, by an execution as powerful as delicate.'[8] Beaumont, much Canova's partisan, might have had Minto in mind when he expressed displeasure at 'the nibbling witlings of would be critics & men of taste' who condemned his hero as meretricious.[9] It is interesting to note that it was a Scot, Gavin Hamilton, who had encouraged Canova at the very outset of his Roman years, and had directed him to a more profound understanding of the Antique; and that it was another Scot, Minto, who condemned him at the end of his life for failing to match the standards of the ancients.

Lord Minto first visited Canova's studio on 29 December 1821, early in his stay in Rome and once the 'dumb show and other mummery' of Christmas was over. It is clear that Canova was a spectacle to be visited as a matter of some priority: on the day in question, Minto (having earlier seen the Vatican and St Peter's, and having toured the Forum Romanum, the Colosseum and St John Lateran the previous day) allocated the next to the Pantheon and Canova's studio, 'where [he] was much pleased.' (NLS MS.11986, f.72v) On 2 January 1822 Minto began to place Canova in context, as it were, by making the round of the Roman studios (ff.76v–77). First he called on John Gibson in Via Fontanella. Gibson was, of course, Canova's protégé. He himself would comment on the freedom of exchange of ideas in the artistic community in the city at this time: 'In Rome all the studios are open to each other, every man sees another's works, and holds free communion with him, giving and receiving advice, and carrying on the labour of art by a combination of minds'.[10] Minto writes, describing a piece to be bought by Sir George Beaumont (and by him called 'one of the most beautiful groups I have seen'[11]): 'Gibson, a young man of talents who is modelling a group of Psyche borne by Zephyrs – very prettily conceived and well executed as far as it is done. The back is not very happy.' Minto visited four Italian sculptors: 'Barozzi' [Cincinnato Baruzzi, a Bolognese who finished Canova's statues after his death, and who made copies]; one Fabricci, who had modelled 'a good sleeping Cupid and a bad Psyche'; 'Tentanova' [Raimondo Trentanove, from Faenza, who worked on the plinth of Canova's statue of George Washington; see also cat. no. 17]; and [Carlo] Finelli, in whose workshop Minto saw 'a very pretty group Cupid and Psyche, but the marble sadly spotted. A repetition of the same in beautiful marble, the position of the female head higher, the muscles of the cupid's body softened, the whole more graceful, but something less of merit in parts of the right side. This is good work of the 2nd class.'[12]

After noting a visit to the studio of [Rudolf] Schadow, 'a Prussian artist of merit: some good things', Minto made his first contact with Thorvaldsen. He wrote: 'In talent and conception vastly superior to Canova or any modern artist. His basso Relievos the finest I have seen since the Elgin marbles. In his working of the surface of the marble equally inferiour to Canova. His male statues are fine, his females yield to Canova's...'. The next day Minto took his wife to Finelli's and again he went to Thorvaldsen, where he admired the bas-reliefs as much as he had done previously, 'although today I had first gone round the Gallery of the Vatican to familiarise myself to the fine works of ancient sculpture'.

On 7 January Minto visited both Thorvaldsen's and Canova's studios (ff.78–80). His interest seems to have been focused upon a version of the former's celebrated *Shepherd Boy*.

> In the morning I was at Torwalson's in hopes of obtaining his sitting shepherd, which is fractured by a fall, but it is sold. He told me that he was paid 3000 zequins, nearly £1500, for the fine statue of Poniatowsky [Jozef Poniatowski, for Warsaw] which he is to finish in marble in three years. It is a splendid work, one of the finest modern statues in existence. He told me that a sitting consular figure, but only of the natural size, with basse reliefs on the pedestal would cost about the same sum. I afterwards went to Canova's studio and am more than ever confirmed in my opinion of his great inferiority to Torwalson in every thing except the surface he gives his marble. Scarcely any one figure of Canova's is free from affectation, and few of them have either in attitude or countenance any natural expression. I looked round in vain for a bust I might be tempted to purchase till I came to one of Marcus Aurelius (a young man) which I found was an ancient work.
>
> Torwalson's compositions, on the contrary, are full of genious. The expression is natural & easy, and some of his best works if they received a last finish from Canova might approach the excellence of ancient sculpture. But Torwalson himself does little to the marble, and his statues are less than those of almost any other artist the actual work of the master; indeed they betray this too strongly. In conversing with Torwalson of the minute and imperceptible touches which I think must contribute much to the inimitable beauty of the old statues, he did not appear to think that any inequality of surface could be so slight as to escape our sight in proper lights. Yet my own impression remains, that in passing the hand over the dying gladiator [i.e. the *Dying Gaul* in the Capitoline Museum] I can perceive an undulation of surface expressing to the touch the presence of muscles &c which, being in a state of repose or deeply seated, could not without exaggeration be distinctly expressed to the eye. In many modern statues the contours of the parts are most delicately expressed with anatomical truth; but in passing my hand over them I feel nothing but what I can see. In an ancient statue every muscle which, in a state of exertion could be seen, is, when in rest, still expressed by, to the eye, an imperceptible undulation of surface; which, tho only to be detected by passing the hand over it, must add to the truth and effect of the figure.

Ten days later (NLS MS.11987, f.4) Minto returned to 'Torwalson's to make another attempt to buy his broken shepherd boy, but he assures me it is sold to a Monsr. Crouse at Vienna'. This must the version (one of the five known) bought by von Kraus and now in the Hermitage.[13] Minto moved on to see for a second time Gibson's *Zephyrs Raising Psyche to the Heavens*: 'It is a clever composition, and the male figures are generally good. But it has a good deal of the mannerism of his master Canova.'

The next recorded visit to the studios was on 7 February (ff.15–15v) when, in company with Samuel Rogers, Minto went to see Schadow's studio,[14] 'Tenerano' [Pietro Tenerani, who worked with both Canova and Thorvaldsen] who 'promises great things', and to Thorvaldsen's again, where he admired the statues of Christ and the Apostles for the Vor Frue Kirke in Copenhagen; 'his apostles very fine; and the figures that his scholars are doing from his designs for the pediment of the church.'

Minto subsequently viewed the ancient pedimental sculptures from the Temple of Aphaia on Aegina (ff.18v–19v). These had been heavily restored and arbitrarily grouped by Thorvaldsen.[15] Whereas Canova had declined to 'restore' the *Elgin Marbles*, declaring himself unfitted to the task, the less modest Dane had cut, smoothed, scoured and polished those bought for the Munich Glyptothek by Prince Ludwig.[16] The sculptures are transitional

work, on the frontiers of the Archaic and Classical periods: Minto makes comparisons with Etruscan and Egyptian art. The compositions illustrate the two sieges of Troy, each with Athena in the centre, the west front showing the Homeric siege and the east that by Herakles and Telamon. A small crude sketch by Minto appears to show the west pediment, as he illustrates the elaborate akroteria at the apex and angles (see fig. 65):

13 February ... Went with Torwalson to the Egina marbles, one of the most interesting and beautiful collections of Greek sculptures now in existence. These statues were the ornaments of a pediment. [sketch] They were offer'd to England for a small sum, 3 or £4000, but rejected as not worth having. The Prince of Bavaria gave £1000 more for them, and they have been restored by Torwalson in a manner worthy of the originals, of which Torwalson has preserved the style and spirit. Independently of their beauty these marbles are most curious as presenting some of the highest merits of the art whilst it yet retained a strong tinge of the ancient Etruscan or Egyptian (which ever one may call it) style from which it had recently emerged. The truth, life, spirit and action of these statues are unequalled. The faces are inferior to the rest of the work, which is of the very highest order in point of natural expression and composition and only left it to succeeding artists to make one stride further in the delicacy of the sculpture and even that perhaps at the expense of some of the spirit of their early school. They are much corroded but apparently have lost but little of their effect by the loss of their polished surface. Perhaps this may be owing to the strong style of the early sculpture, for the exquisite surface of the [Vatican] Antinous [i.e. the *Hermes*] has always struck me as one of its great beauties.

There follows a fascinating account of an inspection of the statues in the Vatican by torch-light (ff.28v–33). This is particularly interesting in view of arrangements made to light the sculptures in the Townley Gallery of the British Museum, by which it was said that 'the improved effect of the marble amounted ... almost to animation'[17], and because we know that Canova's practice was to give his statues the last touches by candlelight.[18]

I had always been a little sceptical with regard to the power of torchlight in bringing out the beauties of a fine statue, as it did not appear to me that the statues I had seen in lighted rooms at night gained very much. But in the Vatican, and with the concentrated light of one flambeau, the effect is quite marvellous. I have often maintained, with Torwalson, that in the finest ancient sculpture some of the shading was so delicate and minute as not to be detected by the eye and only to be perceived by

fig. 65 An opening from Lord Minto's *Journal*, MS 11987, ff.18 v–19., Edinburgh, National Library of Scotland

76

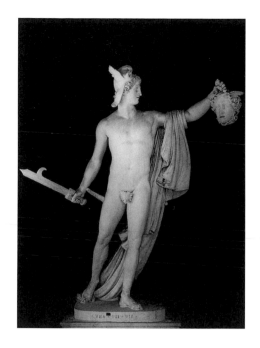 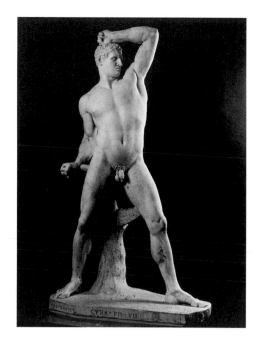 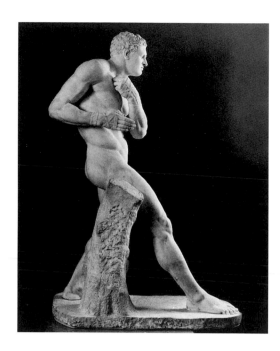

LEFT fig. 66 Antonio Canova, *Perseus Triumphant*, 1797–1801, marble, 235cm high, Vatican City, Musei Vaticani

CENTRE fig. 67 Antonio Canova, *Creugas*, 1797–1801, marble, 225cm high, Vatican City, Musei Vaticani

RIGHT fig. 68 Antonio Canova, *Damoxenos*, 1797–1806, marble, 215cm high, Vatican City, Musei Vaticani

passing the hand over it. He, on the contrary, always asserted that the most minute depression or elevation in the surface of the marble was easily detected by torchlight, and I am now satisfied that he is right.

The [Belvedere] Torso, which is the first we saw, is also that which gains the most by torchlight, as in addition to the beautiful display of form & muscle it acquires a fleshy appearance which gives it an air of life such as I never saw in any other work. That however which I should quote as the greatest proof of the effect of torchlight is the Laocoon. Seen by day, the unrivalled beauty of the composition and execution of this statue (the only unquestionable *chef d'oeuvre* of Greek sculpture that we know) affects everyone very powerfully. But it is at night only that we can really appreciate the grandeur, the variety and the expression of this miraculous work. The light thrown from above gives a shade to the eyes and mouth which in daylight is wanting to all statues, and by carrying the torch around we obtain a new expression of the profile which, as in the Laocoon, proves how carefully the ancients studied the perfection of their works so as to leave no weak side, and that they might be eminently beautiful under every possible aspect. By lowering the flambeau & throwing the light from below, altho the effect (as in nature) is bad, one completes the survey of the indefatigable care and minuteness with which the ancient artists finished their works. The Meleager, the Antinous or Mercury, and the Apollo [Belvedere] afforded us a very delightful illustration of the effect of a concentrated light. Perhaps the last, in general effect, gained less than it did in the exhibition of the beauty of the detail. The Jupiter's head [possibly the Jupiter of Otricoli in the Sala Rotonda of the Museo Pio-Clementino], some of the busts and the two sitting statues Menander & [blank in MS.] in the cabinet were also very fine.

I was very curious to see how Canova's three statues would endure a test which added so much to the charms of the fine works about them. The first thing that struck me on entering was the exceeding deadness and coldness of the marble, which looked more like plaister. I think that the affectation of the Perseus [fig. 66] was a little softened. But so far from gaining anything, neither that nor the boxers [the pugilists *Creugas* and *Damoxenos*, figs.67 and 68] displayed so much of the merit (such as it is) of the execution as they do by daylight, and they all showed very distinctly how far Canova (the most laborious and patient finisher of all modern artists) falls short of the unwearied minuteness of the old masters. This I did not expect; the defects of his style and composition were apparent at first sight, but I was not conscious how much less work he put in his statues. The truth is that Canova's excellence consists in the delicacy & softness with which he finishes the surface of his marble after the clay or plaister model. It is in the modelling that he fails even in the execution of the subject such as he has conceived it. It is in general only the greater contours that he exhibits; these are highly finished, but all the slight shading of anatomical detail is absolutely omitted, whilst in his male figures the details

that are given are offensively exaggerated, and from strained muscles and starting sinews the eyes suddenly drop upon a surface of round marble without a shade in it. Torchlight, which shows every touch, betrays the poverty of Canova's work, for in his three statues in the Vatican a Greek artist would only have seen the sketch of a subject in which the great muscles were left to be softened down, and in which the whole of the lesser detail remained to be supplied. Having been much delighted with the great progress of modern sculpture in Rome, I was sadly mortified to find how little the best living artists could bear the comparison with ordinary ancient sculpture, and how wide the interval by which they fall short of the models they profess to study.

There are indeed many obstacles in the way of modern sculpture. In the first place the artist is not familiarly acquainted with the forms he is to represent. The ancients, in the daily habit of seeing the naked body under every species of exertion or repose, became as familiarly acquainted with all the varieties of shape, attitude and action of the whole body as we are with that of the face alone, and the least deviation from the truth & nature in the limbs or trunk must have been as offensive to their feelings as a squint or an under jaw is to us. Passions & feelings have an appropriate expression in the body as in the face; they could read the expression of the muscles of the body, and of the limbs and of attitude, as well as that of the countenance; our experience is confined to the latter. Every man is by habit a physiognomist; but the moderns only know the human form as a study to which their attention is occasionally directed. This alone must continue to prevent the moderns from attaining the excellence of the old masters, and the absence of a public sufficiently familiar with the human form to reject everything that is not in perfect nature relieves the sculptor from the apprehension of very rigorous popular criticism. The labour, too, bestowed on the ancient works is so very much greater than anything our modern artists are accustomed to, that the price of a statue must be doubled in order to admit of it, and whilst the art depends on individual patronage, and not on the encouragement of public or national demands, the market is scarcely wide enough to ensure the application of a sufficient mass of first-rate talent to the art of sculpture.

Minto later (26 February: ff.33v–34v) recorded Thorvaldsen's disparagement of Canova, and joined this with his own criticism of Thorvaldsen.

I made a visit to Torwalson who promises that I shall find my shepherd in hand when I return from Naples.[19] He spoke very unreservedly (but with too much acrimony) of Canova. His criticisms were some of them very just and curious. I was amused by his calling him a 'grand maitre pour les defauts', and regretting the talents which gave currency to bad taste. The want of detail and truth in Canova's modelling he most particularly objected to & with great justice, for highly as he [Canova] glazes his surface the work is always meagre. He complained also, and I fancy not without justice, of Canova's quackery in setting off and obtaining puffs for his own works.

I remarked that no one ever saw his (Torwalson's) statues finished. His studio contained only what was in progress, and that most people thinking these his finished works complained that he neglected to give a fine surface to his statues, which was of great disservice to him. He said that the instant a statue was finished he put it into the case and forwarded it to the impatient owner whom he had no right to detain it from, but that he was aware of the injury he sustained by doing so.

I afterwards went to Canova's to look at the two nymphs [very probably the *Naiad* commissioned by the Earl of Darnley in 1818 and now in the Metropolitan Museum of Art, New York; and certainly the *Sleeping Nymph*, ordered by the Marquess of Lansdowne in 1820 and now in the Victoria and Albert Museum]. They are very good. Torwalson had joined before very liberally in my praise of them, but I think the expression of one of them a little affected, and there is something in the position of the shoulder of Lansdowne's which almost approaches to a deformity.

By mid-April 1822 the Minto family was in Naples. The Earl recorded (ff.67v–68) the recent discovery at Pompeii of statues displaying remains of their original polychrome decoration. He subsequently went to Portici 'to see Canova's colossal equestrian statues', namely the monuments to Charles III of Bourbon and Ferdinand I which stand today in the Piazza del Plebiscito in Naples. The horse of the former had been intended for a statue of Napoleon, but was later cast for a rather different ruler's commemoration. By the time of

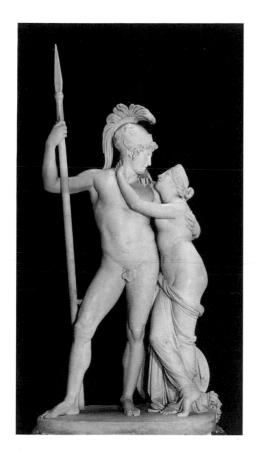

fig. 69 Antonio Canova, *Mars and Venus*, 1816–22, marble, 210cm high, London, Buckingham Palace, Her Majesty The Queen

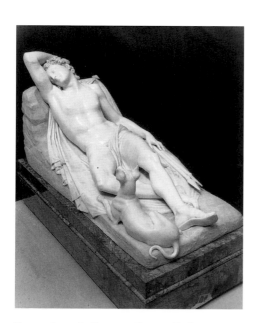

fig. 70 Antonio Canova, *Sleeping Endymion*, 1819–22, marble, 93cm high, 185cm wide, Chatsworth House, The Duke of Devonshire and the Chatsworth House Trust

Canova's death only the horse for the Ferdinand statue had been modelled by the master: the king's body was supplied subsequently by Antonio Calì. Minto's comments, including the observation that the horses are derived from antique models, are directly in contradistinction to the opinions of Isabella Albrizzi:[20] 'the horses', Minto wrote, 'are far from good, copied in many details from the antique with an exaggeration of bad shapes, the upright neck so un-natural as to give the animal more the appearance of a centaur than of a horse, the action incorrectly expressed, altho in one of them the hind legs if seen alone are very expressive of motion.' Canova went to Naples in May to oversee the preparation of the moulds.[21] Minto witnessed the preparations for the *cire-perdue* (lost-wax) casting, presumably in trials (f.69):

I was glad to see the process of founding on this great scale. The model is plaister. From this a plaister mould is taken; in that mould a wax cast is made which when put together represents the figure as it is to be in bronze. The inside of this wax cast is strongly supported by a framing of iron and wire, and the whole stands in a deep pit. The inside of the wax model is filled with sand, as is also the pit in which it stands; and the melted metal being poured in dissolves the wax and occupies its place between the two bodies of sand.

Back in Rome, Lord Minto became even more outspoken in his criticism of Canova, joining with this a thinly-veiled attack upon the taste of his British patron George IV, purchaser of the *Mars and Venus* group (fig. 69) – a theatrical allegory on peace and war, supposed to be symbolic of the end of the Napoleonic Wars (ff.74v–75). Nevertheless Minto isolated and freed from all opprobrium what he saw as the sculptor's true strength. His earlier, perhaps over-hasty criticism of the anatomy of the *Sleeping Nymph* appears to have been entirely set aside in the light of his more considered and admiring view of Canova's treatment of the female figure in repose. It is also interesting to note that Minto seems to have liked this work (as indeed he did the *Naiad*) in its unfinished state, with its surface more closely approximating to the less highly finished statues of Thorvaldsen.[22] In mentioning the extraordinary *Dying Magdalen*, bought by Lord Liverpool, Minto was so uncomplimentary in his diary that the comment has subsequently been so heavily scored out as to be totally illegible: we may suppose that it related to the evidently inappropriate sensuousness and eroticism of this 'religious' sculpture.[23]

I went to Canova's studio in order to ask about Lord Lansdowne's nymph, and was glad to find it in hand. It is a delightful statue & as well as the Endymion [fig. 70] intended for the Duke of Devonshire, quite free from the false graces & affection of Canova's usual style. It is the sleep in both of these subjects that has rescued these statues from the taint of French smirking & opera dancing that offends one in Canova's studio, and this should afford a hint to those who wish to order statues from him in the selection of their subjects: to avoid representing action or passion, and to seek subjects of repose in which no attempt to introduce an active or energetic expression can be made. Besides the fine statues of Endymion and the Sleeping Nymph, I saw the King of England's Mars & Venus finished, a vulgar and affected group which I have no doubt he will admire greatly. The marble is sadly spotted. And a Magdalen for Lord Liverpool … [rest deleted].

Minto proceeded that day to Thorvaldsen's studio and saw him 'preparing a new cast from which he might work my shepherd boy. His Christ and Apostles are in plaister and are great works.' On 25 April, on the eve of his departure from Rome, Minto was again with the sculptor (ff.76v–78).

The figures that his scholars are doing under his directions from his designs for the church at Copenhagen are many of them very good: much more highly finished than the nature of the building demanded, for they cannot be executed in a manner worthy of the designs of the models for want of funds, and will probably be roughly carved out of coarse marble or stone. They are in the models finished highly, even in the parts that touch the wall, but this is because they are studies for his pupils to exercise themselves on.

In Thorvaldsen's own house [in the Via Felice (Via Sistina)] Minto saw gessos of reworked

parts of his splendid frieze of *Alexander the Great Entering Babylon*, originally modelled in stucco in only three months in anticipation of a Napoleonic visit (1812), and installed in the Salone d'Onore of the Quirinal Palace. These comments, and Minto's description of the reworking, are of particular interest, for the revised posture of Alexander, noted by the Earl, was not incorporated in the marble versions of the frieze made for the Villa Carlotta at Tremezzo and for Christianborg Palace, Copenhagen. From 1822 Pietro Galli worked under the master's direction on a reduced version of the frieze.[24]

> I saw the center [sic] piece (on a reduced scale) – Alexr. in his chariot – very much alter'd and improved. This was the worst & the only very bad piece in the whole series and had always offended me as affected and unlike his style. He has now made this piece worthy of the rest, giving Alexander a firm and natural posture and looking back, Victory with both arms stretched forward to the reins and the chariot and wheels raised. He intends to go over the whole composition in the same manner, correcting its defects of which he sees many. He says that it was a hurried work originally, and that he was obliged to finish two palms in length every day, so that he only considers it as a sketch which he is now to improve. I went round it all with him, and was much pleased with his criticisms on it, which he gave as freely as if the work had been Canova's instead of his own. Some of the compartments satisfied him, and he praised them without scruple; others he found fault with as unreservedly, and pointed out many faults that had escaped my notice before – one horse in particular excited his wrath as perfectly unnatural & indeed its neck distorted in a manner such as he said no force could have effected. The improved series is to be in about ½ size of the original and he means to have it done in terra cotta.
>
> As soon as he has a new cast which is now in progress of my shepherd boy he will begin it in marble, and I have told him that I think of placing it for a time in Lansdowne's Gallery between Canova's two statues [the *Sleeping Nymph*, to which reference has already been made, and the Lansdowne version of the famous *Venus Italica*, acquired from Lucien Bonaparte in 1816], in order to excite him to do his best with it.

Minto's plan to exhibit his Thorvaldsen group beside Lord Lansdowne's new Canovas in the Marquess's Ball Room or Sculpture Gallery, interesting though it is as a scheme with the deliberate purpose of playing on the rivalry of the two great sculptors, may in fact have been rather more subtle. For Lansdowne House in Berkeley Square, London, contained one of the most celebrated collections of classical sculpture in Great Britain, most of the marbles having been supplied by Gavin Hamilton from his excavations of Hadrian's Villa at Tivoli.[25] By suggesting that three highly regarded works of the most admired of modern sculptors be displayed there, not only next to each other but in juxtaposition with so many excellent ancient marbles, Minto was evidently planning to illustrate in a striking way his view – so clearly set out in his Roman journal – of the dependence of the Moderns upon the Ancients, and of the triumph (in the vast majority of cases) of Antiquity in taste, conception, execution and truthfulness to nature.

Aidan Weston-Lewis

CATALOGUE OF EXHIBITS

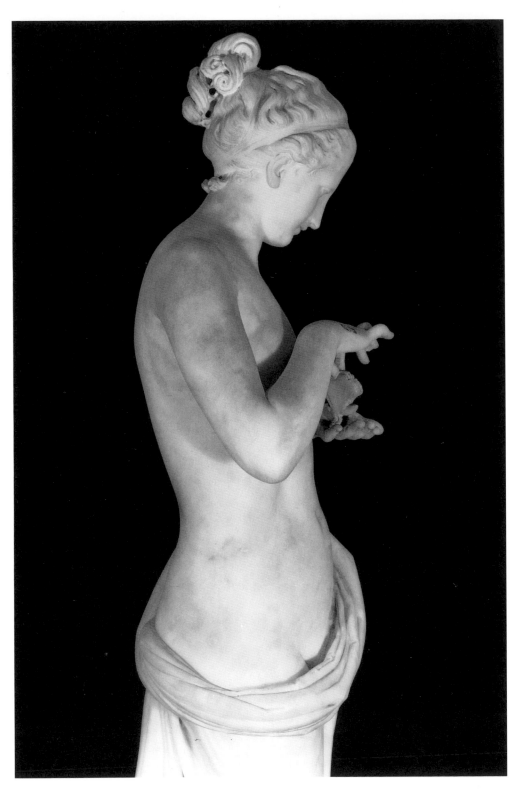

Detail of *Psyche* (cat. no. 20)

1

ANTONIO CANOVA

Sketch for the Standing Cupid and Psyche

Pencil on paper; stained
11.3 × 8.4cm max. (irregular)
Provenance: Presented to the museum by
Giovanni Battista Sartori Canova, 1851.
References: Bassi, 1959, p.145; Pavanello, 1976,
no.101; Venice, 1992, no.50.

BASSANO DEL GRAPPA,
MUSEO-BIBLIOTECA-ARCHIVIO
(INV.NO.EB.112.1123)

2

ANTONIO CANOVA

The Graces Dancing to the Music of Cupid

Tempera and lead white over black chalk, squared in
black chalk, on prepared canvas, 65.5 × 60.6cm
Provenance: Stecchini Collection; bequeathed to the
museum, 1849.
References: Bassi, 1959, p.279; Pavanello, 1976, no.D80;
Venice, 1992, no.100.

BASSANO DEL GRAPPA,
MUSEO-BIBLIOTECA-ARCHIVIO
(MONOCROMO NO. 13)

3

ANTONIO CANOVA

Study for the Painting of The Three Graces

Pencil on paper, 14.2 × 11.8cm
Provenance: Presented to the museum by Giovanni
Battista Sartori Canova, 1851.
References: Bassi, 1959, p.175; Pavanello, 1976,
no.D26; Venice, 1992, no.71; Rome, 1993, no.
LXXXXV.

BASSANO DEL GRAPPA,
MUSEO-BIBLIOTECA-ARCHIVIO
(INV. NO. EC.45.1244)

This is a preliminary sketch for the two-figure marble group of the standing *Cupid and Psyche*, the first version of which was commissioned in 1796 by John Campbell (see cat. no. 18) and is now in the Louvre. The figure of Psyche in this group is a close adaptation of the independent statue of her commissioned in 1789 by Henry Blundell (cat. no. 20). In the sketch exhibited here, Canova experiments with alternative ways in which to accomodate the adolescent Cupid to Psyche's predetermined pose. The resulting drawing anticipates to a surprising degree the arrangement adopted by Canova for *The Three Graces*, and may indeed have suggested his novel grouping of these figures.

This is one of a group of works generally dated to 1798–9 (but see Hugh Honour's essay, note no.54) – when Canova had retreated from Rome to his native Possagno – in which the artist portrays the Graces dancing in the presence of various mythological deities (Venus, Mars and Cupid). Particularly close to the monochrome exhibited here is a (coloured) tempera painting at Possagno, which features the same composition with the addition of a smoking sacrificial altar. In all of these representations Canova broke with tradition by showing all three Graces more or less frontally, linking arms, thus anticipating in one important respect the arrangement adopted over a decade later for the much more famous marble groups. Monochrome and tempera paintings such as this appear to have been painted for the artist's own personal pleasure and diversion, although that some, like the exhibited monochrome, are squared for transfer suggests that he had some larger scale work in mind.

See illustration on page 25

This drawing is a preparatory study for Canova's painting of this subject in the Casa Canova at Possagno (fig. 28). Signed and dated 1799, the painting provides a useful fixed point for Canova's interest in the Three Graces theme, although it was preceded by several other undated works in both plaster and tempera, together with their preparatory drawings (see figs. 25 and 26, and cat. no. 2). The only significant difference between the present drawing and the Possagno painting lies in the orientation of the Grace at the right. In the drawing she is shown in profile looking away from her sisters, whereas in the painting she is turned towards them, creating a more symmetrical and unified composition. A version of this drawing, with only minimal variations, is in the Biblioteca Reale, Turin (inv. no. 15983).

A reproductive print after the painting was published in 1813. An intermediary drawing by Giovan Battista Bonini was produced, on the basis of which the design was etched by Pietro Bonato and the plate then finished by the engraver Angelo Bertini.

See illustration on page 26

4

ANTONIO CANOVA

Two Sketches for The Three Graces *(one of them scarcely legible)*

Pencil on paper; sheet folded into four
19.5 × 12.5cm (whole sheet: 38.8 × 24.8cm; see comments below)
There are six other sketches of various subjects on the *recto* and *verso* of the same sheet (see figs. 71 and 72).
Provenance: Presented to the museum by Giovanni Battista Sartori Canova, 1851.
References: Bassi, 1959, p.274; Pavanello, 1976, pp.124–5; Venice, 1992, no.73.

BASSANO DEL GRAPPA, MUSEO-BIBLIOTECA-ARCHIVIO (INV. NO. F8.40.1762)

See illustration on page 26

5

ANTONIO CANOVA

Two Sketches for The Three Graces *(one of them very faint)*

Pencil on paper, 16 × 23.7cm
Numbered '65' at upper right
Provenance: Presented to the museum by Giovanni Battista Sartori Canova, 1851.
References: Bassi, 1959, p.231; Pavanello, 1976, pp.124–5; Venice, 1992, no.70.

BASSANO DEL GRAPPA, MUSEO-BIBLIOTECA-ARCHIVIO (INV. NO. F3.65.1574)

See illustration on page 27

6

ANTONIO CANOVA

Sketch for The Three Graces and a Seated Female Figure in Mourning

Pencil on paper, 12 × 19.1cm
Numbered '25' at upper right
The sheet bears the wax seal of Giovanni Battista Sartori, Canova's half-brother, and his inscription, dated 15 March 1851, declaring all the drawings in the sketchbook to be authentic works by Canova.
Provenance: Presented to the museum by Giovanni Battista Sartori Canova, 1851.
References: Bassi, 1959, p.244.

BASSANO DEL GRAPPA, MUSEO-BIBLIOTECA-ARCHIVIO (INV. NO. F5.26.1649)

[Exhibited in the form of a facsimile]

See illustration on page 27

7

ANTONIO CANOVA

Two Sketches for The Three Graces

Pencil on paper, 12 × 19.1cm
On the other side of this sheet there is a sketch of a standing, heavily draped female figure (F5.24.1647) and the inscription *'dall'antico sotto la Loggia dei Lanzi a Firenze'* and *'Tusnelda'*.
Provenance: Presented to the museum by Giovanni Battista Sartori Canova, 1851.
References: Bassi, 1959, p.244; Pavanello, 1976, pp.124–5; Venice, 1992, no.72.

BASSANO DEL GRAPPA, MUSEO-BIBLIOTECA-ARCHIVIO (INV. NO. F5.25.1648)

See illustration on page 27

8

ANTONIO CANOVA

Study for The Three Graces

Pencil on paper, 17.1 × 9.3cm
Provenance: From an album of 'contemporary' Venetian drawings given to the Gamba sisters in 1844 by a group of artists and friends in memory of their father Bartolommeo Gamba, who died in 1841; presented by them to the museum.
References: Bassi, 1959, no.61; Pavanello, 1976, pp.124–5; Venice, 1992, no.74; Los Angeles, 1993, no.89.

VENICE, MUSEO CORRER, BIBLIOTECA (INV. NO. A74.CL.III, 1798 BIS)

See illustration on page 31

9

ANTONIO CANOVA

Sketch for The Three Graces and a Detail Study for the Grace at the Right

Pencil on paper, 20 × 11.1cm
Provenance: From an album of 'contemporary' Venetian drawings given to the Gamba sisters in 1844 by a group of artists and friends in memory of their father Bartolommeo Gamba, who died in 1841; presented by them to the museum.
References: Bassi, 1957, no.60; Pavanello, 1976, pp.124–5; Venice, 1992, no. 75.

VENICE, MUSEO CORRER, BIBLIOTECA (INV. NO. A74.CL.III, 1797 BIS)

See illustration on page 32

These six drawings, one of which (cat. no. 6) could not be borrowed because it is stuck down in a sketchbook, can all be related directly to the evolution of the marble group of *The Three Graces*. They constitute a series of closely related variations on the arrangement of the three figures, each containing features adopted in the final sculpture, but displaying no clear progression of ideas or chronological order within themselves. The three sketches which present a back view of the right-hand Grace (cat. nos. 4 and 7) have much in common with the spirited first terracotta *bozzetto* for the group (see following entry). Other sketches which show all three sisters more-or-less frontally evidently took the 1799 composition (cat. no.2), or even the *Standing Cupid and Psyche* sketch (cat. no.1), as their point of departure. The two larger studies from the Museo Correr (cat. nos. 8 and 9) are less exploratory in character than the others and are likely to have been drawn immediately prior to the execution of the second, much more elaborate *bozzetto* from Lyon. The Graces in both of these drawings gaze somewhat spookily out at the viewer, an idea wisely abandoned during the modelling of the clay in favour of a much more subtle and introspective arrangement.

None of the six drawings is dated and Canova's manner of drawing remained too consistent to permit dating them on stylistic grounds alone. Were it not for one or two complicating factors, it would seem reasonable to place them all in 1812, between 11 June – the date of Josephine de Beauharnais' initial request to Canova for a sculpture of this subject – and 10 October, when Canova mentions what is probably the Lyon terracotta in a draft letter to Josephine (see Hugh Honour's essay, p.35). The complications arise from the fact that one sketch (cat. no. 4) is drawn on the same sheet as six other studies, at least some of which seem to date from the mid to late 1790s, while another drawing (cat. no. 5) comes from a sketchbook one leaf of which is dated 1806. So closely is one sketch (cat. no. 6) connected with the 1799 painting of *The Three Graces*, and especially the preparatory drawing for it (cat. no. 2), that it comes as some surprise to learn that it appears in a sketchbook probably used by Canova in the summer of 1812. The evidence of the preparatory drawings thus suggests that the design of Canova's full-length marble group of *The Three Graces* was both erratic and prolonged, possibly spanning some fifteen years.

From the surviving studies for *The Three Graces* one might be forgiven for concluding that Canova was interested largely or exclusively in the appearance of the group from the front. In fact he was greatly concerned that his free-standing statues should look well from all angles, but surprisingly seldom explored more than one viewpoint of a group in his preparatory drawings. He would nevertheless no doubt have approved of – perhaps even suggested – the Duke of Bedford's decision to mount his *Three Graces* on a plinth which could be rotated to permit comfortable viewing of the sculpture in all its finely calculated and varied aspects.

figs. 71 and 72 Antonio Canova, *Various Compositional and Figure Studies*, mid–1790s (?), pencil on paper, 38.8 × 24.8cm, Bassano del Grappa, Museo-Biblioteca-Archivio (*recto* and *verso* of the whole sheet which features cat. no. 4)

10

ANTONIO CANOVA

Model for The Three Graces

Terracotta, 36.2 × 16.5 × 14.7cm
Provenance: From the collection of the Florentine sculptors Fantacchiotti.
References: C. Del Bravo, '*Idee* del Canova', *Intersezioni*, VII, no.1, April 1987, pp.80–83; Venice, 1992, under no.94.

TURIN, GIANCARLO GALLINO

This recently rediscovered and never previously exhibited terracotta illustrates Canova's modelling of clay at its most spontaneous and spirited. Having explored this grouping of the three figures in several sketches (cat. nos. 4 and 7, especially the right-hand study on the latter sheet), Canova proceeded to test his solution in three dimensions, and then to preserve this model by having it fired. The forms are blocked out rapidly in the clay, with scant attention to surfaces and details, and much evidence of the use of fingers. It may have been the imbalance of the group – with the taller central figure dominating and one Grace clinging to her sisters as if in supplication – which led the sculptor subsequently to reject this arrangement. The view from the back would have been unsatisfactory too, with only two of the three Graces visible.

See illustrations on pp.29–30

11

ANTONIO CANOVA

Model for The Three Graces

Terracotta, 42.7 × 25 × 17cm
Inscribed on the base: *Idea / fatta a Frascati / in casa di M.d Tambroni 1812* (Idea executed at Frascati in the house of Mme Tambroni).
Provenance: Probably presented by the sculptor to Juliette Récamier; bequeathed by her to the museum in 1849.
References: Pavanello, 1976, p.121, no.234; Venice, 1992, no.94.

LYON, MUSÉE DES BEAUX-ARTS

In contrast to the earlier sketchy model, this second *bozzetto* for *The Three Graces*, complete with inscription, is one of Canova's most refined and fully resolved. Dated 1812, it was almost certainly modelled between June and September of that year (see Hugh Hounour's essay, pp.28–35). At least two of the preparatory studies exhibited here (cat. nos. 8 and 9) probably date from the period between the execution of the two *bozzetti*. Having experimented with other options for the Grace at the right (the figure that appears consistently to have given Canova most trouble), Canova in the end adapted the pose of Venus from a group of *Venus and Adonis* carved in the early 1790s. As part of the sculptor's progressive refinement of his composition, the second terracotta was itself modified in several respects during the execution of the full-scale model, most radically in the arrangement of the arms and drapery of the right-hand Grace. The small supporting column in the terracotta was substituted with a rectangular altar in the full-scale model, only to be reintroduced in the second version of the marble. It is possible that these changes were made in a third *bozzetto*, now lost, prior to the execution of the full-scale model (see cat. no. 16).

See illustrations on pp.33–4

12

ANTONIO CANOVA

The Three Graces

Marble, 173 × 97.2 × 75cm (maximum dimensions)
Provenance: The Temple of the Graces, Woburn
Abbey. Purchased jointly by the National Gallery of
Scotland and the Victoria & Albert Museum with
the aid of major contributions from the National
Heritage Memorial Fund, the National Art Collec-
tions Fund, John Paul Getty II, Baron Hans
Heinrich Thyssen-Bornemisza and public donations,
1994.
References: London, 1972, pp.207–8, no.322 (with
earlier references); Pavanello, 1976, p.125, no.272;
Licht and Finn, 1983, pp.203–11; Draper, 1985,
pp.1242–4; Washington, 1985, pp.541–2, no.480;
Venice, 1992, under no.135.

EDINBURGH, NATIONAL GALLERY OF SCOTLAND
AND LONDON, VICTORIA & ALBERT MUSEUM

When John Russell, 6th Duke of Bedford, arrived in
Rome in December 1814, work was in progress on the
first marble group of *The Three Graces* ordered by
Josephine de Beauharnais, and its final appearance
could be accurately gauged from the full-scale plaster
model visible in Canova's studio. The Duke was
much taken with the group, and after trying unsuc-
cessfully to steal the commission – Canova having as
yet received no down-payment for it – he wrote on 21
January 1815 formally requesting a second version,
with any variations left to the sculptor's discretion
(see cat. no. 14). The price of 6000 *zecchini* matched
that of the first group and the Duke, eager to take
possession of the work, proved much more forth-
coming in the payment of his three instalments than
did Josephine or Prince Eugène (the latter inherited
the commission after his mother's death in May
1814). Some progress on the second marble block had
been made before the Duke and Duchess left Rome
for England in June 1815, and by the end of 1817 the
group was declared finished. The sculpture had
begun its journey to England by August 1818, al-
though it did not arrive until the following May. It
was installed in the specially constructed Temple of
the Graces at Woburn Abbey in the summer of 1819.

The reproductive prints of *The Three Graces*
produced under Canova's supervision (figs. 46–48)
identify each of the sisters by name – Euphrosine at
the left, Aglaia in the middle and Thalia to the right
– apparently the only occasion in the history of the
group that they are distinguished in this way.
Whether it can be inferred from this that Canova
intended to imbue each Grace with particular
qualities or attributes is, however, doubtful, for it is
clear that what he strove above all to express was the
'close and indissoluble union of The Graces' (Hunt,
1822), not their diversity.

See illustrations on pp.46–59

13

JOSEPH NOLLEKENS 1737–1823

Bust of John Russell, 6th Duke of Bedford (1766–1839)

Marble, 71cm high (including socle)
Signed and dated on the back: 'Nollekens Ft. 1811'.
Provenance: Ordered from the sculptor by George,
Prince of Wales, and paid for in June 1811; inv. no.
RCIN 35413

HER MAJESTY THE QUEEN, WINDSOR CASTLE

Nollekens's great talents as a portraitist were recog-
nised by Francis, 5th Duke of Bedford, who commis-
sioned from him the celebrated and much repeated
bust of Charles James Fox (dated 1801, still at
Woburn Abbey). Following his premature death in
1802, his successor the 6th Duke immediately
ordered from Nollekens a bust of his late brother (fig.
55) and over the following two years he carved six
further portrait busts of close friends and political
associates of Fox, to be placed with the latter's
portrait in the Temple of Liberty at Woburn. When
the 6th Duke came to have his own portrait and that
of the Duchess carved, Nollekens was the obvious
choice.

The present bust is a slightly later autograph
replica of one at Woburn Abbey, signed and dated
1808, which was exhibited at the Royal Academy in
that year (no. 972). The commission was probably
occasioned by the Duke's appointment in 1806 as
Lord Lieutenant of Ireland, as part of Lord
Grenville's 'Ministry of all the Talents', 1806–7. The
bust exhibited here, signed and dated 1811, is one of
twelve by Nollekens of Whig politicians and military
leaders which George, Prince of Wales, acquired
between 1807 and 1816 and displayed at Carlton
House in London. Most of them, including that of
Francis, 5th Duke of Bedford, were repetitions of
earlier busts and were ordered and paid for by the
Prince himself. Nollekens's account for the 6th
Duke's bust, together with two others (both dated
1810) of Lord Grenville and Lord Moira, is dated 6
June 1811; he charged 120 guineas for each bust.
In 1828 the series of busts was moved to Windsor
Castle, where they remain, and Chantrey was called
in to advise on their arrangement. The piece of
marble between the bust and the socle bearing each
sitter's name was probably inserted at this time.

[I am grateful to John Kenworthy-Browne for his
help in compiling this entry].

See illustration on page 19

14

Letter from the 6th Duke of Bedford to Antonio Canova

Dated 21 January 1815, Rome
17.7 × 23.4cm

BASSANO DEL GRAPPA,
MUSEO-BIBLIOTECA-ARCHIVIO
(MANOSCRITTI CANOVIANI, 4.LXXXVIII.1/1105)

This is the earliest of fifteen surviving letters from the
Duke of Bedford to Canova, several of which contain
useful information regarding the progress of *The
Three Graces* project. The exhibited letter, written
when the Duke and Duchess were in Rome, opens
with the Duke's formal request to the sculptor to
carve him a version of *The Three Graces*, the full-size
model for which was visible in the studio and the first
marble version of which was underway.
For a transcription of the French text of the letter
and a translation, see the Appendix, p.99.

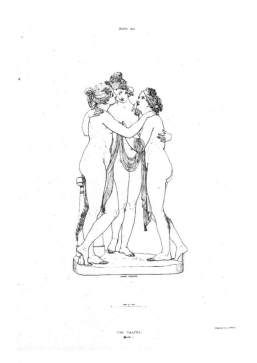

fig. 73 Henry Moses, *The Three Graces (after
Antonio Canova)*, engraving, from *Outline
Engravings and Descriptions of the Woburn Abbey
Marbles*, 1822

15

Outline Engravings and Descriptions of the Woburn Abbey Marbles

The engravings are by Henry Moses and George Corbould after drawings by Henry Corbould. The descriptions are by the Rev. Dr. Philip Hunt, with an appendix by Ugo Foscolo.
Folio volume, unpaginated.
Privately printed, London, 1822.

16

GEORGE HAYTER 1792–1871

Portrait of Antonio Canova

Oil on canvas
86.5 × 72.5cm
Provenance: Commissioned by John Russell, 6th Duke of Bedford; thence by descent at Woburn Abbey; sale, Christie's, London, 23 July 1954 (lot 140).
References: London, Morton Morris and Co., *An Exhibition of Drawings by Sir George Hayter and John Hayter,* 1982, pp.8, 43; M. Beal and J. Cornforth, *British Embassy, Paris: The House and its Works of Art,* 1992, pp.55–6.

This expensively produced catalogue of ancient and modern sculptures in his own collection was commissioned by the 6th Duke of Bedford and published in 1822, three years after *The Three Graces* were installed at Woburn. Canova's group is accorded two plates in the book, one viewed from the front, the other from behind (figs. 73 and 74). The exhibited copy, signed by the Duke, was presented by him to the Advocates Library in Edinburgh, and passed from there to the National Library.

For a full discussion of this publication, see the essays by Hugh Honour and John Kenworthy-Browne in this catalogue.

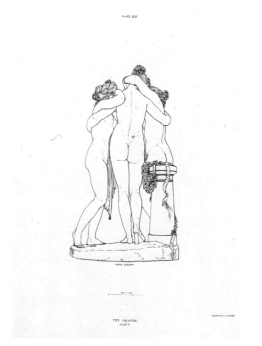

fig. 74 Henry Moses, *The Three Graces (after Antonio Canova),* engraving, from *Outline Engravings and Descriptions of the Woburn Abbey Marbles,* 1822

This portrait was commissioned from Hayter by the 6th Duke of Bedford and painted in Rome in 1817. The surprisingly youthful appearance of the sixty-year-old sculptor was helped, no doubt, by the black toupée which features in all portraits of him painted after 1810. Executed in a harmonious palette of warm golds and browns, Canova is shown holding the chisels of his trade. A terracotta model for *The Three Graces,* the Duke's marble version of which was then being carved in Canova's studio, is fittingly included in the right foreground of the portrait. This does not, as has been claimed, represent the *bozzetto* from Lyon exhibited here (which Canova apparently gave to Juliette Récamier in 1813), since the arrangement of the arms and drapery of the right-hand Grace corresponds to the marble versions rather than to the terracotta. It may conceivably record another, now lost, final *bozzetto* for the group; alternatively, Hayter may have derived it from the full-scale model or from one of the marble versions in the studio. Returning to the portrait, a monumental left foot on a base inscribed with Canova's name appears behind the terracotta, seemingly intended as an evocation of the colossal scale on which the sculptor frequently worked rather than a reference to a specific piece of sculpture.

It was at the urging of the Duke of Bedford that the young George Hayter, already a successful portrait miniaturist in London, embarked on a trip to Italy to perfect his art in the autumn of 1816. The Duke wrote on his behalf a letter of introduction to Canova (see Appendix, p.103) who, with his customary kindness towards young artists, welcomed him warmly and sponsored his admission to the Accademia di San Luca (of which he was President) as its youngest ever member. Hayter later expressed his gratitude by dedicating to Canova his etching (1820) after Titian's Frari *Assumption of the Virgin.* For his part, the Duke of Bedford bought unseen Hayter's first ambitious history painting, *The Tribute Money,* executed in Rome in 1817, and he was to

remain the artist's most devoted supporter and patron throughout the 1820s.

The Duke referred to Hayter's portrait in a letter to Canova of 4 May 1817, in which he requested a marble bust of the sculptor to accompany it since, he explained, 'the regard and esteem I entertain for you makes me feel that the likeness cannot be too often multiplied' (see Appendix, p.104). There is indeed a version of Canova's colossal *Self-Portrait* bust still at Woburn, although when it arrived has not been determined. Hayter's portrait had reached Woburn by the summer of 1818, since the Duke mentioned in his letter to Canova of 8 August that it pleased him greatly. Meanwhile Hayter had himself executed an etching of the portrait (it is signed 'GH 1817 Roma'); the artist's manuscript notes accompanying a collection of his etchings now in the British Museum record of this print: 'from a head which I painted in Rome, by desire of His Grace the Duke of B[edford]'.

See illustration on page 18

17

RAIMONDO TRENTANOVE

1792–1832

Copy of Antonio Canova's Self-Portrait

Marble, 58.5cm high (including socle)
Signed at the back: 'R. TRENTANOVE SCULPI. IN
ROMA'; inscribed on the truncation at the front:
'A. CANOVA'.
Provenance: Sale, Christie's, London, 23 October
1978 (lot 12).

LONDON, DANIEL KATZ LTD

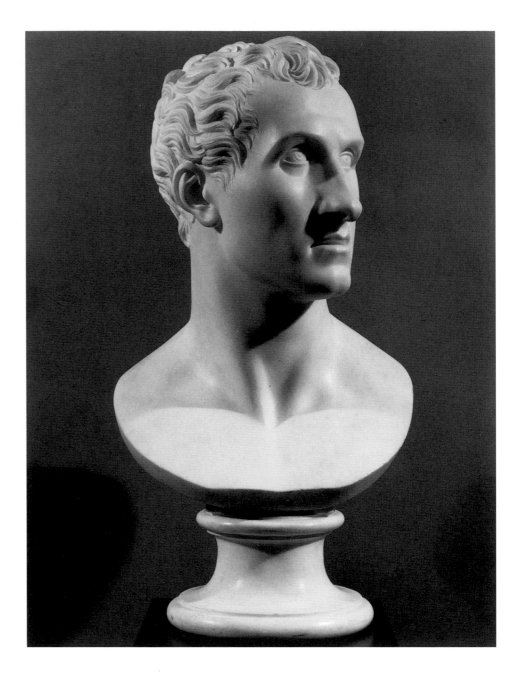

This bust is a version of Canova's *Self-Portrait* placed
by his tomb in the enormous Pantheon-like Tempio
which he had constructed at his own expense on the
hill above his native village of Possagno. That *Self-
Portrait*, probably the only fully autograph marble
version, is inscribed 'CANOVA SEIPSUM F/AN. MDCCCII',
although it was apparently not finished until the
following year, 1813. The artist portrayed himself over
life-size and in an idealised form reminiscent of some
imperial Roman portraits. Numerous plaster casts
were taken from this bust for distribution to the
sculptor's friends and patrons.

Replicas of the bust were much in demand:
witness, for example, the Duke of Bedford's request
for one (see Appendix, p.103), and the survival in the
Gipsoteca of a plaster cast applied with the characteris-
tic metal points used to facilitate the production of
accurate copies. Many marble versions of varying size
exist, some of them signed by sculptors who at one
time or another worked with Canova (in addition to
the present bust by Trentanove, there is one by
Cincinnato Baruzzi in the Capitoline Museum and
another by Rinaldo Rinaldi at Chatsworth). Although
faithful in its details, Trentanove's bust is considerably
smaller than the original in the Tempio and is there-
fore likely to be an accurate freehand copy, rather than
a measured replica based on the pointed model or a
cast of the marble. Another copy of Canova's *Self-
Portrait* bust by Trentanove is in the Galleria d'Arte
Moderna in Milan (inv. no. 489; 57cm high); it is
inscribed 'R. Trentanove fece, Roma 1817', which may
be the approximate date of the present bust.

A native of Faenza, Trentanove went to Rome in
1814 and was one of numerous budding sculptors
commissioned by Canova to carve artists' portraits for
the Pantheon. He was contracted, with Canova's
approval, to carve reliefs for the plinth of the *Monu-
ment to George Washington* (destroyed), but seems to
have remained largely independent, since he also
assisted Thorvaldsen on the execution of his version of
The Three Graces (fig. 49). Copies by Trentanove of
other works by Canova (including a *Vestal* at
Chatsworth and a version of *Pauline Borghese as Venus
Victorious* formerly at Stowe) were probably carved
after Canova died, and suggest that he had free access
to the gesso models left in the studio.

18

CHRISTOPHER HEWETSON

c.1739–1798

Bust of John Campbell, 1st Baron Cawdor (1755–1821)

Marble, 72cm high (including socle)
Inscribed: 'CHRISTOPHUS HEWETSON FECIT'
Provenance: By descent in the sitter's family at
Cawdor Castle, Nairn.
References: F. Russell, 'A Distinguished Generation:
The Cawdor Collection', *Country Life*, 14 June 1984,
pp.1746–8; B. de Breffny, 'Christopher Hewetson',
Irish Arts Review, Autumn 1986, cat. no. 3.

CAWDOR CASTLE,
THE DOWAGER COUNTESS CAWDOR

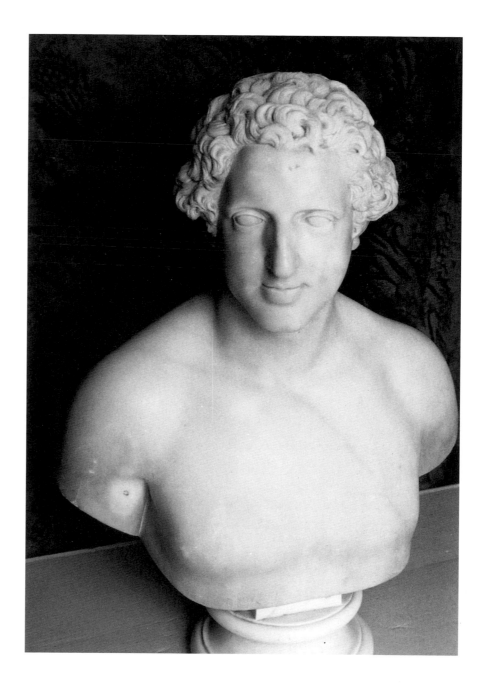

Emphatically neoclassical in its severity, this bust
was presumably carved during one of Campbell's
Italian trips (1784 and 1786–8), where Hewetson was
a permanent resident from 1765. The stylistic
similarity of this bust to Hewetson's bust of Thomas
Giffard, a friend of Campbell's, suggests that the
latter may have sat for his portrait in the same
year, 1784.

A keen collector of classical antiquities, including a
large group of so-called 'Etruscan' vases, Campbell
was equally generous in his patronage of contempo-
rary artists, among them Louis Ducros, Hugh
Douglas Hamilton and the Neapolitans Xaverio
della Gatta and Giovanni Battista Lusieri. The stars
of his collection were the magnificent antique *Lante
Vase*, now at Woburn Abbey, and Giovanni Bellini's
Doge Leonardo Loredan in the National Gallery in
London. That Campbell was forced to part with
both of these during his lifetime is indicative of his
financial recklessness in the pursuit of works of art.

Campbell's long-lasting friendship with, and
patronage of, Canova began in December 1786, and
he was the first to import a work by the sculptor into
Britain (see following entry). He was responsible for
commissioning the celebrated reclining *Cupid and
Psyche* (see fig. 1) and also the standing version of the
same couple, although Canova was prevailed upon
to cede these to Joachim Murat, Napoleon's
brother-in-law, rather than deliver them to
Campbell. Both are now in the Louvre. Undeterred,
Campbell, by then Lord Cawdor, agreed in 1811 to
buy a version of the *Hebe* begun for another client;
this was delivered in 1816, shown in that year at the
Royal Academy but sold soon after Cawdor's death
to the Duke of Devonshire for Chatsworth, where it
remains. Meanwhile, after the fall of Napoleon
Cawdor had returned to Rome and immediately
resumed his patronage of Canova, ordering early in
1815 a head of *Peace* (despatched to England in the
summer of 1816; present whereabouts unknown)
based on the statue carved for Nicolai Rumjancev
(see cat. no. 24); and also a *Reclining Nymph* (or
Naiad), a commission he agreed in December 1815
to cede to the Prince Regent (now in the Royal
Collection at Buckingham Palace).

19

Amorino

Marble, 141cm high
Provenance: Ordered from the sculptor in 1787 by
'Colonel' John Campbell, later 1st Baron Cawdor;
acquired by Thomas Pemberton (1793–1867), later
Baron Kingsdown, for Torry Hill, Kent; D. Leigh
Pemberton, Torry Hill; sold by him at Christie's, 22
July 1937 (lot 20), bought by the London dealer
Frank Partridge; Mr. and the Hon. Mrs. Basil
Ionides, Buxted Place, Sussex; Thomas Crowther
and Son, 1964; Lord Fairhaven, Anglesey Abbey,
1965; bequeathed by him to the National Trust.
References: London, 1972, pp.200–1, no. 309; H.
Honour, 'Gli Amorini del Canova', *Arte Illustrata*,
no. 55–56, 1973, pp.312–20; Pavanello, 1976, p.93,
no.33; H. Honour, 'Canova's *Amorini* for John
Campbell and John David La Touche', *Antologia di
Belle Arti (La Scultura: Studi in onore di Andrew S.
Ciechanowiecki)*, nuova serie, nos. 48–51, 1994,
pp.129–40.

THE NATIONAL TRUST, ANGLESEY ABBEY,
CAMBRIDGESHIRE

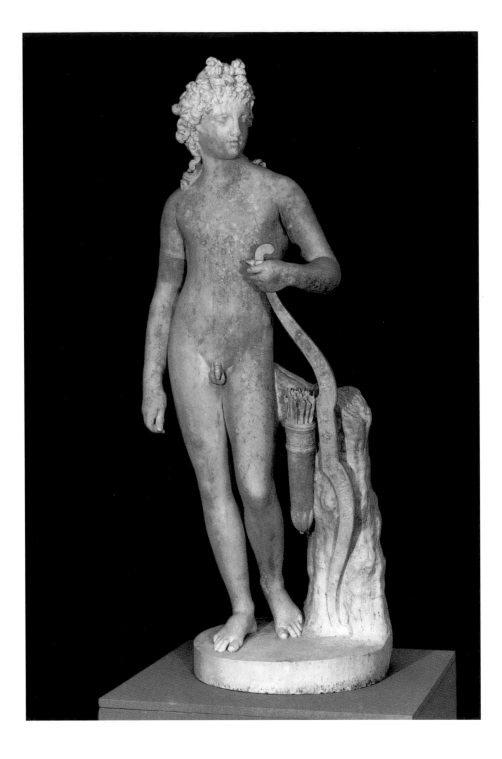

This statue of an adolescent Cupid is of considerable
interest as the first work by Canova to arrive in
Britain. Although much of the sculptor's exquisite
surface finish has been lost to the elements – the
Amorino having been displayed for long periods this
century outside as a garden statue – the graceful poise
of his design is still fully appreciable. It is the second
of five statues carved over a period of a dozen years
from a single full-scale *modello* executed in 1786, each
displaying considerable variations from the others. As
was customary with Canova, he considered each
version an improvement on the last.

It has long been assumed that the exhibited
Amorino from Anglesey Abbey is identical with the
version commissioned from Canova in 1787 by John
Campbell (for whom see previous entry), but only
recently has this been established beyond doubt. The
Amorino was not the first work ordered by Campbell
from Canova. In April 1787 the sculptor agreed to
carve for him a two-figure group, a project that was
eventually to produce one of his most celebrated
statues – the recumbent *Cupid and Psyche* now in the
Louvre. Only at the end of that same year (or possi-
bly early in 1788) did Campbell commission a version
of the *Amorino* then being carved for the Polish
princess Izabela Czartoriska Lubomirska (it remains
to this day in her Castle of Łańcut in Poland). This
first version of the statue is distinguished by the fact
that the head is a portrait of Izabela's young nephew
Henryk Lubomirski. For Campbell's version Canova
substituted a more appropriate wholly idealised head,
although the remainder of the figure followed the
earlier example closely. In April 1789 Canova wrote
to Campbell, by then back in England, informing
him that his *Amorino* was finished. There followed a
delay caused by complications over payment –
although the patron agreed readily to the price of 500
zecchini and added a further 100 as 'a little token of

my friendship' – but by the summer of 1790 the
statue had been despatched from Rome together with
its pedestal (which, like that adapted later for *The
Three Graces*, could be rotated). Canova also wrote to
Campbell advising him on how it could be displayed
and lit to best effect. Although the sculptor seems to
have had some reservations about the success of this
version of the *Amorino*, Campbell was fully satisfied
when it arrived in London in January 1791, and it was
greatly admired by his friends. Of all the *Amorini*
carved by Canova, it is the one most fully imbued
with the spirit of classical antiquity.

For the recently rediscovered third version of the
Amorino (Private Collection) executed in 1790–1 for
the Irishman John David La Touche, Canova again

radically revised the features and the hair, and
slightly adjusted the proportions of the torso and
limbs. The fourth version was almost finished in
the autumn of 1794, when the Russian prince
Nikolaj Jusupov (or Youssoupof) agreed to buy it.
This figure, now in the Hermitage, St Petersburg,
was endowed with the large wings which more
readily identify the subject as Cupid, an idea
originally proposed for Princess Lubomirska's
version but subsequently dropped. For the fifth
and final figure carved from this well-used model,
Canova modified the attributes to create a statue of
the young Apollo. It was bought speculatively by a
Parisian called Jullot (or Julliot) in 1798 and its
present whereabouts are unknown.

20

ANTONIO CANOVA

Psyche

Marble, 152 × 50 × 45cm
Provenance: Bought from the sculptor by Henry
Blundell and installed at Ince Blundell Hall, Lancashire;
by descent in the family to the present owner.
References: London, 1972, pp.202–3, no. 314; Pavanello,
1976, p.98, no.68; Honour (ed.), 1994, pp.251, 255, 257,
304, 400; London, 1994, p.443, no.291.

PRIVATE COLLECTION

The precise circumstances of the commission for this
statue of *Psyche* are unknown, but it features under the
year 1792 in a list of payments drawn up by Canova in
1795. This establishes that it was ordered by Henry
Blundell, an avid collector of antique statuary, who paid
Canova 600 *zecchini* for it and added a gift of drawing
instruments and 'other things', valued at over 100
zecchini. The manuscript biography of Canova written
in 1804–5 specifies that he modelled the figure of *Psyche*
for the '*cavaliere Enrico Blundell inglese*' in October
1790, and finished it in marble the following year. The
chronological catalogue of Canova's statues first pub-
lished in 1817 dates the work to 1789, possibly the year in
which it was commissioned, and describes it as 'a statue
of Psyche in marble, representing a fourteen year old
girl'. It was put on show briefly in London in 1793 before
being moved to the relative obscurity of Ince Blundell
Hall outside Liverpool, where it was catalogued along
with the rest of the collection by Blundell himself
in 1803.

 Although Blundell was in Rome between 1765 and
1772 buying antiquities in company with Charles
Townley, he is not known to have returned to Italy and
there is no surviving correspondence between him and
Canova. It has been suggested that John Thorpe, a
former Jesuit who acted as Blundell's agent for the
purchase of classical statues, may also have placed the
order for the *Psyche* on his behalf.

 The fable of Cupid and Psyche, recounted by
Apuleius in *The Golden Ass*, was an important source for
Canova's mythological statues dating from the 1780s and
1790s. In addition to the independent figures of Cupid
(four versions) and Psyche (two versions), he also carved
the celebrated groups of the young lovers together, one
recumbent (two versions; see fig. 1), the other standing
(two versions; see cat. no. 1). The meditative, intro-
spective mood of *Psyche* has encouraged Neoplatonic
interpretations of this figure, according to which she
personifies the soul (also symbolised by her attribute,
the butterfly) in search of desire (Cupid).

 The second version of the *Psyche* was carved in 1793–
4 as a gift for Canova's friend and early supporter
Girolamo Zulian (formerly Venetian ambassador to
Rome), although the latter died shortly before the statue
arrived in Venice. It was bought from his heirs by Count
Giuseppe Mangilli for 700 *zecchini* and is now in the
Kunsthalle in Bremen. In anticipation of the statue's
arrival, Zulian had arranged, by way of payment, for a
gold medal representing *Psyche* on one side and
Canova's portrait on the other to be struck in Rome and
presented to the sculptor.

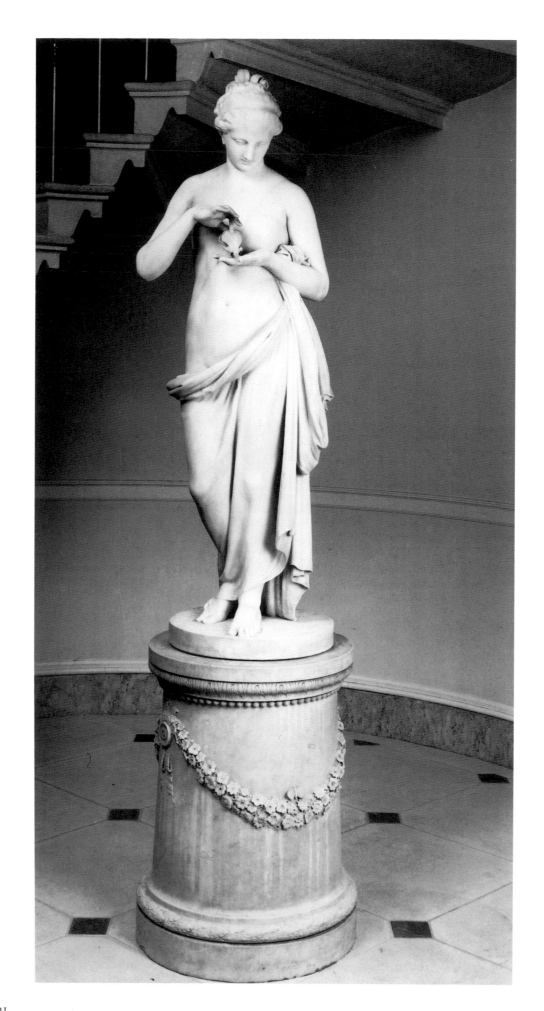

21

Studies of Heads and a Sketch of Four Full-Length Figures

Pencil on paper, 23 × 16.7cm
Inscribed in ink: 'Questa pagina è tolta dal libretto di Memorie di Antonio Canova / da me posseduto, e fu da me offerta all' incomparabile Mme. Eynard – / Roma 12. Marzo 1831 – Lav.o de M. Spada'.
Provenance: Domenico Manera, called Meneghetto (cousin and sometime assistant of Canova; d.1825); Cincinnato Baruzzi (1790–1878); given by him to Monsignor Lavinio de' Medici Spada, 21 April 1830; given by him to Mme Eynard, Rome 12 March 1831; sale, Sotheby's, London, 3 July 1989 (lot 126); Private Collection, London. Purchased 1995 by the Patrons of the National Galleries of Scotland.

EDINBURGH, NATIONAL GALLERY OF
SCOTLAND (INV. NO. D5391)

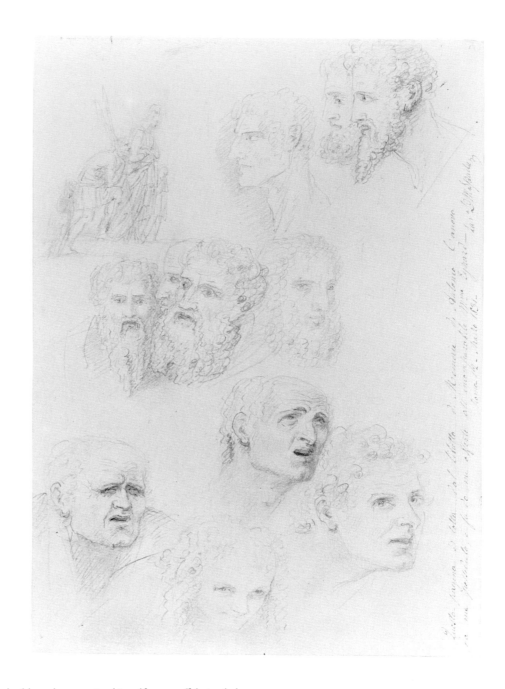

This is one of the few drawings by Canova owned by a public collection outside Italy. From the inscription it can be deduced that it once formed part of the Canova sketchbook now in the Biblioteca Comunale at Cagli in the Marche; inscriptions in the sketch-book itself spell out its earlier provenance (see Ost, 1970, pp.43–4). The doodles of heads which cover most of the sheet – the four at the bottom evidently studies in expression reminiscent of Le Brun's *Passions* – recur on several other sheets by the artist (such as Bassano, Museo-Biblioteca-Archivio, no. F–6–5–1654, and folios 30, 35 and 39 of the Cagli sketchbook).

The most interesting feature of the drawing, and one which allows it to be dated to the late 1790s, is the little sketch of four full-length figures, which relates to Canova's *Monument to the Archduchess Maria Christina of Austria* in the Augustinerkirche in Vienna. This monument, one of Canova's most original creations, consists of a cortège of over life-size mourning figures approaching and entering a dark doorway set in a huge pyramidal tomb, with additional allegorical figures in attendance. The design was adapted from an abandoned project to raise a grand monument to Titian in the church of S. Maria dei Frari in Venice, for which several models survive. The *Monument to Maria Christina* was commissioned in August 1798 (when Canova was in Vienna) by the Archduke Albert von Sachsen-Teschen to commemorate his recently deceased wife. Later that year and in 1799 designs were submitted for the Archduke's approval, who suggested a few minor changes. The full-scale model, now in the Gipsoteca at Possagno (fig. 75), was completed by the summer of 1800 and the marble figures based on it early in 1805. Canova himself went to Vienna that summer to supervise the installation of the monu-ment, which was consecrated in October.

The figures represented in the sketch on this sheet correspond to the group approaching the tomb from the left, to be identified as a blind man, bent almost double and supporting himself on a staff, being led forward by a personification of Beneficence (or Pity). The two children visible in the sketch were reduced in the monument, and in the model for it, to one. A large group of preparatory drawings for the monu-ment survives at the Museo Civico in Bassano, and others are in Vienna (Albertina), Forlì (Biblioteca Antonio Saffi) and Venice (Museo Correr). One of the sheets (fol. 39) of the Cagli sketchbook mentioned above combines, like the present drawing, sketches of heads with a study for the Vienna monument. A fragmentary clay *bozzetto* for the two principal figures visible in our sketch is preserved in the Museo Correr.

Another sheet of head studies detached from the Cagli sketchbook and bearing a similar inscription was sold at Finarte, Milan, 14 November 1990 (lot 35).

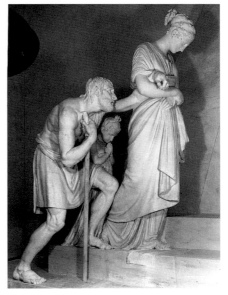

fig. 75 Antonio Canova, *Full-Scale Model for the Monument to Maria Christina* (detail), 1799–1800, plaster, 585cm high, Possagno, Gipsoteca Canoviana

22

ANTONIO CANOVA

Bust of Letizia Ramolino Bonaparte (Madame Mère)

Marble, 48 × 30.5 × 26.5cm
Provenance: Bought from Canova's studio by
William Cavendish, 6th Duke of Devonshire, in late
1822 or 1823; thence by descent.
References: Missirini, 1824, p.223; D'Este, 1864,
p.345; Pavanello, 1976, p.110, no.146.

THE DUKE OF DEVONSHIRE AND THE
CHATSWORTH HOUSE TRUST

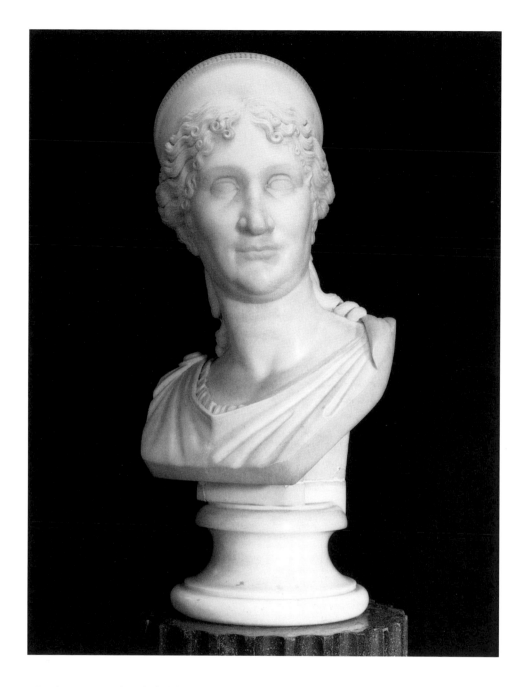

This bust corresponds closely to the head of Madame
Mère (mother of Napoleon) in the full-length seated
portrait of her, also at Chatsworth (fig. 13). The latter
was commissioned by the sitter when she was in
Rome between March and November 1804, and her
portrait was evidently modelled by Canova at that
time. The present bust was presumably carved either
from this model (or rather, as was Canova's practice,
from a plaster cast of it), or from a cast taken from
the full-length marble portrait (just such a cast, plus
another of the head alone, survives in the Gipsoteca
at Possagno). The most noticeable difference be-
tween the bust and the full-length is that in the
former the eyes are blank, whereas in the latter the
irises are lightly incised. (Canova's conception of the
full-length portrait may have been influenced by a
painted portrait of her (*c.*1802–4) by François, Baron
Gérard, known in several versions, one of which was
acquired by the National Gallery of Scotland in 1988.
Canova had met Gérard on his visit to Paris in 1802.)

Although its quality is high, a slight question-
mark remains over the fully autograph status of the
bust, given that it was acquired by the Duke of
Devonshire from the studio after Canova's death.
Many works left in Canova's studio were finished for
sale by assistants, but since Cicognara mentions the
Duke's purchase of the bust in a book published in
1823, there is a good chance that it had been finished
by Canova himself. Missirini (1824) states that the
Bust of Madame Mère was carved specifically for the
Duke of Devonshire, while Antonio d'Este, who as
Canova's studio manager was in an ideal position to
be well informed on such matters, also accepted it as
autograph. That plaster casts and at least two other
marble versions of this bust are recorded adds weight
to this argument. Furthermore, the Duke of Devon-
shire was by that date the proud owner of numerous
masterpieces from Canova's own hand and would
surely have been a good judge of what was or was not
an authentic work.

Shortly after he purchased this bust, the 6th Duke

met Madame Mère, who rebuked him for having
bought from the French (in 1818) the full-length
statue of her. He wrote to a relative in 1824: 'I am
growing particular with Madame Mère. She scolds
long and loud about the statue which she says they
had no right to sell nor I to buy. It is being copied
now for Jerome [Bonaparte], and it is interesting for
me to see how very like the old lady it is. She has a
very stately walk and her whole appearance is miracu-
lous for a woman of 80' (see The Duchess of Devon-
shire, *Treasures of Chatsworth: A Private View*,
London, 1991, pp.80–1).

Canova's relationship with Napoleon and various
members of his family was an ambivalent one. He
deplored the Emperor's appalling treatment of the
Pope and his removal of many of Italy's greatest art
treasures to Paris (he was appointed to negotiate their
return after Napoleon's downfall). On the other
hand, the Bonaparte clan was the sculptor's most
important patron for a period of a dozen years or

more, and he developed cordial relations with many
of its members, including Napoleon himself. It was
the Emperor's first wife, we remember, who commis-
sioned the first version of *The Three Graces*.

23

ANTONIO CANOVA

Model for Maria Luisa as Concord

Terracotta, 39 × 20 × 23cm
Provenance: Presented by the sculptor to Miss Mary Berry, probably in 1820 or 1821; bequeathed by her to George Howard, 7th Earl of Carlisle, 1853; by descent at Castle Howard.
References: J. Clifford, 'Miss Berry and Canova: a Singular Relationship' (forthcoming).

THE CASTLE HOWARD COLLECTION, YORKSHIRE

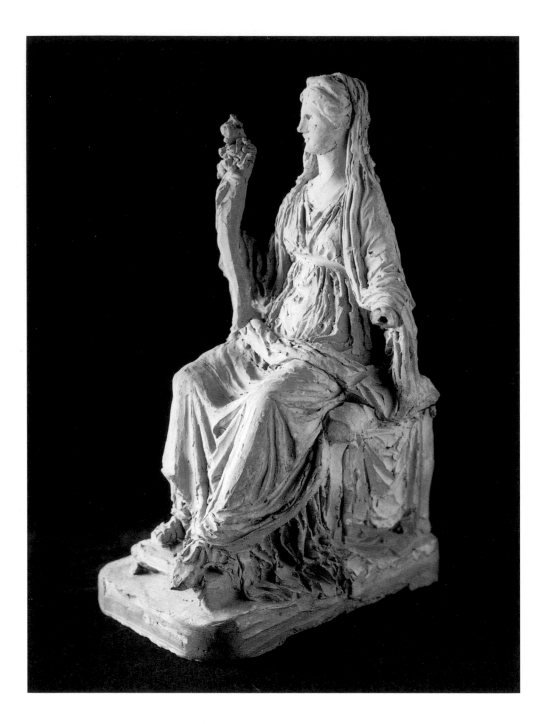

This previously unpublished terracotta is an initial idea for Canova's statue of Maria Luisa Habsburg, second wife of Napoleon, in the guise of Concord, which is now in the Galleria Nazionale in Parma. The basic form of the sculpture – with an imposing female figure enthroned and holding attributes – reflects antique Roman prototypes, such as the Capitoline *Agrippina* (although in another context Canova strenuously denied any direct dependence on this figure). The immediate precedents in Canova's own work were the full-length seated portrait of *Madame Mère* at Chatsworth (1805–7; fig. 13) and a projected statue of Elisa Baciocchi Bonaparte, Grand-Duchess of Tuscany, as Concord, ordered in 1809 (Canova having appropriated the latter concept for Maria Luisa's statue, he subsequently came to an agreement with Elisa Baciocchi that she should be represented instead as the muse Polymnia).

It has been suggested that one of the antique sources drawn upon by Canova for this composition was a Pompeiian wall-painting representing Ceres, and this may explain the prominent inclusion of a cornucopia in the terracotta (an attribute more usually associated with representations of plenty or summer, or more generally as one of the benefits of good government). The long ceremonial staff which Maria Luisa holds in the final marble was derived instead from ancient coins, although the cornucopia was retained in the form of decorative reliefs on Maria Luisa's throne. The missing left hand in the *bozzetto* may, of course, once have held the saucer-like patera which appears in the finished work.

The present *modellino* was followed by a much more highly finished plaster one (Possagno, Gipsoteca) which corresponds in all but minor details to the final marble. Two further *bozzetti* at Possagno representing seated female figures are more difficult to link with certainty to one or other of Canova's projects of this type. The more interesting of these in the context of the present exhibition consists of a figure very close in pose to *Madame Mère* (with the right leg rather than the left extended and the left arm resting in relaxed fashion over the back of the chair) but with three

naked female figures, arms linked around their shoulders, standing behind. Sometimes – for obvious reasons – identified as the Graces, the latter must at any rate have been meant to personify some positive quality such as harmony, friendship or concord.

The statue of *Maria Luisa as Concord* was commissioned in October 1810 when Canova was in Paris at the invitation of Napoleon. He modelled the Empress's portrait in clay at Fontainebleau between 13 and 27 October. It was highly praised for its veracity, of which Canova was especially proud since there had been no formal sittings (he had studied his subject while she amused herself playing billiards). Adapted as the design was from a project already worked out for another sitter, progress on the commission was unusually swift. The full-scale

modello was ready by June 1811 and the marble well advanced by the end of that year. It was finished before January 1814 when Canova wrote asking for payment, but was finally delivered to Maria Luisa, by then Duchess of Parma, only in the spring of 1817.

[I am grateful to Jane Clifford for her help in compiling this and the following entry].

See also illustration on p.17

24

ANTONIO CANOVA

Model for a Figure of Peace *(Pax)*

Terracotta, 40 × 17 × 14cm
Provenance: Presented by the sculptor to Miss Mary
Berry, probably in 1820 or 1821; bequeathed by her to
George Howard, 7th Earl of Carlisle, 1853; by descent
at Castle Howard.
References: J. Clifford, 'Miss Berry and Canova:
a Singular Relationship' (forthcoming).

THE CASTLE HOWARD COLLECTION,
YORKSHIRE

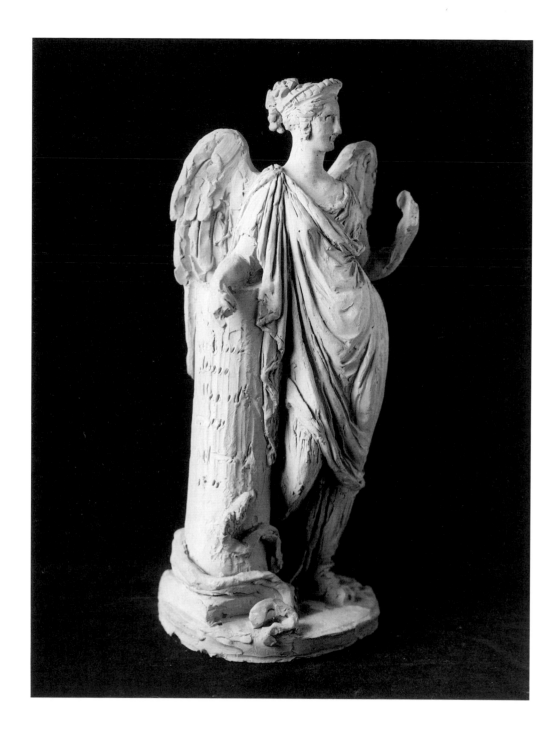

In 1811 the Russian chancellor Count Nicolai
Rumjancev (Romanzow) commissioned from
Canova an allegorical figure representing *Peace*.
The original full-scale plaster model in the
Gipsoteca at Possagno is inscribed 'Finita in 7bre
1812' (finished in September 1812). The marble
figure was completed by August 1814 (when
Canova wrote to Quatremère de Quincy to that
effect) and arrived in St Petersburg in 1816. It is
now in the National Museum in Kiev, Ukraine.
Apparently taking an antique Claudian medal as
a point of departure, Canova conceived his
allegory of *Peace* as a generously draped winged
female figure, coronet on her head, long staff in
her left hand, and resting her right hand on a
truncated column. On the column's surface is an
inscription celebrating a series of peace treaties
concluded by the Russians (legible in the final
marble but merely indicated in a summary
shorthand in the terracotta), while around its
base is coiled a vanquished serpent. A caduceus,
emblem of peace, also appears in relief on the
column in the final statue, although there is no
sign of this in the exhibited *bozzetto*. In her right
hand the figure holds a sprig of olive (again
absent in the terracotta).

The exhibited model is the smallest and most
loosely worked – and therefore probably the
earliest – of three closely related *bozzetti* for the
figure. The other two, both modelled in gesso
(plaster) and one of them headless, are in the
Gipsoteca at Possagno. Unlike the exhibited
bozzetto, the last of these to be executed shows
Peace treading the serpent under her right foot,
as in the final marble, but otherwise the changes
are insignificant. Quite why Canova felt it
necessary to make three *modellini* displaying very
little in the way of variations from one to the
next is something of a puzzle, since he would
normally have made such minor adjustments
while executing the full-size clay model for the
statue.

Canova had been thinking about carving a
figure of *Peace* since 1805, and an unfired clay
bozzetto at Possagno may represent an early idea
for this project. It shows a partly draped female

figure in a relaxed pose leaning on a square column
or altar from which a quiver and shield are sus-
pended, at rest.

The present terracotta, like the *Maria Luisa as
Concord* (previous entry) and a third representing a
Dancer (now lost), was given by Canova to the
Englishwoman Mary Berry, whom the sculptor had
first met (with her sister Agnes) in Rome in 1784.
They renewed their acquaintance in 1815 and devel-
oped a particularly warm and touching friendship
during Canova's final years. Very seldom did he agree
to part with his working terracotta models.

See also illustration on p.17

25

ANTONIO CANOVA

Bust of Laura

Marble, 43 × 25.5 × 21.5cm
Provenance: Purchased from the sculptor in 1819 by
William Cavendish, 6th Duke of Devonshire; thence
by descent at Chatsworth.
References: London, 1972, p.211, no.326; Pavanello,
1976, p.127, no.291.

THE DUKE OF DEVONSHIRE AND THE
CHATSWORTH HOUSE TRUST

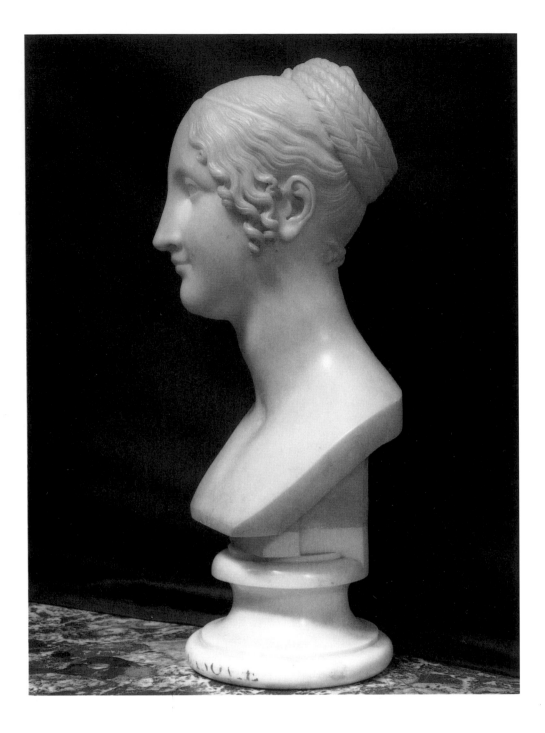

Canova completed this bust, together with one
of *Beatrice* (which he gave to his friend Leopoldo
Cicognara) early in 1818 and it was bought by the
6th Duke of Devonshire the following year. The
Duke later recalled that it took much persuasion
on the part of the Duchess before Canova
conceded to part with it.

During the last decade or so of his life
Canova carved a series of ideal busts and heads,
working on them particularly during the sum-
mer months when the ageing sculptor found the
demands of large scale projects too taxing. He
drew the subjects of his busts from classical
mythology (especially the Muses) and Italian
literature (as here, from Petrarch), but the
specific identity of his figures was of secondary
importance to the sculptor: he frequently
referred to them simply as 'ideal heads' or 'ideal
busts'. Although many of these were sold or
given away as presents, they were seldom carved
to commission and as a group are among his
most personal works, allowing an unfettered
expression of his highest aesthetic ideals.

26

ANTONIO CANOVA

Venus ('The Hope Venus')

Marble, 180 × 52 × 57cm
Provenance: Purchased from the sculptor in 1820 by
Thomas Hope and installed in his London house in
1822; sold at The Deepdene, July-August 1917, sale
no. 90 (lot 268); bought by Colonel (later Lord)
Brotherton; bequeathed by him to his niece
Mrs. D. U. McGrigor Phillips; presented by her to
the Leeds City Art Gallery, 1959.
References: London, 1972, pp.211–2, no.327;
H. Honour, 'Canova's Statues of Venus', *Burlington
Magazine*, cxiv, 1972, pp.658–70; Pavanello, 1976,
p.129, no.309; D. Lewis, 'The Clark Copy of Antonio
Canova's *Hope Venus*' in Washington, Corcoran
Gallery of Art, *The William A. Clark Collection*,
exhibition catalogue, 1978, pp.105–115.

LEEDS CITY ART GALLERIES

In the appendix added in 1819 to the chronological
catalogue of Canova's sculptures first published as a
pamphlet two years previously, there appears under
the year 1818 the following entry: 'New model of
another Venus, different from that existing in the
royal imperial Pitti Palace, to be executed for Signor
Tommaso Hope inglese'. This was Thomas Hope,
the well known writer, collector and designer of
interiors, furniture and decorative arts, whose
London house much impressed Canova during his
visit to England in 1815. The statue referred to in the
Pitti Palace is Canova's celebrated *Venus Italica*,
which had been moved there from the Tribuna of the
Uffizi following the return of the antique *Medici
Venus* from Paris in 1816.

The enormous popularity of the *Venus Italica*,
completed in 1811, had led to a flood of commissions
for replicas and versions of it. One such order was
placed in 1815 or 1816 by an otherwise unknown Mr.
Standish, but Thomas Hope, in Rome between
December 1816 and April 1817 and already well
acquainted with Canova, persuaded the sculptor to
divert the commission to him. Then, writing to
Hope on 13 January 1819, Canova offered to carve
him a new statue of Venus as a substitute for the
version of the *Venus Italica* he had ordered, specify-
ing that work on the marble was already well ad-
vanced. Hope accepted, the statue was finished by
June 1820 and the price of 2000 *zecchini* paid
promptly. It was presumably with the intention of
making casts and putting it on view in his studio that
Canova asked Hope's permission to delay the
despatch of his Venus until the following spring. In
the event it arrived in London only in January 1822
but Hope was delighted, judging it better – 'more
precious and more highly finished' – than the Venus
he had previously been so eager to acquire. Canova's
Venus was given pride of place in Hope's house in
Duchess Street, 'occupying the central point of a
rather long perspective, … isolated and turning on its
pedestal, and illuminated by a fine daylight (for
London) from somewhat high up and with a rich
drapery behind to bring out her white contours and
delicate reflections'.

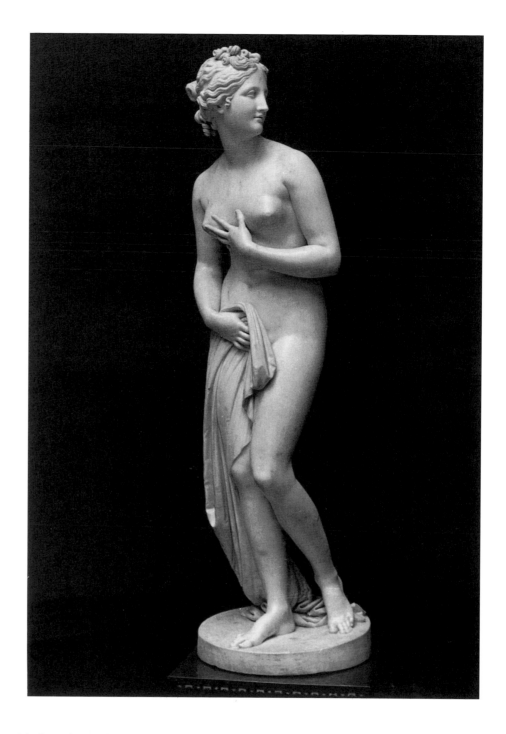

The basic design of the *Hope Venus* can be traced
back through the *Venus Italica* to a commission
Canova received in December 1802 from the
Florentine authorities to carve a copy of the *Medici
Venus* removed by Napoleon to Paris (a task which
he accepted with some reluctance and never ful-
filled). The *Hope Venus* is the sole marble carved
from the plaster model executed in 1818, which
survives in the Gipsoteca at Possagno.

In 1821 Canova, through the agency of the
Scottish sculptor Thomas Campbell, offered the
Trustees' Academy in Edinburgh a plaster cast of one
of his sculptures. The Academy gratefully accepted
the offer but left the choice to Canova himself. At the
same time they asked Campbell to order, at their
expense, six additional casts of other works by
Canova, together with a cast of his *Self-Portrait* bust.

In December 1821 Canova wrote to inform the
Academy that he had chosen to give them a cast of
his most recent Venus – the *Hope Venus* – and that
Campbell was arranging for its transport to Edin-
burgh. The Board of Trustees' order for other casts
was subsequently modified, on Campbell's advice, to
include many after the Antique and one after
Thorvaldsen, although the additional casts after
Canova were limited to the *Self-Portrait* (Informa-
tion from the minutes of the meetings of the Board
of Manufactures preserved in the Scottish Record
Office, Edinburgh). The cast of the *Hope Venus*
certainly arrived safely in Edinburgh, for it features
in nineteenth-century catalogues of the Academy's
cast collection; it was transferred with most of the
cast collection to the Edinburgh College of Art in
1904 and cannot now be traced.

APPENDIX

The following letters from the Duke and Duchess of Bedford to Canova are published by kind permission of the Direction of the Museum, Library and Archive of the city of Bassano del Grappa. Punctuation and the use of capital letters have been regularised. Phrases given in SMALL CAPITALS are the subject of explanatory notes in the right margin. For an explanation of the abbreviation BCBC, see p.109

1

Monsieur

Comme M. le Prince EUGENE DE BEAUHARNAIS s'est decidé a prendre votre inimitable statue des trois Graces, je suis enchanté que vous consentrez a faire pour moi un grouppe dans le même genre, car je vous avoue franchement que je n'ai rien vu en sculpture, ni ancienne ni moderne, qui m'a fait plus de plaisir que ce bel ouvrage. Je me trouverais heureux d'être en quelque sorte le moyen de faire immortalizer le nom de Canova en Angleterre, autant qu'il l'est deja sur la Continent de l'Europe, et j'ose me flatter que vous pourriez vous même etre le porteur de votre ouvrage en Angleterre l'année prochaine et de placer selon votre propre gout 'chez moi', ou je serois enchanté de vous recevoir, et de vous assurer de vive voix de l'estime tres parfaite avec la quelle je vous prie de me croire,

> Monsieur
> Votre tres humble et tres obeissant serviteur
> Bedford.

Je laisse les variations dans le grouppe et dans les figures des trois Graces, entierement à votre jugement, mais j'éspere que *la vrais Grace*, qui distingue si particulèrement cet ouvrage, sera entierement conservée.

A Rome ce 21 Janvier 1815.

BCBC 1105

[Monsieur / Since M. le Prince Eugene de Beauharnais has decided to take your inimitable statue of the three Graces, I am delighted that you agree to make a group of the same genre for me, since I frankly declare that I have seen nothing in ancient or modern sculpture that has given me more pleasure than this beautiful work. I will be happy to be in some way the means to immortalise the name of Canova in England as much as it already is on the continent of Europe; and I dare to flatter myself that you might yourself bring your work to England next year and place it according to your own taste in my home, where I will be delighted to receive you, and to assure you in person of the very special esteem with which I beg you to believe me, / Monsieur, / Your most humble and obediant servant / Bedford. / I leave the variations in the group and in the figures of the three *Graces* entirely to your judgement but I hope that *the true Grace*, which so distinguishes this work, will be completely preserved. / Rome 21st January 1815]

2

A Rome ce 30 Mars
Monsieur

Ma niece LADY JANE MONTAGU a bien envie de voir votre belle STATUE DE LA PRINCESSE BORGHESE, et comme vous avez le projet d'y introduire MILADY WESTMORLAND demain, permettez qu'elle l'accompagne.

Si c'est possible d'obtenir la permission du transport des bas reliefs que j'ai acheté de M. CAMUCCINI, je voudrai les faire encaisser avant mon départ pour Naples.

> Je suis avec estime
> votre très humble serviteur
> Bedford.

BCBC 2116

EUGENE DE BEAUHARNAIS *Eugène-Rose de Beauharnais (1781–1824), son of Alexandre, vicomte de Beauharnais and Marie-Joseph-Rose Tascher de la Pagerie (1763–1814), subsequently to marry Napoleon Bonaparte in 1796, be styled Empress Josephine 1804 and divorced 1810. He joined the army of the French Republic in 1797 as aide-de-camp to General Hoche and then to his step-father Napoleon under whom he served in the Egyptian campaign. He was promoted to the rank of general in 1804 and the following year nominated Viceroy of Italy, married Augusta Amalia, daughter of Maximilian, Elector (later first king) of Bavaria, and in 1806 was officially adopted by Napoleon as his successor. After Napoleon's first abdication in 1814, he vainly attempted to assume the role of king of Italy. In 1815 he settled in Bavaria where his father-in-law gave him the title of Duke of Leuchtenberg.*

LADY JANE MONTAGU *Daughter of the 5th Duke of Manchester, who was married to the sister of the Duchess of Bedford. After her death in Rome aged 20, in September 1815, Ingres made a series of drawings for her tomb, calling her 'une jeune demoiselle de Bettfort' (H. Naef,* Die Bildszeichmungen von J.-A.-D. Ingres, *Berne, 1978, vol. II, p.5).*

STATUE DE LA PRINCESSE BORGHESE *Canova's statue of Pauline Bonaparte, Princess Borghese, as Venus Victorious (Galleria Borghese, Rome). On account of the partial nudity of the figure it could be seen only with authorisation from Prince Borghese, who seems nevertheless to have allowed Canova to show it to his friends.*

MILADY WESTMORLAND *Jane Saunders (d.1857) wife of John, 10th Earl of Westmorland. From 1815 she lived apart from her husband in Rome where she was a leading member of the British community.*

M. CAMUCCINI *Pietro Camuccini (1761–1833), a painter who was also, from the late eighteenth century and more prominently from 1815, a dealer in works of art. The reliefs to which the Duke of Bedford referred were presumably those from ancient Roman sarcophagi now in the sculpture gallery at Woburn (E. Angelicoussis, 1992, cat. nos. 62, 64–67, 69).*

[Rome, 30th March / Monsieur / My niece Lady Jane Montagu is most desirous to see your beautiful statue of the Princess Borghese, and since you plan to show it to Milady Westmorland tomorrow, kindly allow her to accompany you. / If it is possible to obtain permission to transport some bas reliefs that I have bought from M. Camuccini, I would like to have them packed prior to my departure for Naples. / I am with regards / your very humble servant / Bedford.]

3

A Monsieur
Monsieur le Chevalier Canova
<u>Bedford</u>

'*To the most Noble* GEORGIANA DUCHESS OF BEDFORD': voila Monsieur la forme d'une dédicasse à une Duchesse en Angleterre, ce qui sera en français, *A la plus noble Georgine Duchesse de Bedford*, vous la saurois mieux rendre en Italien que moi.

J'espere que vous aurois la bonté de me dire la somme que vous permettrais de vous payer en avance pour la groupe des trois Graces, afin que je puis m'acquitter de cette dette envers vous avant de quitter l'Italie. J'attendrais avec une vive impatience le moment de l'arrivée de morceu interessant en Angleterre, ce qui me procurera aussi j'espere le double avantage de vous récevoir chez moi.

Agréez l'assurance des sentimens très sinceres que vous m'avez inspiré, non seulement d'estime pour vos grands talents, mais d'amitié pour votre personne. A mon retour à Rome j'espere avoir le plaisir de vous assurer de vive voix que j'ai l'honneur d'être

votre très obeissant serviteur.
Bedford.

A Rome ce 4 Avril 1815.

BCBC 1107

[A Monsieur / Monsieur le Chevalier Canova / <u>Bedford</u> / *To the most Noble Georgiana Duchess of Bedford*: here, Monsieur, is the form of a dedication to a Duchess in England, which would be in French, *A la plus noble Georgine Duchesse de Bedford*; you would know better than I how to render it in Italian. / I hope that you will be good enough to tell me the sum which you will permit me to pay you in advance for the group of the three Graces, in order that I can discharge this debt to you before leaving Italy. I will await with great impatience the moment of arrival of this interesting piece in England, which will bring with it, I hope, the double benefit of receiving you at my home. / Be assured of the most sincere feelings which you have inspired in me, not only of admiration for your great talents, but of friendship for your person. On my return to Rome I hope to have the pleasure of assuring you in person that I have the honour to be / your most obediant servant / Bedford. / Rome 4th April 1815]

GEORGIANA DUCHESS OF BEDFORD *Lady Georgiana Gordon (1780–1853), daughter of the 4th Duke of Gordon. When visiting Paris with her mother in 1802 she met and became enamoured of Eugène de Beauharnais, but the obstacles to their marriage could not be overcome. In 1803 she married the 6th Duke of Bedford whose first wife had died in 1801. The 'dedication' was that to be inscribed on a print of Canova's* Dancer with her Hands on her Hips *(carved for the Empress Josephine) which he had commissioned Pietro Fontana to engrave after a drawing by Giovanni Tognoli.*

4

A Monsieur
Monsieur le Chevalier Canova
<u>Bedford</u>

Monsieur

Je vous envoie un billet sur mon baquier pour le permier paiement de la groupe des trois graces et j'aurais le plaisir de vous transmettre un second paiement apres mon arrivé en Angleterre. J'etois charmé de voir le progrés que vous avez deja fait et le beau bloc de marbre que vous avez été assez heureux de trouver pour cet interessant ouvrage.

J'espere toujours que vous viendrez le placer vous même chez moi. J'ai le projet de faire batir expres un temple dans mon jardin que je nommerais le Temple des Graces, mais je voudrais avoir votre avis la dessus avant que de le commencer.

Mille remerciemens pour les ESTAMPES que vous avez eux la bonté d'envoyer à la Duchesse et à moi.

Croyez toujours aux sentimens d'estime avec lesquels j'ai l'honneur d'etre

Votre très obeissant serviteur
Bedford.

A Rome ce 4 Juin 1815
Voici mon addresse à Londres
Duke of Bedford
Hamilton Place
London

BCBC 1109

ESTAMPES *Presumably examples of the print dedicated to the Duchess (see previous letter). But Canova may have given the Bedfords prints of some of his other works as well. and if so these would surely have included the recently published engravings of* The Three Graces *(figs. 46–8). A collection of prints after works by Canova was to be hung in the corridor leading to the sculpture gallery at Woburn.*

[A Monsieur / Monsieur le Chevalier Canova / <u>Bedford</u> / Monsieur / I am sending you a bankers draft for the first payment for the group of the three Graces and it will be my pleasure to send you the second payment after my arrival in England. I was delighted to see the progress you have already made and the beautiful block of marble which you have been fortunate enough to find for this interesting work. / I am still hoping that you will come in person to my house to instal it. I am planning to have a temple built in my garden specially, which I will call the Temple of the Graces, but I would like to have your views on it before beginning. / Many thanks for the prints which you so kindly sent to the Duchess and me. / Believe, as always, the feelings of admiration with which I have the honour to be / Your very obediant servant / Bedford. / Rome, 4th June 1815 / Here is my address in London / Duke of Bedford / Hamilton Place / London]

5

A Monsieur
Monsiour le Chevalier Canova
Brunet's Hotel
Leicester Square
Bedford
Hamilton Place No.2
ce 3 Novembre 1815

Dites moi je vous prie mon cher Canova, comment je pourrais vous être utile à Londres. Si vous pourriez venir chez moi à 1 heure cet apres midi, je vous accompagnerrai à l'atelier de mon ami M. Westmacott, qui sera charmé de vous servir dans toutes les manieres possibles pendant votre sejour à Londres … Si vous avez envie de voir nos spectacles et vous voulez me faire le plaisir de diner chez moi à 5 heures, je vous amenerais.

J'espere tres sincerement que vous avez ressenti nul inconvenient, ni de votre voyage, ni de notre climat ingrat. Donnez moi de vos nouvelles et croyez aux sentimens d'estime avec les quels, j'ai l'honneur d'etre votre très obeissant serviteur

Bedford.

BCBC 2113

[A Monsieur / Monsieur le Chevalier Canova / Brunet's Hotel / Leicester Square / <u>Bedford</u> / Hamilton Place No.2 / 3rd November 1815 / Tell me, I pray you, my dear Canova, how I can be of service to you in London. If you would like to come to my house at one o'clock this afternoon, I will accompany you to the workshop of my friend Mr Westmacott, who would be delighted to be of service to you in any way possible during your stay in London. If you would like to see our sights and you will give me the pleasure of dining with me at 5 o'clock, I will conduct you. / I sincerely hope that you have experienced nothing inconvenient on your voyage, nor from our inclement climate. Give me your news and be assured of the feelings of admiration with which I have the honour of being your most obedient servant / Bedford.]

6

à Woburn Abbey
ce 12 Nov. 1815

Nous vous attendons ici mon cher Chevalier avec vive impatience, et je crains beaucoup que vous quitterois l'Angleterre sans venir me voir. Dans une saison si avancée il-y-a peu de choses ici dignes de votre attention et pour la beauté de nos campagnes il faut la prendre a credit dans le triste mois de Novembre, mais je serais toujours charmé de vous recevoir chez moi et de vous assurer de vive voix de mon amitié et tres sincere attachement

Bedford.

Ecrivez moi un petit mot par la poste, addressé a Woburn Abbey pour me dire quand je dois vous attendre, ainsi que M. votre frere.

BCBC 2115

[Woburn Abbey / 12th November 1815 / We are awaiting you here, my dear Chevalier, with great impatience, and I very much fear that you will leave England without coming to see me. At such an advanced season there is little here worthy of your attention; and as for the beauty of our countryside, one must give it the benefit of the doubt during the sad month of November. But I would still be delighted to receive you here and to assure you in person of my friendship and of my very sincere devotion / Bedford. / Send me a few words by post, addressed to Woburn Abbey, to let me know when I should expect you, together with your brother.]

Canova was to visit Woburn on 21 November.

Brunet's Hotel *One of the several hotels in Leicester Square patronised by foreign visitors since the mid-eighteenth century. The French actor Talma was to stay at Brunet's in 1817.*

M. Westmacott *The sculptor Richard Westmacott (1775–1856), who had made the acquaintance of Canova while studying in Rome 1793–6.*

M. votre frere *Giovanni Battista Sartori (1775–1858), Canova's half-brother, the son of his mother Angela and her second husband Francesco Sartori. He was educated at the seminary in Padua where he received minor orders 1795 and subsequently styled himself abate. From 1800 he was Canova's secretary and inseparable companion.*

7

Woburn Abbey 26 Novembre 1815

La Duchessa di Bedford non saprebbe formare un augurio piu cordiale ne esprimere con maggior piacere che desiderando un buon viaggio al Cavalier Canova. Il tempo e la lontananza non alteranno mai l'amicizia che la Duchessa ha per lui, e sarà ben contenta ogni volta che potrà dargliene delle prove.

La Duchessa di Bedford in questa occasione prega il Sig.r Canova d'incaricarsi all'acclusa lettera.

BCBC 2114

[Woburn Abbey 26th November 1815 / The Duchess of Bedford is at a loss how to fashion a more heartfelt farewell or to express it with greater feeling than to wish the Cavaliere a safe journey. Time and distance will never change the friendship which the Duchess feels for him, and she will be more than happy to be able on any occasion to give him proof of it. / The Duchess of Bedford takes this opportunity to ask Sig. Canova to take with him the enclosed letter.]

8

à Tavistock 29 7bre 1816

Monsieur,

J'ai reçu avec un plaisir très vif la lettre que vous avez eu la bonté de m'écrire au sujet de la grouppe des trois Graces, et je suis charmé de savoir qu'elle est si avancée et que vous êtes content de la qualité du marbre, qui pourtant n'est qu'une consideration sécondaire dans un ouvrage des mains de Canova. Le petit temple qui est destiné a recevoir ces trois beautés rares sera achevé j'espere dans le mois de juillet ou d'août 1817, et j'espere que vous n'oublierez pas votre engagement de venir vous même placer vos Graces à Woburn. Votre reputation a eté très connue en Angleterre avant que vous avait fait l'honneur de venir parmi nous; mais en nous quittant, vous avez laissé un souvenir de l'amabilité et de la douceur de vos moeurs qui ne s'effacera jamais. Tout le monde qui a eu l'avantage de vous voir ici parle avec enthousiasme de Canova. Je vous offre mes felicitations sur la honorable dignité que le Saint Pere vous a accordé; mais le MARQUIS D'ISTRIA n' effacera jamais le nom de Canova. J'espere revoir le venerable Rome un de ces jours avec tous les monumens d'art restituées à leur place legitime.

LE FILS DE LORD CAWDOR vient d'épouser ma niece, une jeune personne très interessante. Faites moi la grace de l'accueillir avec bonté. Ils sont partis pour l'Italie. Vous verrez aussi cet hiver, LORD ET LADY JERSEY et LORD ET LADY LANSDOWNE, mes parents et mes amis. M. IRVINE a entrepris de me récueillir quelques bons bustes des anciens, voudrez vous bien lui donner vos conseils la dessus. Je vous envoie un ordre pour le second paiement de 2000 séchins que M. SCULTHEIS vous payera en presentant ce billet. Ma femme me charge de vous offrir ses complimens ainsi qu' à votre frère M. l'Abbé que je prie d'agréer mes respects. J'ai l'honneur d'être votre très devoué serviteur

Bedford.

BCBC 1332

[Tavistock 29th September 1816 / Monsieur, / I have received with enormous pleasure the letter which you had the kindness to write to me on the subject of the group of the three Graces, and I am delighted to know that it is so far forward and that you are happy with the quality of the marble; which, however, is no more than a secondary consideration in a work from the hand of Canova. The little temple which is destined to receive these three rare beauties will, I hope, be finished during the month of July or August 1817, and I hope that you will not forget your undertaking to come in person to place your Graces at Woburn. Your reputation had been very high in England before you did us the honour of coming amongst us; but on leaving us you have left a memory of the kindness and of the gentleness of your manners which will never be erased. Everyone who had the fortune to see you here speaks with enthusiasm about Canova. I offer you my congratulations on the distinguished honour that the Holy Father has granted you; but the Marquis of Istria will never extinguish the name of Canova. I hope one of these days to see venerable Rome again with all her art treasures restored to their legitimate places. / Lord Cawdor's son has just married my niece, a most interesting young woman. Do me the honour of welcoming her kindly. They have left for Italy. This winter you will also see Lord and Lady Jersey and Lord and Lady Lansdowne, my relations and my friends. Mr Irvine has undertaken to gather together for me some good antique busts; would you kindly give him your advice about this. I am sending you an order for the second payment of 2000 zecchini, which M. Scultheis will pay you on the presentation of this draft. My wife asks me to send you her regards as well as to your brother the Abbé, to whom I also convey my respects. I have the honour of being your very devoted servant / Bedford.]

MARQUIS D'ISTRIA *The title, Marchese d'Ischia, that Pius VII conferred on Canova in 1816 in recognition of his success in securing the return to Rome of works of art removed by the French.*

LE FILS DE LORD CAWDOR *John Frederick Campbell (1790–1860), who was to succeed his father as Baron Cawdor in 1821. He had just married Lady Elizabeth Thynne, daughter of the 2nd Marquess of Bath and Isabella Byng, who was a sister of the first wife of the 6th Duke of Bedford.*

LORD ET LADY JERSEY *George Child Villiers (1773–1859), 5th Earl of Jersey, and his wife Lady Sarah Sophia Fane (d.1867), daughter of the 10th Earl of Westmorland. In 1815 Lady Jersey had invited Canova to spend a day with her visiting Osterley Park, Chiswick, Syon House etc. (BCBC 3516).*

LORD ET LADY LANSDOWNE *Henry Petty Fitzmaurice (1780–1863), 3rd Marquess of Lansdowne, and his wife Lady Louisa Emma Fox-Strangways (d.1851). Canova had met Lord Lansdowne and seen his collection of antique sculpture in London in 1815. On his visit to Rome in 1816 Lord Lansdowne bought from Lucien Bonaparte a statue of* Venus *by Canova (now in the Hearst San Simeon State Historical Monument, California) and he was later to acquire Canova's unfinished statue of a* Sleeping Nymph *(now in the Victoria & Albert Museum, London).*

MR IRVINE *James Irvine, Scottish painter and art-dealer resident in Rome from 1780. He obtained a number of antique sculptures for the Duke of Bedford (see Angelicoussis, 1992).*

M. SCULTHEIS *A Roman banker whose name is otherwise rendered Schultheis, allied by marriage with the family of the more widely known banker Giovanni Torlonia.*

9

Permettez moi Monsieur de supplier vos bontés et vos attentions pour M. George Hayter, un jeune artiste (peintre) de ce pays ci, qui va voyager en Italie pour se perfectionner dans son art.

Je vous ai ecrit dernierement par M. Hamilton au sujet de la grouppe des trois Graces et je vous renouvelle en cette occasion les assurances de mon estime.

<div align="right">Bedford.</div>

A Tavistock ce 1 8bre 1816

BCBC 1108

[Allow me, Monsieur, to beg your kindness and your solicitations for Mr George Hayter, a young artist (painter) from here, who is travelling to Italy to perfect his art. / I wrote to you previously via Mr Hamilton on the subject of the group of the three Graces and I take this opportunity to renew assurances of my admiration. / Bedford. / Tavistock 1st October 1816]

10

<div align="center">

Italy
Al Signor Cavaliere Antonio
Canova, Marchese d'Ischia
Roma
Bedford
Woburn Abbey
March 3 1817

</div>

My dear Sir

As the two years which you asked to complete my group of the three Graces are now expired, I will continue to flatter myself that it will not be long before this interesting work is completed, and I promise myself much pleasure in seeing it place in the temple which I am building for its reception, and which I hope will be quite finished in six or eight months from this time. I hope you mean to keep your promise of coming to place it yourself in the temple, for I assure you it will give to both the Duchess and myself the greatest pleasure to see you once more in England and in a season of the year when you will be more able to enjoy the beauties of the country.

I remember seeing in your studio at Roma A BUST OF YOU which I believe was done by one of your artists. I am very anxious to have a copy of this bust, and to have it sent to England with the group of the Graces.

The Duchess regrets very much that she has not yet been able to attend to your recommendation of M.DME CAMPORESE, as she has been very ill, and confined to her room for the last three months. She begs her best wishes and regards to be made acceptable to you.

I make no apologies for writing to you in English, because I know you understand our language so perfectly.

<div align="right">

I have the honour to be
with greatest regard and esteem
your very faithful and obedient servant
Bedford.

</div>

PS: We have an idea in this country, that you use some preparation to colour your marble and give a mellow tone to your sculptural works; but you will excuse me for saying that I should prefer to see the group of the Graces in the genuine lustre of the pure Carrara marble.

BCBC 1111

M. George Hayter *The English portriat and history painter George Hayter (1792–1871), who had been awarded by the British Institution a prize of 200 guineas that enabled him to go to Rome. He was given a letter of introduction to Canova by Elizabeth Anne Rawdon (BCBC 4499), as well as that from the Duke of Bedford, who commissioned him to portray Canova (cat. no. 16).*

M. Hamilton *William Richard Hamilton (1777–1859) had been secretary to the Earl of Elgin at Constantinople in 1802 and supervised the transportation to England of the* Elgin Marbles *from Athens and the* Rosetta Stone *from Egypt. He became a friend of Canova in 1815 when, as British under-secretary for foreign affairs, he greatly facilitated the return to Rome of works of art seized by the French.*

A BUST OF YOU *This was perhaps a copy of Canova's heroic-scale* Self-Portrait *carved in 1812. Not until later, however, did the Duke acquire the marble bust of Canova now in the sculpture gallery at Woburn, a copy of the* Self-Portrait *and similar to that at Chatsworth House carved by Rinaldo Rinaldi (see also the slightly reduced copy in this exhibition by Raimondo Trentanove, cat. no. 17)*

M.DME CAMPORESE *Violante Giustiniani Camporese (1785–1839), an Italian singer who had been retained by Napoleon for private concerts. In 1817 she was engaged to sing at the King's Theatre, Haymarket, London where she was acclaimed for her performance in operas by Mozart, as Susanna in the* Nozze di Figaro, *Donna Anna in* Don Giovanni *and Sesto in the* Clemenza di Tito.

11

Al Sig.re
Sig.re Cavaliere Antonio Canova
Marchese d'Ischia
Roma
London May 4. 1817

My dear Sir

I have had the pleasure to receive your very obliging letter of March the 27th and am happy to hear of the continued favourable progress of <u>the Graces</u>, about which I feel so much interested. I never for a moment doubted your zeal in the execution of this truly valuable work, and it gives me pleasure to learn that I am likely to see it in England before the expiration of the present year. The temple which is destined to receive these Beauties is in a state of forwardness, and I hope when you see it you will approve of it. It is the bust in marble of your own portrait, which I wish to have, and although Mr. Hayter has engaged to paint your portrait for me, the regard and esteem I entertain for you makes me feel that the likeness cannot be too often multiplied.

I dined yesterday at the Royal Academy, with the Academicians, at their annual dinner and had the satisfaction to see your HEBE and TERPSICHORE placed in the sculpture room, and to hear them universally admired. I am now fully convinced by ocular demonstration that there is no artificial preparation used to give a colour to the marble, and the only thing I do not quite like is a slight tint of vermilion in the cheeks and lips of the Hebe, which however, as you justly observe may easily be taken off by a wet sponge.

I am happy to add that the Duchess is quite recovered in health, and desires me to add her kindest regards to you.

> Believe me to be
> with perfect esteem
> My dear Sir
> Your faithful and obediant servant
> Bedford

May I request you to send me the dimensions of the base of the Group, that I may give instructions respecting the pedestal.

BCBC 1112

HEBE *The statue carved for 1st Baron Cawdor, whose son sold it to the 6th Duke of Devonshire (now Chatsworth House). This is the third, greatly modified version of a statue the first of which was carved for Giuseppe Vivante Albrizzi (completed in 1800, now in the Nationalgalerie, Berlin) and the second for the Empress Josephine (completed in 1808, now in the Hermitage, St Petersburg).*

TERPSICHORE *The statue carved for Sir Simon Houghton Clarke, now in the Cleveland Museum of Art, Cleveland, Ohio. This is the second version of a statue commissioned by Lucien Bonaparte but completed in 1812 for Giovanni Battista Sommariva (now in the Fondazione Magnani-Rocca, Corte de Mamiano di Traversetolo, Parma).*

12

à Endsleigh en Devonshire

ce 31 10bre 1817.

Je suis enchanté de savoir M. le Chevalier, par M. Hayter que la grouppe des trois Graces est tant perfectionnée que je puis maintenant esperer de la recevoir en Angleterre dans le moi d'avril. Je vous assure que ce chef d'oeuvre dans la sculpture est attendu avec la plus vive impatience par tous les amateurs des beaux arts. J'ai seulement a regretter que nous ne verrons pas le Phidias qui a crée ce monument de sa genie. Le petit temple sera pret a recevoir ces belles Déesses dans peu de temps, et je vous envoie une copie de l'inscription que je compte mettre au dessus de la porte du temple. J'aurais preferé une en Italien, mais j'ai vainement cherché dans vos quatre grands poetes, l'Ariosto, il Tasso, il Dante et il Petrarca pour quelque chose analogue aux Graces, et M. FOSCOLO m'a assuré qu'ils n'y avoit absolument rien sur ce sujet. J'eus donc secours à mon ami M. ROGERS (qui vous avez connu à Rome) un de nos meilleurs poétes, et qui a le plus de gout et de grace. Vous connaissez assez la finesse de notre langue pour admirer la beauté de ces vers – ils sont très classiques et tirées d'un fragment grecque du Pindare. M. Hayter me promet bientot votre portrait, j'espere le trouver resemblant a l'estimable original, et je vous prie de croire mes sentimens de respect et d'amitié avec lesquels j'ai l'honneur d'etre votre très humble et obeissant serviteur

> Bedford

La Duchesse de Bedford desire de rappelier à votre souvenir, et je vous prie d'agréer mes remercimens des bontés que vous avez eu pour le jeune Hayter.

Aussitôt que la grouppe est expediée par un vaisseau sur je vous supplie de m'écrire un petit mot et je vous envoierai un billet sur M. Scultheis pour le 2000 sequins.

BCBC 1333

[Endsleigh Devonshire / 31st December 1817 / I am delighted, M. le Chevalier, to hear from Mr Hayter that the group of the three Graces is brought to such perfection that I can now hope to receive it in England in the month of April. I assure you that this masterpiece of sculpture is awaited with the greatest impatience by all lovers of the fine arts. I can only regret that we will not be seeing the Phidias whose genius created this monument. In a short time the little temple will be ready to receive these beautiful goddesses, and I am sending you a copy of the inscription which I plan to place above the door of the temple. I would have preferred one in

M. FOSCOLO *Ugo Foscolo (1778–1827), Italian poet and novelist. Although born on the island of Zante (a Venetian colony), he became an ardent Italian patriot with a well-known hatred of the Austrians and after their restoration to the government of Lombardy and the Veneto he prudently emigrated and in 1817 settled in England, where he spent his last years.*

M. ROGERS *Samuel Rogers (1763–1855) poet, banker and collector of works of art, a member of the Whig 'Holland House circle'. He met Canova in Rome in the winter of 1814–15 and invited him to dinner in London in November 1815.*

Italian, but I have searched in vain among your four greatest poets – Ariosto, Tasso, Dante and Petrarch – for something appropriate to the Graces; and M. Foscolo assures me that they have absolutely nothing on this subject. I had recourse therefore to my friend Mr Rogers (who you met in Rome), one of our best poets, who has the finest taste and style. You know well enough the subtleties of our language to admire the beauty of these verses – they are very classical and based on a Greek fragment by Pindar. Mr Hayter has promised me your portrait soon; I hope to find it true to the admirable original, and I beg you to accept my expressions of respect and friendship with which I have the honour to be your most humble and obedient servant / Bedford. / The Duchess of Bedford wishes to be remembered to you, and I beg you to accept my thanks for the kindness you have shown towards young Hayter. / As soon as the group is despatched on a vessel write me, I beg you, a few words and I will send you a banker's draft on Mr Scultheis for the 2000 zecchini.]

13

Copie d'une inscription pour la porte du *Temple des Graces* à Woburn Abbey.

[Copy of an inscription for the door to the Temple of Graces at Woburn Abbey.]

> Approach with reverence. There are those within,
> Whose dwelling place is heaven. Daughters of Jove
> From them flow all the decencies of Life;
> Without them nothing pleases, Virtue's self
> Admired not loved: and those on whom they smile,
> Great though they be, & beautiful & wise,
> Shine forth with double lustre.

BCBC 1106

Presumably sent to Canova with the letter of 31 December 1817 (no.12 above). Only the superscription is in the Duke's hand. The lines by Samuel Rogers paraphrase a passage in the 14th of Pindar's Olympic Odes.

14

à Woburn Abbey

ce 6 août 1818

J'ai reçu M. le Marquis votre aimable lettre avant de partir Paris et comme mon ami M. le CAPITAINE SPENCER m'a ecrit par le même courier que les belles Graces etoient actuellement à bord son vaisseau, je les attends ici avec la plus vive impatience. Comme vous ne dites rien au sujet de votre portrait en buste je crains que vous avez oublié les voeux que je vous ai exprimé la dessus.

Mon cousin le CAPITAINE WALDEGRAVE de la Marine Royal se charge de cette lettre, et je prends la liberté de lui reccomander ainsi que son aimable epouse à vos bontés.

Ma femme me charge de vous offrir ses complimens affectionnés et je vous prie d'agréer les sentimens de mon amitié et de mon estime.

Bedford.

Votre portrait par le jeune Hayter me plait beaucoup.

BCBC 1110

[Woburn Abbey / 6th August 1818 / I received, M. le Marquis, your kind letter before leaving Paris, and since my friend Captain Spencer wrote to me by the same post that the three Graces are now aboard his ship, I await them here with great impatience. Since you say nothing about your portrait bust, I fear that you have forgotten the promises that you made regarding it. / My cousin Captain Waldegrave of the Royal Marines is conveying this letter, and I am taking the liberty of recommending him to you together with his good wife. / My wife has asked me to send you her affectionate regards and I beg you to accept my feelings of friendship and esteem. / Bedford. / Your portrait by the young Hayter pleases me greatly.]

CAPITAINE SPENCER *Probably the distinguished naval officer Robert Cavendish Spencer (1791–1830), son of the 2nd Earl Spencer.*

CAPITAINE WALDEGRAVE *Presumably William Waldegrave (1788–1859), who was to succeed his nephew as 8th Earl Waldegrave in 1846. He had married in 1812 Elizabeth, daughter of Samuel Whitbread.*

15

Woburn Abbey
March 6 1820

My dear Sir

I have just had the pleasure to receive your letter of the 25th of January last which was transmitted to me by Captain Bradford. The group of the three Graces was placed on its pedestal in the temple which I have erected for the reception of these beautiful females last summer and I need scarcely add that since that period has excited universal admiration. I believe it is *unique* in this country not excepting THE KING'S NYMPH and LORD LANSDOWNE'S VENUS. Many of your friends have been here and have expressed an ardent wish that you should see your beautiful work as it is placed here. I need not add that I join most heartily in that wish and I feel confident that you would be pleased with what I have done. The Temple of the Graces is a chaste and simple building and your friend Rogers's pretty verses over the entrance have a good effect. I was fortunate in meeting with a pedestal for the group, which had been brought from Rome 60 years ago by one of our celebrated architects. It is antique but suits the subject admirably. The whole thing is perfectly classical and I wish you would give me some hope, that some time or other, I may have the pleasure of shewing it to you and of assuring you *viva voce* of the sincere regard and esteem with which

I have the honour to be
my dear Sir
your very faithful servant
Bedford.

The Duchess begs her kindest regards and good wishes to you.

BCBC 1113

THE KING'S NYMPH *The statue of a* Reclining Naiad *commissioned from Canova in 1815 by Baron Cawdor but completed for George IV and sent to England in the vessel that was also carrying* The Three Graces *(now in the collection of Her Majesty The Queen at Buckingham Palace).*

LORD LANSDOWNE'S VENUS *One of the three versions of the* Venus Italica *carved by Canova 1807–12 and the second that was completed; purchased in 1810 by Lucien Bonaparte, from whom it passed in 1815 to the Marquess of Lansdowne (now in the Hearst San Simeon State Historical Monument, California).*

SELECT BIBLIOGRAPHY

ANGELICOUSSIS, 1992

E. Angelicoussis, *The Woburn Abbey Collection of Classical Antiquities* (Monumenta Artis Romanae XX), Mainz am Rhein, 1992

BASSI, 1957

E. Bassi, *La Gipsoteca di Possagno: Sculture e Dipinti di Antonio Canova* (Fondazione Giorgio Cini: Cataloghi di raccolte d'arte 3), Venice, 1957

BASSI, 1959

E. Bassi, *Il Museo Civico di Bassano: I Disegni di Antonio Canova* (Fondazione Giorgio Cini: Cataloghi di raccolte d'arte 4), Venice, 1959.

CICOGNARA, 1823

L. Cicognara, *Biografia di Antonio Canova*, Venice, 1823

D'ESTE, 1864

A. d'Este, *Memorie di Antonio Canova … pubblicate per cura di Alessandro d'Este*, Florence, 1864

DRAPER, 1985

M. Draper, 'On a Theme of Napoleon: the Collection of John, 6th Duke of Bedford', *Country Life*, CLXXVII, 24 October 1985, pp.1240–4

HARTMANN, 1979

J. B. Hartmann and K. Parlasca, *Antike Motive bei Thorvaldsen*, Tübingen, 1979

HONOUR (ED.), 1994

Edizione Nazionale delle Opere di Antonio Canova, vol. I, *Scritti*, edited by H. Honour, Rome, 1994

HUNT, 1822

Rev. Dr. P. Hunt, *Outline Engravings and Descriptions of the Woburn Abbey Marbles*, (text by Hunt, with an appendix by U. Foscolo; engravings by H. Moses and G. Corbould after drawings by H. Corbould), privately printed, London, 1822

LICHT AND FINN, 1983

F. Licht and D. Finn, *Canova*, New York, 1983

LONDON, 1972

London, Royal Academy of Arts and Victoria and Albert Museum, *The Age of Neo-Classicism* (The Fourteenth Exhibition of the Council of Europe), organised by the Arts Council of Great Britain, 1992

LONDON, 1994

London, Royal Academy of Arts and Washington, National Gallery of Art, *The Glory of Venice: Art in the Eighteenth Century*, exhibition catalogue edited by J. Martineau and A. Robison, New Haven and London, 1994

LOS ANGELES, 1993

Los Angeles County Museum of Art, Philadelphia Museum of Art and Minneapolis Institute of Fine Arts, *Visions of Antiquity: Neoclassical Figure Drawings*, exhibition catalogue edited by R. J. Campbell and V. Carlson, 1993–4

MERTENS, 1994

V. Mertens, *Die drei Grazien*, Wiesbaden, 1994

MISSIRINI, 1824

M. Missirini, *Della vita di Antonio Canova*, Prato, 1824.

MOSES, ALBRIZZI AND CICOGNARA, 1824–8

The Works of Antonio Canova in Sculpture and Modelling Engraved in Outline by Henry Moses; with Descriptions from the Italian by Countess Albrizzi, and a Biographical Memoir by Count Cicognara, 3 vols., London, 1824–8

OST, 1970

H. Ost, *Ein Skizzenbuch Antonio Canovas 1796–1799* (Römische Forschungen der Biblioteca Hertziana, Band XIX), Tübingen, 1970

OUTLINE ENGRAVINGS…

see HUNT, 1822

PARRY, 1831

Rev. J. D. Parry, *The History of Woburn and its Abbey*, London, 1831

PAVANELLO, 1976

G. Pavanello, *L'Opera completa del Canova (Classici d'Arte Rizzoli)*, with an introduction by M. Praz, Milan, 1976

QUATREMÈRE DE QUINCY, 1834

A. C. Quatremère de Quincy, *Canova et ses ouvrages, ou mémoires historiques sur la vie et les travaux de ce célèbre artiste*, Paris, 1834

ROME, 1993

Rome, Istituto Nazionale per la Grafica and Bassano, Museo-Biblioteca-Archivio, *Canova e l'incisione*, exhibition catalogue edited by G. Pezzini Bernini and F. Fiorani, 1993–4

VENICE, 1992

Venice, Museo Correr and Possagno, Gipsoteca Canoviana, *Antonio Canova*, exhibition catalogue, 1992

WASHINGTON, 1985

Washington, National Gallery of Art, *The Treasure Houses of Britain: Five Hundred Years of Private Patronage and Art Collecting*, exhibition catalogue edited by G. Jackson-Stops, London and New Haven, 1985–6

WIND, 1958

E. Wind, *Pagan Mysteries in the Renaissance*, London, 1958

The abbreviation BCBC indicates Biblioteca Civica, Bassano del Grappa, MSS. canoviani. The numbers are those given by A. Sorbelli, *Inventari dei manoscritti delle biblioteche d'Italia, volume LVIII, Bassano del Grappa*, Florence, 1934

TIMOTHY CLIFFORD
CANOVA IN CONTEXT: PAGES 9–17

1 The majority of the Farsetti terracottas are in the Hermitage, but others remain in Venice in the Galleria Giorgio Franchetti at the Ca' d'Oro. See S. Androsov and G. Nepi Scirè, *Alle Origini di Canova: le terrecotte della collezione Farsetti*, exhibition catalogue, Rome, Palazzo Ruspoli and Venice, Ca' d'Oro, 1991–2.

2 See Venice, 1992, cat. nos. 117–18, pp.214–21.

3 Venice, 1992, p.218. In similar vein, the Rev. James Dallaway later observed (in *Anecdotes of the Arts in England*, London, 1800, p.394): 'At Rome, there is now flourishing a great celebrity, Antonio Canova, a Venetian sculptor, who has completed, after the antique, Cupid and Psyche, Venus and Adonis, and Hercules and Lycus with the Nessaean Shirt. The two former approach nearly to Grecian excellence, both in character and in sweetness; and the latter has all the force of the unfinished torsos of Michelagnuolo. Bernini's group of Apollo and Daphne, in the Borghese villa is left far behind; and M. Agnuolo would have found a competitor for fame, had he been contemporary with Canova'.

4 Honour (ed.), 1994, pp.35–162 (text printed *in extenso* with notes).

5 For reproductions and brief catalogue entries of these sculptures see Pavanello, 1976, nos.98–100, 121, 124, 131, 174, 213, 215, 319.

6 For Spinazzi see G. Pratesi, *Repertorio della Scultura Fiorentina del Seicento e Settecento*, 3 vols., Turin, 1993, vol. I, pp.60–1, vol. III, figs. 591–601; Honour (ed.), 1994, pp.85 (f.20v), 86 (f.25r).

7 J. Holloway, *Jacob More, 1740–1793*, Scottish Masters 4, Edinburgh, 1987; Honour (ed.), 1994, pp.140–4 (f.70v).

8 For the Albacini casts, see H. Smailes, 'A History of the Statue Gallery at the Trustees' Academy in Edinburgh', *Journal of the History of Collections* 3, no.2 (1991), pp.125–43; Honour (ed.), 1994, p.141 (f.71v).

9 Although disputed, I am inclined to believe this uncharacteristic work. See U. Schlegel, 'Ein Unbekannter Relief des Jungen Canova', *Berliner Museen*, 1964 p.18; *idem*, *Die Italienischen Bildwerke*, Staatliche Museen Berlin, vol. I, Berlin, 1978, pp.122–4, figs.42, 152–5.

10 The National Gallery of Scotland own a fine group of Batoni's drawings; three Batoni oils are to be seen at the National Gallery on the Mound and another at the Scottish National Portrait Gallery. For Canova's association with Batoni, see Honour (ed.), 1994, *passim*.

11 Honour (ed.), 1994, p.74 (f.75v): 'monsieur Amilton pittore eccelente che mi piaque all'estremo'. Hamilton's works are well-represented in the National Gallery of Scotland (see J. Lloyd Williams, *Gavin Hamilton, 1723–1798*, Scottish Masters 18, Edinburgh, 1994).

12 H. Honour, 'Theseus and the Minotaur', Victoria & Albert Museum Yearbook, I, 1969.

13 For Canova's *Libretto di Esercizi di Lingua Inglese*, see Honour (ed.), 1994, pp.231–250.

14 This model was engraved: see Rome, 1993, pp.95–7, cat. no. III.1.

15 Pavanello, 1976, cat. nos. 33, 65, 100, 101, 213, 276.

16 *Extracts of the Journals and Correspondence of Miss Berry 1783–1852*, edited by Lady Theresa Lewis, 3 vols., London, 1865, I, pp.103, 117.

17 Honour (ed.), 1994, p.292, n.32

18 F. Mazzocca, 'Canova: a myth in his own lifetime', in Venice, 1992, pp.77–87.

19 Dedicatory epistle to Hobhouse, as preface to Canto IV of *Childe Harold's Pilgrimage*. See Mazzocca, op.cit. at previous note, p.77.

20 Mazzocca, *ibid.*; Pavanello, 1976, pp.12–14.

21 *Römische Studien*, vol. I, Zurich, 1806.

22 Quoted by A. Lombardo, 'An English Paradox' in Honour (ed.), 1994, p.7.

23 K. Clark, *The Nude*, London, 1956, p.62.

24 Honour (ed.), 1994, p.318(35v) and pp.330–1. Fergusson's portrait by Sir Joshua Reynolds is in the Scottish National Portrait Gallery (acc. no. 2890).

25 H. Honour, 'An Italian Monument to Nelson', *Country Life Annual*, 1962.

26 C. Pietrangeli, 'Ambassador Extraordinaire: Canova's Mission to Paris' in Venice, 1992, pp.15–21.

27 A. H. Smith, 'Lord Elgin and his Collection', *Journal of Hellenic Studies*, XXXVI, 1916, pp. 332 ff.; W. St. Clair, *Lord Elgin and the Marbles*, Oxford, 1967; M. Pavan, 'Antonio Canova e la discussione sugli Elgin Marbles', *Rivista dell' Istituto Nazionale d'Archeologia e Storia dell'Arte*, XXI-XXII (1974–5), pp.219–344; S. Checkland, *The Elgins 1766–1917*, Aberdeen, 1988, pp.58–9.

28 On 22 April 1805 Thomas Hope wrote to the Rev. Edward Forster turning down a cast of a sculpture by Thomas Banks. 'It however only occasions a renewal of that regret which I experienced once before on Mr Canova's offering me a cast of his Perseus; and though I am well aware of the immense difference there is between a copy of an original existing elsewhere, and an original model, I still have to lament that my space is so confined as to oblige me to limit myself entirely to marbles'. See C. F. Bell, *Annals of Thomas Banks*, Cambridge, 1938, pp.62–3.

29 'Appunti sul viaggio in Inghilterra 1815' in Honour (ed.), 1994, pp.383–388; M. Pavan, 'La visita a Londra del Canova nel *Diary* del pittore Joseph Farington', *Atti del Istituto Veneto di Scienze, Lettere ed Arti*, 1976–7, p.65.

30 *Report of the Select Committee on the Earl of Elgin's Collection of Sculptured Marbles*, House of Commons, London, 1816, p.68.

31 *The Diary of Joseph Farington*, edited by K. Cave, vol. XIII, New Haven and London, 1984, pp.4743–4, 4746

32 W. T. Whitley, *Art in England*, vol. I (1800–1820), Cambridge, 1928, pp.251–52.

33 C. R. Leslie RA, *Autobiographical Recollections*, edited by T. Taylor, 1860 (1978 ed.) p.73.

34 *The Diary of Joseph Farington*, op. cit. at n.31, p.4738.

35 Private Collection; unpublished.

36 Formerly collection of Sir Ranulph Bacon, Hove, Sussex.

37 The National Gallery of Scotland possesses a fine full-length oil portrait of Madame Mère, enthroned, by François, Baron Gérard (c.1803), commissioned by Jerome Bonaparte, Napoleon's brother.

38 I am most grateful to my wife, Jane Clifford, for providing me with the full text of her unpublished paper 'Miss Berry and Canova: a Singular Relationship', delivered at the Victoria and Albert Museum, 13 May 1995.

39 A. Gilchrist, *Life of William Etty RA*, 1855, vol. I, [1978 ed.], p.129–180.

40 *Extracts of the Journals and Correspondence of Miss Berry 1783–1852*, op. cit. at n.14, vol. III, p.324.

41 Lawrence was clearly much influenced by Canova's types in his portraits. For example, the full-length of Georgina Mary, Lady Leicester, of 1814 (Tabley House, Cheshire) seems to have been influenced by Canova's *Hebe*, completed in 1814, now at Chatsworth).

42 Victoria & Albert Museum accession number E1727–1762–1925. Unpublished.

HUGH HONOUR
CANOVA'S THREE GRACES: PAGES 19–47

1 E. Bassi and L. U. Padoan, *Canova e gli Albrizzi*, Milan, 1989, p.80.

2 In reply to a request transmitted to him by Giovanni Gherardo De Rossi, Canova wrote to Visconti on 28 June 1802, explaining how difficult it would be for him to comply (Berlin, Staatsbibliothek Preussischer Kulturbesitz, mss. Darmst. 1919, 248). Visconti wrote back reiterating the request on 18 August 1802 (BCBC 1759; printed in F. Boyer, *Le Monde des Arts en Italie et la France de la Révolution et de l'Empire*, Turin, 1969, p.127).

3 Boyer, op.cit. at previous note, p.128.

4 He mentioned both works in a letter to Quatremère de Quincy of 17 December 1807 (Paris, Bibliothèque Nationale, mss. Ital. 65 f. 63r.; partially printed in Quatremère de Quincy, 1834, p.365). The model for the *Dancer* in the Gipsoteca Canoviana, Possagno, is however inscribed 'xbre 1806'.

5 The agreement with Canova was negotiated by Cardinal Joseph Fesch, Napoleon's uncle and ambassador in Rome (BCBC 724).

6 G. Rosini, *Saggio sulla vita e sulle opere di Antonio Canova*, Pisa, 1825, p.63.

7 BCBC 744.

8 Draft for letter, BCBC 745.

9 BCBC 1583.

10 Pausanias, *Itinerary of Greece*, Bk. IX, 25; Bk. VI, 6–7. For the paintings derived from the latter passage, see W. Crelly, 'The iconography of the Elian Graces' in *Essays in Honour of Walter Friedlaender*, New York, 1965, pp. 23–39. Canova stated that his statues of the pugilists Creugas and Damoxenos were inspired by a passage in Pausanias.

11 *Nicomachean Ethics*, v, v, 7; quoted by Crelly, op.cit. at previous note.

12 *De Beneficiis*, Bk. I, I, 9.

13 Servius, *In Vergilii Aeneidem*, I, 720; quoted by Wind, 1958, p.35.

14 Wind, 1958, pp. 31–67.

15 For the medal see *The Currency of Fame: Portrait Medals of the Renaissance*, exhibition catalogue edited by S. K. Scher, Washington, National Gallery of Art, New York, Frick Collection and Edinburgh, National Gallery of Scotland, 1994, pp.135–6, no.45.

16 C. Ripa, *Iconologia*, Rome, 1603, p.17. R. Varesi ('Una ipotesi di iconografia canoviana: Le Grazie' in *Arte-Documento* 7, 1994, p.234) points out that Canova's close friend Leopoldo Cicognara owned the five volume edition of 1764, and another friend Guiseppe Bossi no fewer than seven editions. For accounts of the Graces in Ripa's work and other iconographical manuals, notably Vincenzo Cartari, *Le imagini de i Dei de gli Antichi*, Venice, 1571, with numerous later editions to 1687, see Mertens, 1994, *passim*.

17 *Essay on Criticism*, 1709, lines 144–5.

18 Mertens, 1994, p.222 and pl.94.

19 *Iconologie ou traité de la science des allégories, à l'usage des artistes*, Paris, 1765, vol. II, p.81.

20 *Oeuvres complètes*, vol. I, Paris, 1771, p.86; quoted Hartmann, 1979, p.109.

21 G. Venturi 'La grazia e le Grazie' in Venice, 1992, pp.69–75, with references to the several discussions of the topic.

22 M. de La Rocque, *Voyage d'un amateur des arts... fait dans les années 1775–76–77–78*, Amsterdam, 1783, vol. II, p.129.

23 Honour (ed.), 1994, p.54. The group had been excavated in Rome but Canova, like all his contemporaries, believed that it had been discovered in the course of excavating foundations for the Cathedral.

24 Hartmann, 1979, p.110.

25 F. Brun, quoted in Hartmann, 1979, pp.110–11.

26 The group was said to be the best preserved by E. Q. Visconti, *Museo Pio-Clementino*, vol. IV, Rome 1788, p.22, and was fully described by G. A. Guattani, *Memorie Enciclopediche*, v, s.d. (1815?), p.113, when Pietro Vitali was named as the owner. Although acquired for the Vatican museums it was taken off public exhibition in 1826 because of the nudity of the figures and was hidden away for more than a century (see G. Lippold, *Die Skulpturen des Vatikanischen Museums*, vol. III, 2, Berlin, 1956, nr.433). Another damaged version was owned by Canova's friend Giovanni Volpato. For all these, and groups discovered later, see G. Becatti, 'Le tre Grazie' in *Bolletino della Commissione Archaeologica Comunale di Roma* LXV (1937), pp.41–60.

27 *Le Antichita di Ercolano, Pitture*, Rome, 1789, vol. II, pl.XI. Piroli had engraved prints after reliefs by Canova 1794–1802.

28 Lippold, op.cit. at note 26, no.550a. The sarcophagus in Potsdam which Canova could have seen on his visit in 1798 was illustrated in an engraving of 1731 by P. L. Ghezzi (see Hartmann, 1979, pl.51,1).

29 Hartmann, 1979, p.111 mentions a copy carved in ivory by Magnus Berg in 1723 but this seems to have been exceptional.

30 E. Q. Visconti, *Sculture del Palazzo della villa Borghese*, Rome, 1796, vol. II, p.24 remarked '*rimane incerto, se nelle tre figure si rappresentano le Ninfe, o le Grazie*', but favoured their identification as the Graces.

31 Mrs Morgan, *A Tour to Milford Haven in the Year 1791*, London, 1795, pp.349–50. A photograph of the conservatory at Stackpole Court, probably dating from the 1930s, showed a pair of these groups, possibly casts.

32 An example by a member of the Triscorni(a) family of sculptors at Pavlovsk is illustrated, and erroneously said to have been designed by Canova, in *Trésors d'art en Russie*, vol. III, Paris, 1903, p.143. Bronze statuettes executed by Giovanni Zoffoli and Francesco Righetti, and listed in their printed catalogues published in the last decade of the eighteenth century as 'Gruppo delle Tre Grazie di Villa Pinciana' and 'le trois Graces de la Villa Borghese', were almost certainly after this group rather than that with the figures standing side by side.

33 B. de Montfaucon (*Antiquité expliquée*, Paris, 1719, vol. I, pl.110) states that the altar was at 'Rossana'. His engraving was derived from a drawing by Jean-Jacques Boissard.

34 V. L. Goldberg, 'Graces, Muses and Arts: the Urns of Henry II and Francis I', *Journal of the Warburg and Courtauld Institutes* XXIX (1966), pp.206–18. The altar at 'Rossana' is not mentioned in this context.

35 A. Lenoir, *Musée des Monumens Français*, Paris, 1800–6, vol. III, p.134.

36 Venetian bronze statuettes of the late sixteenth or early seventeenth century attributed to Niccolò Roccatagliata, and a lime-wood group by Leonhard Kern, showing the figures nude, are illustrated in Mertens, 1994, pls.16, 20 and 21. Elaborate late eighteenth-century clock-cases were sometimes adorned with statues of the Graces. One with marble figures is supposed to be by Falconet, though this attribution is convincingly rejected by Réau, who mentions another clock which had bronze figures of the Graces by Louis-Claude Vassé (L. Réau, *Etienne-Maurice Falconet*, Paris, 1922, vol. I, pp.240–4.) A marble relief by Luc François Breton derived from one of the antique groups of the Graces, with the addition of Cupids at either side, was placed over the chimney-piece in the dining-room of Syon House, Middlesex, designed by Robert Adam in 1761 (see A. T. Bolton, *The Architecture of Robert and James Adam*, London, 1922, vol. I, p.261). These are small scale works. The only recorded large group earlier than Canova's is that by the Viennese sculptor Johann Michael Fischer of c.1790 in the park of Schloss Eisgrub, Czech Republic (illustrated in M. Poch-Kalous, *J. M. Fischer*, Vienna, 1948, pl.8).

37 Two examples are known, both in plaster, Staatsgalerie, Stuttgart and Schloss Tiefurt, Weimar; see C. von Holst, *Johann Heinrich Dannecker, der Bildhauer*, Stuttgart, 1987, pp.216–21.

38 Musée Condé, Chantilly (Wind, 1958, pl.34). The group at Siena inspired also the painter of a maiolica roundel made at Gubbio c.1525, the name-piece of the anonymous Master of the Three Graces (Victoria & Albert Museum, London).

39 Wind, 1958, pl.16.

40 S. J. Freedberg, *Painting of the High Renaissance in Rome and Florence*, Cambridge (Mass.), 1961, p.323 and pl.398. In the *Loggia di Psiche* the Graces figure also in the fresco of the *Wedding Feast of Cupid and Psyche*, probably painted by Gianfrancesco Penni after Raphael.

41 H. Tietze, *Tintoretto*, London, 1948, pl.227; see also Crelly, op.cit. at note 10.

42 L. Lanzi, *La Real Galleria di Firenze*, Pisa, 1782, p.140.

43 *Natural History*, XXXV, 141; Mertens, 1994, pp.305 ff.

44 This was painted for Cardinal Ippolito de' Medici and Vasari wrote a description of it in a letter, mentioning that the scene included a satyr admiring the beauty of Venus and the Graces and that '*al cardinale gli è piaciuto tanto quel satiro*'. The letter, published in Giovanni Bottari's *Raccolta di lettere*, may perhaps have inspired Canova's strange painting of Venus observed by a satyr (Possagno, Casa Canova).

45 Staatsgalerie, Stuttgart; Mertens, 1994, pl.127.

46 One of Boucher's paintings of the subject is in the Musée du Louvre, Paris, another in the National-museum, Stockholm.

47 London, Royal Academy, *Reynolds*, exhibition catalogue edited by N. Penny, 1986, pp.224–5, no.57.

48 N. Wilk-Brouard, *François-Guillaume Ménageot*, Paris, 1976, p.79.

49 *Artisti austriaci a Roma*, exhibition catalogue, Palazzo Braschi, Rome, 1972, no.2, pl.86.

50 For the best account of Canova's reliefs, see G. Pavanello in *Venezia nel età di Canova*, exhibition catalogue, Venice, Museo Correr, 1978, p.67

51 The painting was in the Medici Villa at Castelli until 1815 when it was transferred to the Uffizi in Florence.

52 Canova offered some image of the Graces, possibly a cast of this relief, to the architect Giacomo Quarenghi who replied from St Petersburg, 29 May 1795: '*Le di Lei Grazie saranno il più bell' ornamento del piccolo mio gabinetto...*' (BCBC 1675, printed in *Giacomo Quarenghi, Lettere ed altri scritti*, edited by V. Zanella, Venice, 1988, p.303). In the anonymous biography of Canova written in 1804–5, the relief is approximately dated to before 1798, and in the catalogue of his works published in 1817 it is assigned with other reliefs to 1797 (Honour (ed.), 1994, pp.309, 402).

53 A. Muñoz, *Canova: le opere*, Rome, 1957.

54 Pavanello, 1976, pp.139–43. These little paintings have usually been dated to Canova's stay in Possagno 1798–9, though Pavanello has pointed out that drawings closely associated with some of the series are dated 1794. Some may have been later than 1799, though all had been finished by 1810 when Canova began to commission prints of them (Rome, 1994, pp.264–314). In Canova's catalogue of his works published in 1816 they are described as *'vari pensieri di danze e scherze di Ninfe con Amori, di Muse, e filosofi ecc. disegnati per solo studio e diletto dell'artista'* (Honour (ed.), 1994, p.406). They are all now in the Casa Canova, Possagno.

55 For Canova's interest in the theatre, see the numerous comments in his travel diary of 1779–80 (Honour (ed.), 1994, pp.43–144).

56 Honour (ed.), 1994, pp.259–70.

57 The altarpiece, much of which he re-painted on subsequent visits to Possagno, was later to be installed in its present location in the new parish church or 'Tempio Canoviano' built to his design and at his expense. The other paintings are all in the Casa Canova, Possagno (Pavanello, 1976, pp.137–8).

58 J. J. Winckelmann, *Geschichte der Kunst des Altertums*, Dresden, 1764, p.229.

59 F. Brun, *Römisches Leben*, Leipzig, 1833, p.79.

60 C. F. Fernow, *Über den Bildhauer Canova*, Zurich, 1806, p.131. But grace was not a quality highly regarded by Fernow who (p.228) criticised Canova's statue of Pauline Borghese holding an apple in her hand with 'französischer Grazie'.

61 Foscolo, 1985, p.974.

62 For the very complicated history of the composition of *Le Grazie* and the several manuscript versions, see Foscolo, 1985, pp.162–604.

63 *Lettere di Giuseppe Bossi ad Antonio Canova*, Padua, 1839, pp.49–50.

64 Cicognara, 1823, p.102. With reference to other accounts of Canova's relations with Minette, who married an elderly Spanish general, Baron d'Armendariz, see L. Cicognara, *Lettere ad Antonio Canova*, edited by G. Venturi, Urbino, 1973, pp.21–2.

65 L. Cicognara, *Storia della Scultura*, III, Venice, 1818, pp.255–6.

66 Rome, 1993, pp.108, 262, 276.

67 Guiseppe Tambroni and his wife, Teresa Couty, were among Canova's closest friends in Rome at this time. See S. Rudolph, *Guiseppe Tambroni e lo stato delle belle arti in Roma nel 1814*, Rome, 1982, and R. Varese 'Un dipinto canoviano di Filippo Agricola' in R. Varese (ed.), *Studi per Pietro Zampetti*, Ancona, 1993, pp.571–3.

68 BCBC 753.

69 For a documented account of Canova's studio practice, see H. Honour *Dal bozzetto all' 'ultima mano'* in Venice, 1992, pp.33–43 and Honour (ed.), 1994, pp.163–210.

70 Pavanello, 1976, pp.124–5.

71 V. Malamani, *Un'amicizia di Antonio Canova*, Città di Castello, 1890, p.24.

72 *Idem*, p.25.

73 Rome, 1994, p.223.

74 Giovanni degli Alessandri to Canova, BCBC 1901.

75 *Lettere di Giuseppe Bossi ad Antonio Canova*, Padua, 1839, p.55.

76 *Giornale di Vincenzo Pacetti*, Rome, Istituto per la Storia del Risorgimento Italiano, MSS 654–5

77 Copenhagen, Thorvaldsens Museum, *C. W. Eckersberg i Rom 1813–16*, exhibition catalogue by D. Helsted *et al.*, 1983, p.12.

78 Violante Giustiniani Camporese to Canova, Paris, 7 October 1813, BCBC 1406.

79 BCBC 755.

80 BCBC 756.

81 BCBC 757.

82 Draft for letter, BCBC 758.

83 G. Hubert, 'La collection de sculptures 'modernes' réunie par l'impératrice Joséphine dans son domaine privé de Malmaison' in Recontres de l'Ecole du Louvre, *La Sculpture du XIXe Siècle*, Paris, 1986, p.76. Eugène's letter (BCBC 1468), referring to Canova's of 29 November, is published in facsimile in J. B. Hartmann, *Thorvaldsen a Roma*, Rome, 1959, p.42.

84 BCBC 760–776.

85 J. M. Colles (ed.), *The Journal of John Mayne*, London, 1909, pp.197–9.

86 The earliest reference to this project seems to be a letter from Charles Heathcote Tatham, London, 17 March 1802 (a fortnight after the death of the 5th Duke) asking Antonio d'Este to find out whether Canova would carve a statue of an un-named *'Nobile Inglese già morto'*, approximately according to sketches of a seated figure (BCBC 473).

87 Canova refused, but not firmly enough, and three years later the architect Robert Smirke sent him the plan and section of the building in which the statue was to be placed. See Honour (ed.), 1994, p.331.

88 Lord Cawdor's unpublished diary of his visit to Rome in 1815 is in the Carmarthen Area Record Office. I am grateful to John Kenworthy-Browne for this reference.

89 J. R. Hale, *The Italian Journal of Samuel Rogers*, London, 1956, p.236.

90 BCBC 1107.

91 I am grateful to Mrs. Noel Blakiston for drawing my attention to this letter – the only one from Canova to the Duke of Bedford that has been traced – in the archive of the Bedford Estates. It was mentioned by Draper, 1985, p.1242. The Marquess of Tavistock and the Trustees of the Bedford Estates have, however, refused permission to publish a transcription or translation of this letter.

92 BCBC 1109.

93 Angelicoussis, 1992, pp.20–1, 75–95. These were presumably the reliefs to which the Duke referred in his letter to Canova of 30 March (BCBC 2116).

94 H. Naef, D*ie Bildniszeichnungen von Ingres*, Berne, 1977, vol. I, pp.563–70, with a valuable account of the Duke from contemporary sources, and vol. IV, p.280.

95 Hartmann, 1979, pp.136–43.

96 M. Howitt, *Friedrich Overbeck sein Leben und Schaffe*, Freiburg, 1886, vol. I, p.400.

97 Draft of a letter, BCBC 773. Canova's reference to the Duchess rather than the Duke suggests that he was aware that Eugène had known her in 1802, when she had hoped to marry him (see G. Blakiston, *Woburn and the Russells*, London, 1980, p.168).

98 The contract was not signed until September 1815 (N. Kossareva in *Canova all'Ermitage*, exhibition catalogue, Rome, Fondazione Memmo, 1992, p.42), but negotiations probably began soon after Alexander I arrived in Paris.

99 Antonio Re to Canova, Rome, 4 August 1815 (BCBC 776).

100 Venice, Biblioteca Querini Stampalia, MSS. Classe VII, cod. 104 (736), f.181.

101 BCBC 2113.

102 BCBC 2115.

103 Honour (ed.), 1994, pp.390, 394. The visit was later to be recalled in a letter from Jeffrey Wyatt to Canova 13 February 1821 (BCBC 1773).

104 BCBC 2114.

105 Paris, Bibliothèque Nationale, mss. Ital. 65, ff. 129–132; printed with some errors of transcription in Quatremère de Quincy, 1834, pp.393, 395.

106 New York, Metropolitan Museum of Art Library, 920.3.V52, p.133, in the first of five volumes of Westmacott's correspondence. I am grateful to Nicholas Penny for drawing my attnetion to this letter.

107 BCBC 1332.

108 BCBC 1111.

109 BCBC 1112.

110 BCBC 5292.

111 BCBC 1113. Angelicoussis, 1992, p.21 states that the plinth is not, in fact, antique.

112 BCBC 776.

113 A. M. Corbo, 'L'esportazione delle opere d'arte dalli Stati Pontefici' in *L'Arte* 13 (1971), p.90. The group was to remain in the possession of Eugène's descendants until 1901 when it was bought by Czar Nicholas II for the Hermitage, where it joined the other works commissioned from Canova by the Empress Josephine.

114 BCBC 1333.

115 BCBC 1108.

116 BCBC 1110. On the 27 May 1819 Captain Young wrote to Richard Westmacott: 'The Alliance Transport which is expected at Deptford from Portsmouth has on board a case for the Prince Regent containing a statue of a Nymph by Canova; in the same vessel is a group of the Graces also by Canova for the Duke of Bedford' (collection of the late Rupert Gunnis; present location unknown).

117 BCBC 116.

118 For an interesting interpretation of the symbolism of the altar, see R. Varese, 'Una ipotesi di iconografia canoviana: Le Grazie' in *Arte-Documento* VII (1994), pp.233–6.

119 Quatremère de Quincy, 1834, p.253.

120 Rome, 1993, pp.220–4.

121 *Report from the Select Committee on the Earl of Elgin's Collection of Sculptured Marbles*, London, 1816, pp.4–5, 55–8; A. Michaelis, *Ancient Marbles in Great Britain*, Cambridge, 1882, pp.134–6.

122 Foscolo, 1985, pp.243–4, 1079–1132 (reprinting the text in *Outline Engravings*).

123 *Childe Harold's Pilgrimage*, Canto IV, stanza IV. In the dedication of this canto, Byron included Foscolo in a list of 'great names' of contemporary Italian writers.

124 Lord John Russell wrote to Foscolo on 20 August 1819 saying that his father 'would be glad to see you, and you would like to see Canova's Graces' (Foscolo, 1985, p.1243).

125 Foscolo, 1985, p.1124.

126 For the various interpretations of the relationship between Foscolo's poem and Canova's group, see G. Venturi in Venice, 1992, pp.69–74.

127 Foscolo, 1985, pp.1080–1.

128 L. Cicognara, *Lettere ad Antonio Canova* edited by G. Venturi, Urbino, 1973, p.54.

129 Quatremère de Quincy, 1834, pp.248–50.

130 Full size copies include those at Belvoir Castle (illustrated *Sotheby's: Art at Auction*, London, 1992–3, p.18), Ny Carlsberg Glyptotek, Copenhagen, and Musée des Beaux Arts, Nice.

131 Rome, 1993, pp.220–4.

132 E. Axelson (ed.), *South African Explorers*, London, 1954, p.302.

JOHN KENWORTHY-BROWNE
THE SCULPTURE GALLERY AT
WOBURN: PAGES 57–67

1 Earl of Ilchester, *The Home of the Hollands* 1605–1820, 1937, vol. II, p.233.

2 C. Avery, 'Laurent Delvaux's Sculpture at Woburn Abbey', *Apollo*, CXVIII, 1993, pp.312–21.

3 For details of the Cawdor sale, see Angelicoussis, 1992, no.82. Each piece of antique sculpture is illustrated and fully described in this excellent catalogue.

4 J. Kenworthy-Browne, 'The Temple of Liberty at Woburn Abbey', *Apollo*, CXXX, 1989, pp.27–32.

5 J. Britton, *The Beauties of England and Wales*, vol. I, London, 1801, pp.58–60.

6 E. Croft Murray, 'An Account Book of John Flaxman RA', *Walpole Society* XXVIII, 1940, p.76.

7 Draper, 1985, p.1240.

8 *The Annual Register*, October 1803, p.440.

9 *The Greville Memoirs* 1814–1860, ed. L. Strachey and R. Fulford, 1938, vol. IV, p.209.

10 W. J. Hooker, *Copy of a letter… on the occasion of the death of the late Duke of Bedford*, Glasgow, 1840.

11 J. R. Hale, *The Italian Journal of Samuel Rogers*, London, 1956. Lord Cawdor's brief and unpublished journal is in the Cawdor archives deposited at Dyfed Archives Service, Carmarthen Area Record Office.

12 G. F. Waagen, *Treasures of Art in Great Britain*, vol. III, 1854, p.469.

13 Angelicoussis, 1992, no.8.

14 The descriptions are from Hunt, 1822.

15 *The New Monthly Magazine*, London, 1818, p.173.

16 Parry, 1831, p.244.

17 J. M. Thiele (edited by M. R. Bernard), *Life of Thorvaldsen*, 1864, p.94.

18 The authority is Rupert Gunnis (*Dictionary of British Sculptors*, London, 1954, p.424), quoting the Woburn Archives.

19 *Giornale Arcadico*, XXXV, Rome, 1827, pp.97–101.

20 Parry, 1831, p.255: 'This is universally allowed to be a most beautiful specimen of modern art'.

21 See Angelicoussis, 1992.

22 Flaxman's second Account Book, preserved at Columbia University, New York, p.41: 'His Grace the Duke of Bedford – A Bassorelievo of Satan from Milton to be executed in Marble for £500.' The undated entry is probably of 1826–7.

23 A copy of the 1828 list is preserved at the Royal Academy Library, *Sir R. Westmacott, Miscellaneous Papers*, vol. IV.

24 P. F. Robinson, *New Vitruvius Britannicus: History of Woburn Abbey*, 1833, unnumbered engraving.

25 The mosaic is described in Parry, 1831, pp.238f. For Lord Kinnaird's portion, now on loan to the National Gallery of Scotland, see A. H. Millar, *The Historical Castles and Mansions of Scotland*, 1890, p.21.

26 Angelicoussis, 1992, pl.4.

IAIN GORDON BROWN
CANOVA, THORVALDSEN
& THE ANCIENTS: PAGES 69–76

1 [A. Jameson] *Diary of an Ennuyée*, new ed., London, 1826, pp.208–9.

2 National Library of Scotland, Edinburgh, MSS. 11986–7, *passim*

3 See F. J. B. Watson, 'Canova and the English', *Architectural Review*, CXXII (1957), pp.403–6.

4 Moses, Albrizzi and Cicognara, 1824–8, I, pp.XXXVII-XXXVIII.

5 *Lord Byron: Selected Letters and Journals*, edited by L. A. Marchand, London, 1982, p.140; *Byron's Letters and Journals*, edited by L. A. Marchand, 12 vols., London, 1973–82, V, p.235.

6 *The Diary of Joseph Farington*, edited by K. Cave, 16 vols., London, 1978–84, XVI, p.5677

7 J. B. Hartmann, 'Canova, Thorvaldsen and Gibson', *English Miscellany*, 6 (1955), p.217.

8 Quoted in D. Irwin, *English Neoclassical Art*, London, 1966, p.165.

9 F. Owen and D. B. Brown, *Collector of Genius: a Life of Sir George Beaumont*, New Haven and London, 1988, p.207.

10 *Life of John Gibson, R. A., Sculptor*, edited by Lady Eastlake, London, 1870, pp.50–1.

11 Owen and Brown, op.cit. at note 9, p.207

12 On these sculptors see U. Thieme and F. Becker (eds.), *Allegemeines Lexikon der bildenden Künstler*, 37 vols., Leipzig, 1907–50: vol. II, p.586 (Baruzzi); XXXIII, p.378 (Trentanove); and XI, p.580 (Finelli). See also H. Honour, 'Canova's Studio Practice – II: 1792–1822', *Burlington Magazine*, CXIV (April 1972), pp.225–6.

13 London, 1972, p.286.

14 The sculptor is recorded as having died on 31st January 1822: see Thieme-Becker, op. cit. at note 12, XXIX, p.546. Mrs. Jameson reported his death, op.cit.at note 1, p.211.

15 M. Robertson, *A Shorter History of Greek Art*, Cambridge, 1981, p.45.

16 M. Robertson, *A History of Greek Art*, 2 vols., Cambridge, 1975, I, pp.165–7.

17 London, 1972, p.180; s.v. Wright of Derby.

18 [C. A. Eaton] *Rome in the Nineteenth Century… in a Series of Letters*, 3 vols., Edinburgh,1820, III, p.299.

19 It is probable that Minto's version of the *Shepherd Boy* was never delivered. He was still enquiring about it in a letter he wrote to Thorvaldsen from Edinburgh five years later (17 February 1827; preserved in the archive of the Thorvaldsen Museum, Copenhagen). For this reference I am grateful to Helen Smailes, whose attention was in turn drawn to the letter by the late Bjarne Jørnæs, formerly of the Thorvaldsen Museum. For the version of this statue purchased by Thomas Hope, see T. Clifford, 'Thomas Hope's *Shepherd Boy*', *Connoisseur*, vol. 175, no. 703, 1970, pp.12–16.

20 Moses, Albrizzi and Cicognara, 1824–8, III, letterpress accompanying plates of the statues.

21 J. S. Memes, *Memoirs of the Life of Antonio Canova, with a Critical Analysis of his Works, and a Historical View of Modern Sculpture*, Edinburgh, 1825, p.499.

22 I am indebted to Hugh Honour for this observation.

23 On the inappropriateness, see F. Licht and D. Finn, *Canova*, New York, 1983, pp.93–5.

24 *Bertel Thorvaldsen 1770–1844: scultore danese a Roma*, exhibition catalogue edited by E. di Majo, B. Jørnæs and S. Susinno, Rome, Galleria Nazionale d'Arte Antica, 1989–90, pp.44, 121, 157–60, 227.

25 On the sculpture at Lansdowne House see A. Michaelis, *Ancient Marbles in Great Britain*, Cambridge, 1882, pp.435–71, and the monograph prepared by A. H. Smith and based on Michaelis's work, *A Catalogue of the Ancient Marbles at Lansdowne House*, London, 1889.